D0937038

XXVII

TAB. XII.

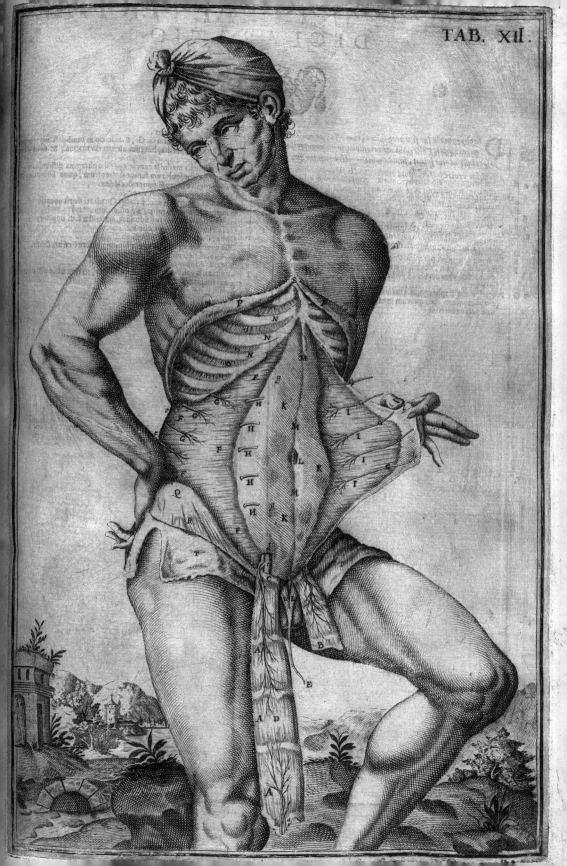

Human Anatomy

{From the Renaissance to the Digital Age}

Benjamin A. Rifkin

Michael J. Ackerman

Biographies by Judith Folkenberg

Abrams, New York

Editor: Elaine Stainton
Designer: Eric Himmel
Production Manager: Maria Pia Gramaglia

Library of Congress Cataloging-in-Publication Data

Rifkin, Benjamin A.
Human anatomy : five centuries of art and science / Benjamin A. Rifkin ;
afterword by Michael J. Ackerman ; biographies by Judith Folkenberg.
p. cm.
Includes index.
ISBN 0–8109–5545–8 (hardcover)
1. Anatomy, Artistic. 2. Medical illustration—History—Atlases.
I. Title. [DNLM: 1. Medical Illustration—Atlases. 2. Anatomy, Artistic—Atlases.
3. Medical Illustration—history. 4. Anatomy, Artistic—history. WZ 17 R564h 2006]
NC760.R54 2006 743.4'9—dc22
2005022192

Page 1: Bones of the leg. From William Cheselden,
Osteographia, or The anatomy of the bones (London, 1733)

Page 2 (frontispiece): Muscles and blood vessels of the abdominal wall.
Male figure, in vivo, anterior view. From Giulio Cesare Casseri and Adriaan van den Speighel,
De humani corporis fabrica libri decem (Venice, 1627)

Illustrations © 2006 Harry N. Abrams, Inc.
"The Art of Anatomy" © 2006 Benjamin A. Rifkin
"Anatomy in the Digital Age" © 2006 Michael J. Ackerman
Biographies of anatomists © 2006 Judith Folkenberg
Published in 2006 by Abrams, an imprint of Harry N. Abrams, Inc.
All rights reserved. No portion of this book may be reproduced, stored in a retrieval system,
or transmitted in any form or by any means, mechanical, electronic, photocopying, recording,
or otherwise, without written permission from the publisher.

Printed and bound in China
10 9 8 7 6 5 4 3 2 1

HNA
harry n. abrams, inc.
a subsidiary of La Martinière Groupe
115 West 18th Street
New York, N.Y. 10011
www.hnabooks.com

CONTENTS

The Art of Anatomy

Benjamin A. Rifkin

Go soul, the body's guest, upon a thankless errand,
Fear not but touch the best, the truth shall be thy warrant.
—Sir Walter Raleigh

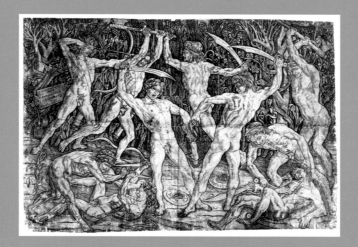

Antonio Pollaiuolo, *Battle of Ten Nude Warriors,* 1472

T HE BODY WAS NEVER A FREE GIFT; it gives temporary shelter to our aspirations on a finite lease. We try to preserve and commemorate its tenure. In our age of increasingly narrow technology, we still begin with the body, the province of schools of art and schools of medicine, heirs to our first struggles against mortal limits. These schools cloister optimism. Medical students press through the aromatics of boiled linen, disinfectant, and formaldehyde, making the rounds of formal lectures, half-draped patients, and stripped cadavers. They study the body to improve its fate. Art students, half-nourished by a miasma of primed linen, turpentine, and chalk, study the undraped model in life class, practice the diagrams of geometric perspective, and memorize the skeleton and muscles in anatomy. Some may yet learn to convey ideas as convincing images for the empathetic response of an audience. With kindred presumptions of benefice, the doctor studies the body to improve its fate; the artist to improve its spirit.

Above all, these students start with the same genre of book: the illustrated anatomy. Here the body is laid bare inside and out in pictures that work in several realms. They are science in subject, illustration in usefulness, but art in their potential emotional impact. Spawned in the ancient union of art and medicine and fears of mortality, these books transform the pathology of death into art concerning the force of life. Their long gestation began at the dawn of the Renaissance in Italy; their first monumental apogee, as we shall see, was the work of Vesalius in the mid-sixteenth century.

Physicians and artists have always shared a fascination with the human body. In the ancient world, Aristotle and Galen dissected the dead in their search for the secret of life, and Phideas sculpted the immortality of gods in human form on the Parthenon. At the dawn of the Renaissance, the Italian anatomist Mundinus (Mondino da Luzzi) again began to open the bodies of the dead, while the artist Giotto painted lifelike figures as empathetic beings. Physician and artist worked to preserve life, but an artist could even revive the dead, an idea that took on particularly witty form in Renaissance anatomy books that show animated cadavers strutting across the landscape. Such books were aimed at a wide audience of surgeons, artists, and intellectuals. Apart from the concerns of science and art, however, the illustrations in these books developed as a special category of imagery that continued well into the nineteenth century. As we shall see, these pictures were often about the nature of anatomy, the cadaver, and the moral condition of being dead and dissected. Above all, they show the dead as living embodiments of our form and fate.

As mid-fifteenth-century Florence saw the revival of Platonic

ideas of body and soul, artists were rediscovering Roman sculpture, a coincidence that reinforced the idea of the body as an agent of thought and feeling. Drawing it convincingly, however, required anatomical information. Artists soon began to commandeer cadavers for dissection, using as their guide an unillustrated handbook published by Mundinus. A measure of their progress can be seen in Antonio Pollaiuolo's immense engraving of 1472, *Battle of Ten Nude Warriors* (p. 6). Modeled in contrasting values of dark and light against a landscape suggesting a Roman relief, these figures established a rhetoric of anatomical display that would last for centuries.

LEONARDO: SCIENTIST AND ARTIST The study of anatomy and motion fascinated Leonardo da Vinci, the most artistically gifted scientist and scientifically acute artist of his age. Anatomical notations began to appear in the late 1480s among the studies of faces and poses that he made for the *Last Supper* in Milan, growing steadily in number and complexity until his death. These drawings trace patterns of motion similar to those of plants and water, but are conceived more like his designs of mechanical devices in which he combined visual acuity with analytic intellect to envision the workings of animate mechanisms. Hardly a casual amateur, Leonardo dissected dozens of cadavers, filling several thick notebooks with meticulous drawings and crabbed notations for a projected textbook on anatomy that would supersede Mundinus. Sadly, it would be another of Leonardo's thwarted projects, known only by a few stray sketches copied and circulated among other artists.

In his anatomy drawings Leonardo devised new ways to better illustrate his findings. To be useful, an anatomical drawing needs to be as objectively literal as possible, although this was rarely the case. Drawing is an inherently personal action prone to three potential distortions as scientific evidence. There is the larger influence of period style, the idiom that remains more or less common to a time and place. The Renaissance liver – complete with peripheral lobes like the horns on early wombs – is not the bulbous Baroque liver, and neither resembles the elongated Neoclassical liver. A period style is modified by personal instinct, without which all art would look the same, as often happens with weaker spirits in stronger circles. Finally, technique, the limits and effects of tools and materials, determines the final cosmetic look of supposedly objective data.

Leonardo the scientist seems to have found an artistic solution for medical illustration not unlike the style of his botanical drawings. Stripped of the flourishes of an improvising pen, the anatomies are spare outlines with dry, mechanical hatching, form without an atmospheric context. Recognizably human, they elicit

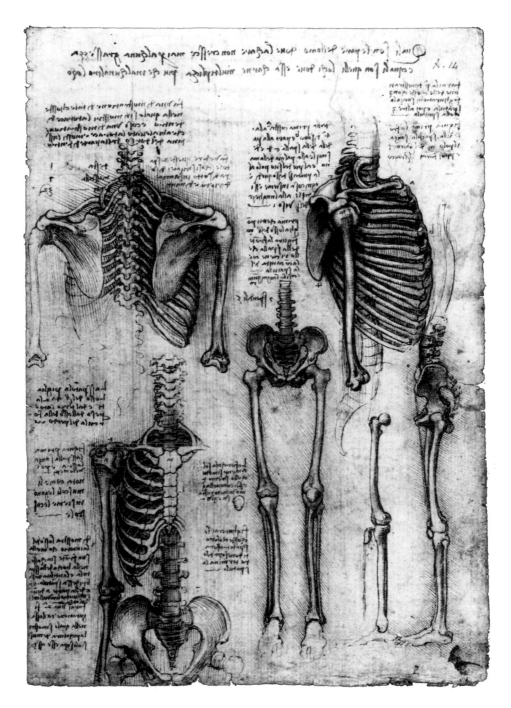

Leonardo da Vinci, details of articulated skeletons, from the Anatomical Notebooks, c. 1510

inadvertent empathy, although they are truly conceived like machines without intentional emotional or aesthetic context. No scientist before and precious few after Leonardo could claim as truthfully efficient an illustrator for his work. Leonardo's graphic shorthand largely solved another problem inherent in anatomical art: the fact that, before chemical preservatives and refrigeration, cadavers decomposed quickly. An artist had to draw a single segment quickly, compiling a whole body from studies of many cadavers.

After Leonardo's death, his drawings were largely lost from view. Their rediscovery and publication at the turn of the nineteenth century profoundly clarified the nature of pure scientific illustration at last. In the meantime, the anatomy book had prospered as a luxury publication of greater or lesser scientific value for a widely erudite audience. Its artistic appeal barely skirted the danger of fatal distortion for surgical practice. The lasting value of the art in these books is its expression of evolving ideas about death, medicine, and the hereafter in early modern culture.

KETHAM:
THE GHOST
IN VENICE
It began with the ghost of a long-dead author. In 1492 the de Gregoriis brothers in Venice published a sumptuous edition of the *Fasciculus medicinae* (*The Medical Gathering*), a ragbag of old tracts on midwifery, bloodletting, and urinoscopy ascribed to a long-dead physician known as Johannes de Ketham. The text was unimportant. It was pretext for the presentation of a luxury volume of folio-size woodcuts copied from sources as hoary as the texts, including a Zodiac Figure showing the planetary signs affixed to the organs they were thought to influence. It was hardly modern medicine, but the de Gregoriis brothers knew their market. The printing press, with illustrations made from carved wood blocks, had stimulated a rush into literacy among the nobility and upper bourgeoisie of Renaissance Europe. Knowing that seasoned bibliophiles, such as Federico da Montefeltro, the duke of Urbino, "would have been ashamed to own a printed book," Venetian publishers introduced handsomely printed similacra of luxury manuscripts. The idea worked: the ardently literate marchioness of Mantua, Isabella d'Este, collected printed editions of the classics and even Leonardo stopped in Venice to buy books. This new audience read everything, including illustrated books on anatomy and medicine.

In 1493 the de Gregoriis issued a new Italian version of their book as the *Fasciculo de medicina,* without Ketham's name but with a translation of Mundinus's textbook on anatomy. It had four woodcuts showing richly detailed genre scenes of medical practice and

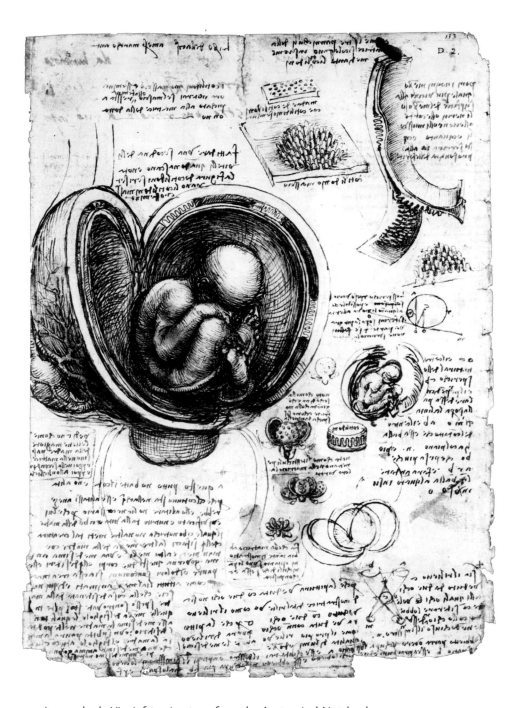

Leonardo da Vinci, fetus in utero, from the Anatomical Notebooks, c. 1510

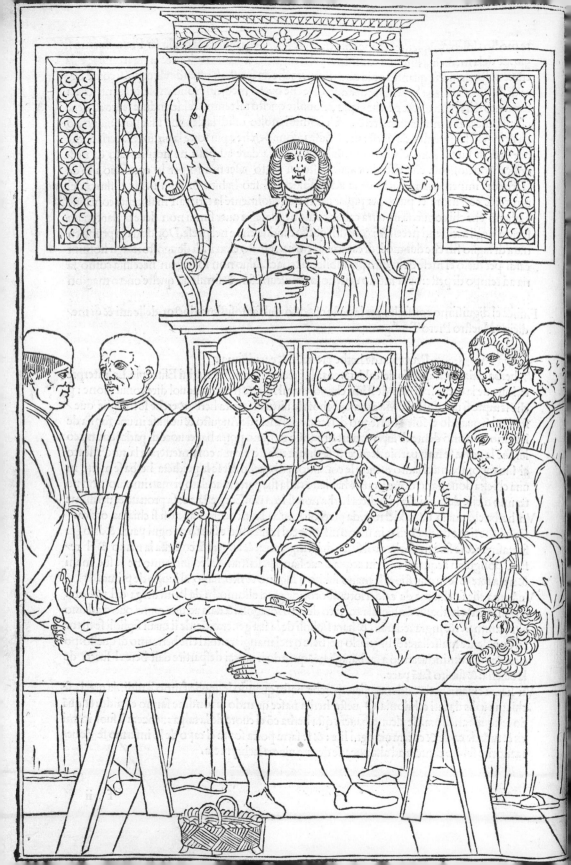

training, including a dissection as performed in Mundinus's generation (opposite). A professor reads a text from a lectern, the cadaver is opened by a surgeon, and body parts are pointed out by an assistant. The clean, classical simplicity of line typifies the elegant High Renaissance style of great Venetian publishing in this decade. At one time optimistically attributed to Bellini or Mantegna, the woodcuts are in fact the products of a publishing workshop. Executed with cleanly drawn figures in simple drapery and lined up like friezes in shallow settings, they were produced by manuscript illuminators working with wood-cut specialists in a generic company style of consistent quality and appeal. They helped the de Gregoriis create an audience among artists, surgeons, and the curious erudite for years to come. The new book was wildly successful, going through twelve versions in the next decade, superseded only by the appearance of Berengario's great works in the next century.

The first full-scale illustrated anatomy book was the *Commentaria super anatomia Mundini* of 1522, by Jacopo Berengario da Carpi (1460–1530). The son of a physician, Berengario had grown up in the courts of Italy's Po Valley, an intellectual at home in the best Humanist circles of his time. He fleshed out Mundinus's handbook with over one thousand pages of annotations, including invaluable material from his own surgery and dissection. Based on hands-on research, his book made a sharp break between the medieval past and Renaissance modernity, and it included real anatomical illustrations. Probably based on Berengario's own sketches worked up by an artist in preparation for the final woodcuts, these created an autonomous picture type: the bodies of the dead depicted as protagonists of moods and morals.

BERENGARIO:
THE FIRST
ILLUSTRATED
ANATOMY

Berengario loved art. He collected Roman sculpture, commissioned goblets from Cellini, and even owned a painting by Raphael. As a scientist, he trusted the testimony of his eyes over theory, and as a man of direct action, he loved the practice of surgery. In his smaller, second book, *Isagogae breves* of 1523, he recommended his woodcut illustrations of the outer muscles both to surgeons, as a guide to vulnerable tendons, and to artists, as an aid in the correct design of figures. Although their drawing is crude, the twenty-eight woodcuts in Berengario's two books form a compendium ranging from a schema of the skeleton and vascular system to direct quota-

Opposite: Anatomy lecture, from Johannes de Ketham, *Fasciculo de medicina,* 1494

tions from High Renaissance art in contemporary Rome. In one, a cadaver proudly striking the pose of an Apollo is surrounded by an aureole of light, a posthumous sun god (opposite). Other figures pull open their chests to reveal their internal organs. This puzzling conceit may illustrate the redemptive potential of dissection accepted by the Renaissance church, based on the Old Testament idea of sacrifice beyond duty as a form of atonement. Indeed, there is a moralizing undercurrent in many of Berengario's woodcuts, particularly the female cadavers illustrating the reproductive organs, whose draping seems to suggest both shame and modesty.

The six woodcuts of male nudes, on the other hand, suggest nothing of the cadavers' personal history. These are drawn both from antique sculpture and from the work of a number of Italian Renaissance artists. Berengario made only smaller quotations from his sources. For example, one woodcut of the skeletal hand and foot copies two Leonardo drawings; a flayed, crucified nude recalls studies by Michelangelo and Raphael; a Man with an Ax shows a back view of the recently excavated Apollo Belevedere; and a Desiccated Man is a quotation from an engraving of skeletons after a drawing by Rosso Fiorentino. Another figure, a Seated Man Pointing – a typical pose in Raphael's frescos and familiar as the model for St. John the Baptist in innumerable paintings – is taken from a woodcut by Berengario's countryman Ugo da Carpi. Berengario's illustrations are a telling intersection of High Renaissance art and science. Moreover their settings convert these technical illustrations into art.

In 1538, Andreas Vesalius (1514–64), a Flemish professor of anatomy at the University of Padua, commissioned the printing of a series large anatomical woodcuts, the six surviving of which are known as *Tabulae sex* (*Six Plates*). Like Berengario, Vesalius did his own dissecting, making rudimentary sketches as he went. His prints, drawn with the help of the Flemish artist Jan Stefan van Kalkar (c. 1500–46), were intended to be used by students as "aids in strengthening the memory" of what they had seen during his dissections. Five years later, in 1543 (twenty years after the second edition of Berengario's *Isagogae*) Vesalius published his great work, *De humani corporis fabrica* (*The Fabric of the Human Body*). This book completely superseded all earlier efforts in the science and art of anatomy, and established Vesalius's work as one of the great watersheds in the history of medical literature. Even now, long after his contributions to medicine have been absorbed by later research, *De fabrica* enthralls us, and it is still in print. Its great and lasting appeal is in its remarkable illustrations.

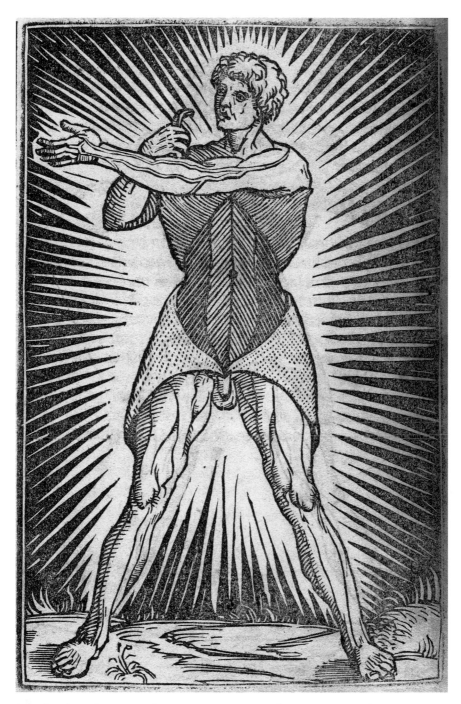

Muscles, deep dissection, from Jacopo Berengario da Carpi, *Isagogae breves, perlucidae ac uberrimae, in anatomiam humani corporis a communi medicorum academia usitatam,* 1523

The illustrations in *De fabrica* (and the *Six Plates* that preceded them) were revolutionary. They were better drawn than anything published before, partly because Vesalius's own sketches greatly enriched the information provided by the mounted skeletons from which van Kalkar drew. Moreover, the finished compositions were meticulously printed. The result was the most accurately detailed and solidly rendered images of the human body ever produced, then and for some time after. These woodcuts greatly advanced the capacity of printed images to provide identical information that could be reviewed simultaneously anywhere, a founding tenet of modern scientific method.

There was more than scientific accuracy at play in Vesalius's illustrations. Unlike the skeletons in medieval representations of the Dance of Death, those in Book I of *De fabrica* are not external agents of destruction, but all-too-sentient victims of a difficult posthumous world. These figures openly mourn their own deaths and grieve the passing of others. One, shown with a gravedigger's spade, began life leaning on a mounting prop in class (opposite); the same figure appears later in paintings by English Romantics as a personification of mortality. In Book II of *De fabrica*, the cadavers are discombobulated, stripped of their last living layers beyond the help of medicine. Their mortality seems all too real, too accurately drawn, to be other than human. Far beyond the needs of medical illustration, their palpable sufferings touch us deeply.

The figures in *De fabrica* were derived in large part from a source that has remained almost unnoticed: Charles Estienne's *De dissectione partium corporis humani* (*Dissection of the Human Body*). This book, although written during the 1530s, was not published until two years after *De fabrica* – in 1545 – and was therefore lost in its shadow. Although *De dissectione* lacked the singular focus of Vesalius's book, its science was good and it included a number of important medical discoveries. Better yet, many of its folio woodcuts introduced pictorial devices new to anatomical illustration.

De dissectione was begun in 1530 – the year of Berengario's death – when the Estienne family in Paris, publishers of the works of Galen and the Galen scholar Jacobus Sylvius, launched a new text to replace Berengario's *Isagogae*. The book was initially supervised by one Étienne de la Rivière, a surgeon with some drawing skill, together with a woodcut artist, Jean Jollat. At this point, the book's eventual author, Charles Estienne, was a student at the University of Padua. In 1534, however, at age thirty, he returned to France to complete his medical degree with Sylvius at the University of Paris. There he was soon joined by the young Vesalius, newly arrived from study in Louvain.

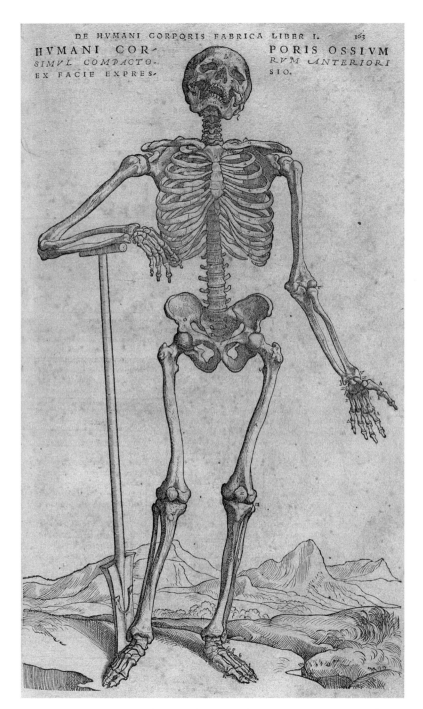

Skeleton in a landscape, from Andreas Vesalius, *De humani corporis fabrica libri septem*, 1543

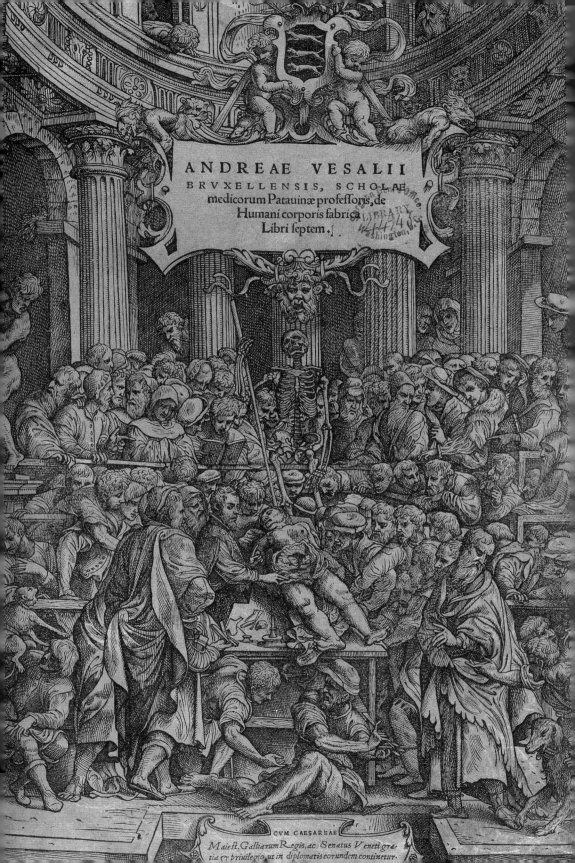

ANDREAE VESALII

BRVXELLENSIS, SCHOLAE
medicorum Patauinæ profeſſoris, de
Humani corporis fabrica
Libri ſeptem.

LIBRARY
Washington

CVM CAESAREAE
Maieſt. Galliarum Regis, ac Senatus Veneti gra
tia & priuilegio, ut in diplomatis eorundem continetur.

The two came from very different backgrounds. Vesalius was descended from a long line of physicians at the Burgundian court in Brussels; like Berengario, he would eventually gain his own court appointment. Estienne was an artisan intellectual, energetically erudite but dependent on his family's publishing business for support. Although he did teach medicine for a while after completing *De dissectione*, he continued to manage his family's printing atelier. He was also an intellectual of some breadth, writing a botany book for children, a work on garden-planning, and an encyclopedia of classical literature that would later prove useful to Spenser, Milton, and a host of Victorian poets.

What Estienne and Vesalius did share was a passion for dissection in a milieu that preferred the study of ancient texts to hands-on investigation. Vesalius had performed some dissections in Louvain, mainly of animals, but now he began foraging for bones at the Cemetery of the Innocents outside the city. Estienne, who probably had dissected human cadavers in Padua and would develop new techniques for mounting and displaying skeletons, probably had a hand in these gleanings and shared in their yield.

Both men understood the appeal of pictures, embracing the Humanist conception of an image as something that could embody an idea. In the preface to *De dissectione,* Estienne commends the value of pictures that offer meaning beyond simple words, recommending his book to all readers who might respond to the "beauty, order, and workmanship" of divine creation. When Vesalius produced his *Tabulae sex,* these were intended for use not only by his students, but also by members of the public, who were admitted to his dissections. With such novices in mind, he appended twelve large separate woodcuts to *De fabrica* as a guide to the body inside and out. Elsewhere, he conceded the strong appeal of pictures apart from their instructive value, and commended his anatomy plates to painters and sculptors as guides to modeling the figure.

While Vesalius was in still in Paris, Estienne was pushing hard to finish *De dissectione,* which was optimistically advertised for publication in 1536, about the time that Vesalius was preparing to move to Italy. The book's first woodcut, a rather clumsy skeleton monogrammed *SR,* is probably by de la Rivière (Étienne = Stephan). The same hack was also responsible for the misshapen figures, marred by poor proportions and twisted faces that continue until the middle

Opposite: Frontispiece, from Andreas Vesalius, *De humani corporis fabrica libri septem,* 1543

of the book. The plates thereafter are the work of a better draftsman, a master whose Italianate architectural settings and figures reflect contemporary work at the French court at Fontainebleau. Moreover, many of the woodcuts earlier in the book were altered before printing by the insertion of small, square blocks that emended the anatomical data. Apparently, just as Estienne discarded five of de la Rivière's early woodcuts of a Zodiac Man and similar astrological piffle, either he or perhaps Vesalius made these insertions to correct de la Rivière's work.

The Renaissance Humanists' rediscovery of Classical culture also revived the portrayal of sex, seen lurking in Humanist guise in Jollat's woodcuts. It is hard to assess Estienne's actual interest in the topic. He was the first to identify the clitoris as a distinct member, and had it drawn and labeled in a woodcut of a female nude pleasantly displaying her genitalia (p. 93). But Estienne assumed that it had a urinary function, an unpromising error partially corrected by Fallopia a decade later.

Sex is clearly conveyed by the borrowed context of another woodcut by the Italianate master whose work appears later in the book. A nude woman sits with open legs in a Renaissance cityscape, ogled from a parapet above (opposite). It is David spying on Bathsheba, whose midriff has been cut away for a woodcut insert of her womb, terminating desire in visceral disarray. Sex is very much a generative issue for seven well-drawn nudes set before Renaissance architecture also drawn by the Italianate master, all distinguished by the parted thighs obliged by gynecology and pornography. Almost all were converted into medical manikins by inserted squibs, a similar technique to the presumed emendations to de la Rivière's earlier male figures, which were however always meant only for a medical book. In an earlier career, these nudes shared the *Loves of the Gods* in a set of engravings by Jacopo Caraglio that were intended as replacements for *I modi,* sixteen notorious engravings by Marcantonio Raimondi that landed Marcantonio in jail and were themselves suppressed. In the new series a literary pretext transforms pornography into genteel Humanist erotica, before a medical disemboweling cancels sexual allure.

Among these is a supine Venus, with Cupid removed and his arrows turned to surgical tools, her stomach a window to her womb. Another, the sleeping Antiope, vulnerably exposed to Jupiter's approach, is opened instead for an inserted detail of the female genitalia (p. 92). A print of Pluto and Proserpina designed by Rosso Fiorentino for Caraglio's *Loves of the Gods* was used twice in *De dissectione.* In one, Persephone is without Pluto, her swollen belly

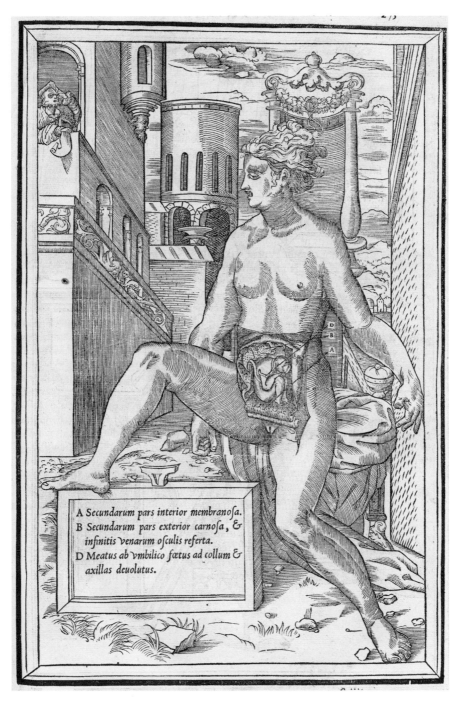

A Secundarum pars interior membranosa.
B Secundarum pars exterior carnosa, &
infinitis venarum osculis referta.
D Meatus ab vmbilico foetus ad collum &
axillas deuolutus.

Dissection of the uterus, showing the fetus. Uterine wall divided and reflected to show fetal membranes, fetus, and umbilical cord. Female figure, anterolateral view. From Charles Estienne, *De dissectione partium corporis humani libri tres,* 1545

marked for a Caesarean incision. The other is a paraphrase of Rosso's Proserpina, now cut open in an extensive dissection through to the aorta and uterus. But here context trumps medicine for meaning. In Rosso's design, Proserpina sits beneath the skeletal branches of a dead tree that locates the scene in the Underworld. The tree is repeated in the anatomy woodcut, adding a sadly appropriate evocation of the realm of the dead.

In 1539, when all the woodcuts for *De dissectione* were long completed and almost all the text set, de la Rivière sued Estienne for author's credit. Some acknowledgment was conceded and the book was finally published in 1545, but the delay was fatal. Stolen galleys had been plagiarized in Germany, and Vesalius had already published his magisterial *De fabrica*.

Little is known about Vesalius's artistic amanuensis, Jan Stefan van Kalkar, other than that he came to Venice to work in Titian's studio, and his woodcuts for Vesalius – all that remains of his work today – were praised by Vasari. He certainly authored the plates of *Tabulae sex,* since his name appears on one of them, and probably also created the far superior woodcuts for *De fabrica*. With the benefit of five more years in Titian's studio, he had matured considerably, as had Vesalius himself: in *Tabulae sex* he describes a five-lobed liver following Galen's account, which he corrected from direct experience in *De fabrica*.

Vesalius's contemporaries were all too familiar with painful punishments in the pandemic conflicts of the Reformation. All personal choices were potentially dangerous, and punishment was as swift and savage as the Spanish Inquisition. For an anatomist, the constant supply of criminal dead was useful, considering the rapid decomposition and stench of the corpse. Indeed, after one classroom subject had became unworkable, Vesalius promised to resume in the morning with the fresh cadaver of a street thug then facing the gallows.

The decorated initials prepared for *De fabrica* ironically portray the progress from transgression to dissection as naked putti cheerfully performing dissections, vivisections, and even a little body-snatching. One large capital V frames the punishment of the mythological shepherd Marsyas, who lost an ill-advised contest with Apollo and so was skinned alive. Pleading for all the dissected, he cries "Who is it that tears me from myself?" so that "the sinews lay discovered to the eye, the quivering veins without a skin lay beating nakedly" (Arthur Golding's Elizabethan translation of Ovid, *Metamorphoses*, VI). This V entwining the image of Marsyas, read allegorically, would be a perfect emblem for Vesalius.

Although generally respectful of Galen's philosophy of medicine, Vesalius was critical of the anatomical errors made by Galen, who had dissected monkeys instead of human bodies. Galen's supporters attacked vituperatively, polarizing the argument beyond the position of the original protagonists. In Paris an indignant Sylvius rationalized the anatomic discrepancies as signs of human decadence since Antiquity. Others, including the anatomist Juan Valverde, praised him as the first to finally differentiate between man and ape. A contemporary woodcut by Titian couched the controversy in a caricature of the ancient Laocoön group – recently discovered and widely imitated – as a trio of apes, strangled like Laocoön and his sons, mocking Galen's suggestion of a simian Golden Age. Yet Vesalius's clinical definition of a human being, as opposed to a sub-human barbarian or a beast, mattered greatly in disputes over Spanish genocide in the Americas, where, in defense of murder, the ingenious Juan de Sepulveda dispatched the natives "as inferior to the Spanish . . . as monkeys are to men."

The realm of the anatomist is governed by melancholy Saturn, whose children proverbially include dolorous poets and violent criminals, including the hanged, whose punishment on the path from gallows to grave is completed by dissection. In Estienne's *De dissectione* a male nude reclines under a dead tree, a traditional symbol of death and the Underworld, often contrasted with the living tree of faith and salvation. The figure's arboreal lassitude provided a model for Elizabethan portrayals of melancholic poets. In Vesalius's *De fabrica*, a skeleton contemplating a skull on an altar inscribed *Vivitur ingenio, caetera mortis erunt* ("Genius lives on, all else is mortal"; p. 68) posits an iconic image of despair that reappears both in Hamlet and in new guise in a painting by the seventeenth-century artist Guercino of shepherds contemplating a skull set on a masonry ruin inscribed *Et in arcadia ego* ("I, Death, am also in Arcadia"), an elegy for a lost Golden Age.

The landscape behind the flayed figures in Book II of *De fabrica* has been identified as the Euganean Hills southwest of Padua (see pp. 72–74). When properly arranged, these prints form a continuous panorama of hills, valleys, and rivers, with Roman baths, churches, and towns, in the fashion of sixteenth-century woodcut murals designed to be pasted on a wall and colored. These landscapes, which originated in Titian's studio, contrast past and present, science and faith, in the pairing of ruined baths – places of medical practice in the ancient world – with standing churches, the earthly entry to paradise.

Everything in Vesalius is a measure of time. A case in point is

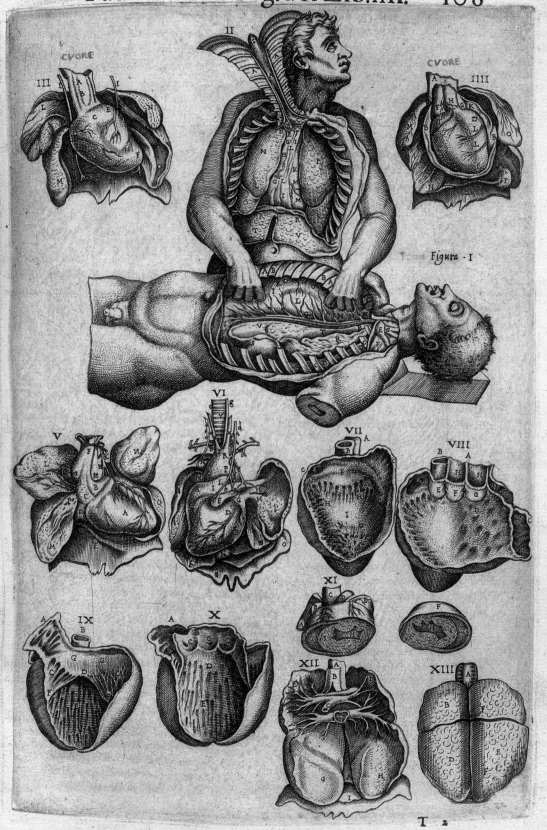

his use of flap anatomy prints, which seem to have made their appearance in the late 1530s. These were large, single sheets showing a nude or skeleton under a pad of paste-on flaps, which added or removed successive layers of the body. The reader progressed, flap to flap, through the muscles to the digestive or reproductive organs, and on to the bones. Few of the surviving sixty-odd examples are intact; almost all are dreadful as anatomy and crude as art. They were intended for popular amusement, or for the walls of barber-surgeons, pharmacies, and midwives' rooms. Vesalius adopted this flap system in his *Epitome*, the dozen large woodcuts issued along with *De fabrica* for use by students, surgical artisans, and the intellectually curious. The series began in the middle of the plates, with a pair of complete nudes, handsomely formed in the manner of contemporary Venetian sculpture. The reader was then invited to cut out from the remaining sheets the body parts, which could be applied to these nudes by matching the guide letters on each print. As the reader moves backward to the first sheet, the male nude loses his skin, then his muscles, ending as a skeleton, holding a skull in a gesture of melancholic *vanitas*. Running from the female nude forward to the last page are separate vignettes of the vascular and nervous system to be cut out and applied, again as recommended by Vesalius. Far from a mere amusement, these flaps serve as a pragmatic instruction, aping on paper the progress of a dissection. It is science with a twist, as the user becomes an agent of time, meting out a sequence of disintegration to these figures.

The old realities of body and soul had seemingly fallen to pieces in the decades after the second edition of *De fabrica*. The Church had been sundered beyond the healing efforts of the Council of Trent, and Galen's image of man had been permanently dismembered. Estienne and Vesalius both died in 1564, Estienne in debtors prison, and Vesalius while returning home from a pilgrimage to the Holy Land. His recent stay in Spain as physician to Philip II had not been happy. Local doctors treated serious injuries with amulets, relics, and by bedding the corpse of a local saint with the patient, and they sabotaged his career and poisoned his reputation when not openly stealing from his publications.

A wider attack on Vesalius was launched in Italy by a group loyal to Galen, reactionary in matters of medical and religious politics, but

VALVERDE
AND
EUSTACHI:
AGAINST
VESALIUS

Opposite: Organs of the thorax, in situ and in isolation, in thirteen numbered illustrations. Two male figures, anterior view. Structures of the heart, dissected in sagittal and transverse sections to show ventricles, valves, pericardium, papillary muscles. Structure of the lungs, showing trachea and pulmonary blood vessels. From Juan Valverde de Amusco, *Anatomia del corpo humano*, 1560

often competent in actual dissections. In a sense, they formed a legitimate anti-Vesalian school, in which a number of books on anatomy were begun, some with additions and corrections to Vesalius. Almost all of these dissolved in false starts, incomplete efforts, and delayed publication. Vesalius's one-time assistant Realdo Colombo planned an anatomy book with Michelangelo that was never published, although elsewhere he did imitate Vesalius's title page.

Perhaps the most openly vindictive adversary to Vesalius's revisions was the formidable north Italian Bartolommeo Eustachi (c. 1520–74), a fixture in the courts of the duke of Urbino and of Cardinal Della Rovere in Rome. Eustachi condemned Vesalius's text for its deviations from Galen and dismissed van Kalkar's woodcuts as flagrantly inaccurate. Eustachi had a distinctly different conception of anatomical illustration, first seen in the eight plates printed in his *Opuscula anatomica* the year Vesalius died (1564) and in thirty-eight other plates published posthumously. His focus on single figures or specific parts is superficially like Berengario's and even some of Estienne's simpler woodcuts, but these illustrations were highly sophisticated works printed from engraved copper plates, the first anatomy illustrations to be produced in this medium. The switch from woodcut to the more demanding technique of copperplate engraving was consonant with Eustachi's aesthetic and scientific intentions. Copper plates were not as strong or lasting as wood blocks, but their engraved lines were better able to reproduce complex drawing and the delicately graduated shading of solid forms.

As adjuncts to a text based anachronistically on Galen, Eustachi's illustrations replaced the ideated imagery of Estienne and Vesalius with simple figures seen close up and large, often simultaneously in front and back views. The novel introduction of framing borders with gradated numbers was probably intended as a guide, following the design of maps, to reference material in the text, eliminating the irritating indicator lines that make some of Estienne's early figures look like acupuncture dolls (see p. 82). Eustachi further espoused the precise and unaffected manner of Leonardo's anatomical drawings as a scientific style of picture-making.

Eustachi was clearly preparing a larger work when he died, for he left thirty-eight further plates, engraved by Giulio de Musi, but no text. These plates became the property, in the early eighteenth century, of Pope Clement XI, whose physician, Giovanni Maria Lancisi, added a simple text to them, the eight already printed, and an additional stray print, as well. Lancisi published all forty-seven engravings in 1714 as *Tabulae anatomicae* (*Anatomical Plates*), and other editions followed. The engravings developed by Eustachi and de Musi

remained in print with various texts until at least 1817, when their illustration of the nervous system appeared in the *Encyclopedia Britannica*. The lasting value of Eustachi's plates was not their defense of Galen, but the perfection of a style of objectively neutral images. In effect, these unpublished plates missed participation in the sixteenth century, but later emerged as the essential forerunner of the Leonardo revival at the dawn of the nineteenth century and the Victorian detachment of Gray's *Anatomy*.

One illustrated work from the anti-Vesalius circle came to fruition, and it was largely pilfered fruit at that, a book by the Spaniard Juan Valverde de Amusco (c. 1525–c. 1588). Valverde studied in Padua with two of Vesalius's critics, Eustachi and Colombo, Vesalius's successor there. Colombo took Valverde to Rome in 1548, where Valverde joined the retinue of the Spanish court. With church sanction, the two performed forensic autopsies, including one on the body of Ignatius Loyola, the founder of the Jesuit order. Valverde emerges as an intellectually indifferent but well-behaved member of the Galen faction, safe from the occasional equation by the Inquisition of anti-Galenism with heresy.

In 1552, Valverde wrote *De animi et corporis sanitate* (*Of the healthy body and soul*), a work typifying prevailing medical thought in Spain before Vesalius. The book was an amalgam of two old-fashioned but enduringly useful genres: the *hortus sanitatis*, or garden of health, an herbal that prescribed diet and simple pharmaceuticals, and the *Mirror of Princes*, a guide to the mores of court behavior. *De animi et corporis sanitate* was published in Paris by Charles Estienne, whose ideas about anatomy illustration may have rubbed off on Valverde at the time. Thus Valverde included illustrations, but at a price: his versions of van Kalkar's woodcuts were severely edited to eliminate or alter their provocative content.

Valverde used borrowed pictures again in 1556 in his illustrated anatomy in Spanish, the *Historia de la composición del cuerpo humano* (*The Fabric of the Human Body*), soon followed by versions in Italian and Latin. It was smaller, less expensive, and more succinct than the thousand immense pages of Vesalius's text. Its various corrections to Vesalius may well have been lifted from Eustachi and Colombo, but it was useful for Spanish students after Philip II, in dread of both medical and theological heresies, recalled all Spanish medical students from Rome in 1559.

Basically, Valverde's forty-two plates are reduced, engraved copies of the originals in Vesalius; of these, fifteen are paraphrases, cannibalizations, or new inventions. The designs were drawn by Gaspar Becerra (1520?–68?) and engraved by Nicolas Beatrizet (c. 1507?–70?),

a French artisan working in Michelangelo's circle in Rome as Nicola Beatricetto. Apart from van Kalkar, they took their models where they found them. The familiar Venus *pudica*, with the thick proportions favored in Berengario's generation and the square-cut abdominal display-window familiar in Estienne shows up as a misplaced remnant from an earlier era. In direct copies from *De fabrica*, Beatrizet's engravings dissipate the power of van Kalkar's woodcuts without the crisp subtlety and solidity of the engravings done for Eustachi. Worse, by occasionally failing to anticipate the reversed sense of a printed image, some of his engravings distort anatomical data in mirror views.

The magisterial landscapes so important to Vesalius are stripped down to trivial hillocks against blank backgrounds bereft of substance and air. Beatrizet knew how to do better work than these clichés, which consequently must reflect Valverde's direct instructions. Another strange bit of Valverde editing occurs in his reworking of the torsos that Vesalius used in the fifth book of *De fabrica* to display digestive and reproductive viscera. The torsos pictured in *De fabrica* descend from the so-called Belvedere Torso, discovered in the early fifteenth century and a continuously protean model for Renaissance art (pp. 78–79). Lacking head and limbs, its expressive force is carried solely by the twist of the body trunk, keeping its original meaning secret while implying much. An animal skin draped over the thigh long suggested Hercules, although now it is thought, with some irony here, to represent Marsyas. The torso obsessed Michelangelo, who expanded it numerous times, as *Day* in the Medici Chapel and St. Bartholomew in the Sistine *Last Judgment*. In using it as a model, Vesalius was tapping into a cult of the torso that lasted well into Caravaggio's day, playing on external dismemberment as an expression of internal disassembly.

Valverde and Becerra replaced the torso with the Roman cuirass, a hard leather jerkin worn as armor (p. 99). Shown as empty as a suit on a rack, each has an open front panel that shows the digestive viscera of its vacant interior like an embellished breastplate, a conceit that perhaps alludes to both health and spirit as the faith that shields the soul in Paul's metaphor: "Put on the whole armor of God . . . For we are not contending against flesh and blood, but against the principalities . . . the world rulers of this present darkness . . . Therefore take the whole armor of God . . . the breastplate of righteousness." (Ephesians 6: 11–13). This military reference was apt for a partisan of the Counter-Reformation, the armor of the Soldiers of Christ empowering the modern Jesuits as the *Regimini militantis ecclesiae* (Regiment of soldiers of the Church). Military references were not

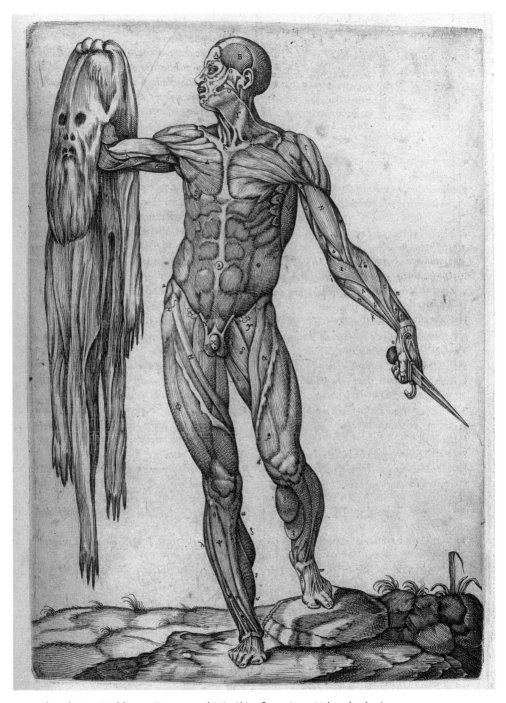

Flayed Man Holding a Dagger and His Skin, from Juan Valverde de Amusco, *Anatomia del corpo humano,* 1560

TAB. XXXI.

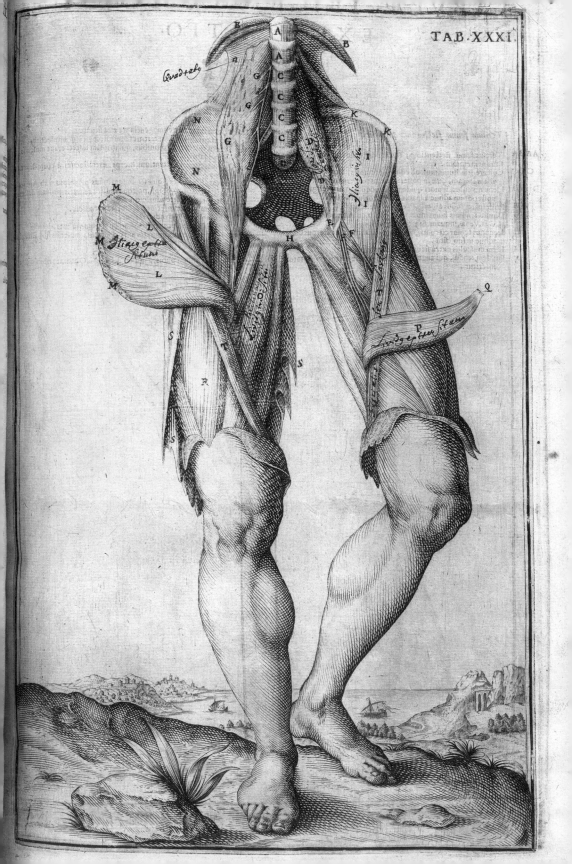

taken casually in this climate. It would be German soldiers in Veronese's *Last Supper* that would bring the artist before the Inquisition somewhat later, a problem resolved by renaming the painting *Feast in the House of Levi* (Venice, Accademia). These details of costume counted.

The most famously startling of Valverde's images is the *Flayed Man Holding a Dagger and His Skin* (p. 29), a picture of unknown source that has frequently been compared to the martyred St. Bartholomew holding his skin – the face being Michelangelo's self-portrait – in the Sistine *Last Judgment.* If Valverde's print also represents St. Bartholomew, then the knife he holds alludes not to self-flaying, but to his martyrdom. Valverde also quoted two figures from Vesalius combined in one composition of a cadaver pulling open another cadaver (p. 24), assigning some element of will to the dead. It is likely that the plagiarist Valverde stayed close to dogma in these striking new images of cadavers permissibly dissected through their own volition as deliberately unredeemed souls.

The opening salvo of the seventeenth century was the shotgun wedding of two orphans in Vesalius's lineage. The elder was Giulio Casseri (Julius Casserius; 1552–1616), a pupil and later a colleague in Padua of Vesalius's successor Girolamo Fabrici, the author of books on embryology and on the anatomy of speech and hearing, illustrated by engravings in the didactic vein of Eustachi's plates. Casseri died while working on the text for what was to be his major work, an illustrated anatomy of the entire body, for which seventy-seven plates survive. Meanwhile, Casseri's Flemish student Adriaan van den Spieghel (Adrianus Spigelius; 1578–1625) had written a text on general anatomy and a monograph on fetal development when he, too, died. Through the efforts of their former student, Daniel Rindfleisch (Bucretius), all this valuable material was paired and published in 1627 in Venice in two folios, the plates as *Tabulae anatomicae* under Casseri's name, and the companion text, *De humani corporis,* by van den Spieghel. The year before, in 1626, van den Spieghel's son-in-law had already arranged publication of his book on fetal development, *De formato foetu,* using nine of these engravings. Although van den Spieghel's work was sound, and was later published in other editions and adaptations, it is the engravings made for Casseri and his successors that followed Vesalius's conception of the meaningful illustration.

CASSERI AND SPIEGHEL: THE LINEAGE OF VESALIUS

Opposite: Muscles of the thigh and abdomen and their attachments to the spine and pelvis, shown in isolation. Psoas muscles and spinal nerves from the lumbar vertebrae shown. Partial figure, in vivo, anterior view. From Giulio Cesare Casseri and Adriaan van den Spieghel, *De humani corporis fabrica libri decem,* 1627

Casseri's plates were the work of Odoardo Fialetti (1573–1638) and Francesco Valesio (c. 1560–c. 1643), both from Bologna but active in Tintoretto's circle in Venice. Fialetti painted, in an approximation of Tintoretto's manner, several large canvases of saints' lives for Venetian churches, while his nearly two hundred and fifty etchings include a mildly soft-core *Scherzi d'amore* (Vignettes of Love). His interest in academic Florentine art inspired in 1608 a grandiloquently titled model book *Il vero modo et ordine per dissegnar tutte le parti et membra del corpo humano* (The True Means and System for Drawing the Parts and Members of the Human Body). Like earlier model books, Fialetti's work charted the stages from outline to full shading for faces and features, with several incomplete torsos derived from Roman sculpture.

Fialetti probably made the drawings for Casseri's plates; the engravings are presumably by Valesio, a partner in a large atelier in Venice. The images are modeled in intricate *moiré* patterns of curving cross-hatching that forms a sculpted skin on each rounded plane, as are the virtuoso engravings of the best northern European masters who were currently publishing prints in Venice. Indeed, these engravings may be the work of a northern artisan in Valesio's atelier. But Valesio could also design prints, as his bird's-eye views of European cities published after his own drawings at this time show. With this in mind, it is worth noting that Fialetti is not known as a landscape artist, which suggests that the landscapes were drawn by Valesio. The figures are certainly Fialetti's, some classically proportioned and posed, with features that resemble his usual prints. Others veer toward a harsh Northern realism.

Four engravings of large female nudes in the 1626 *De formatu foetu* prove the occasional virtue of the collective mind at work in a collaborative creation. If the fetal stages revealed in wombs unfolded like a lotus are put aside, this quartet attains its own order as the Four Seasons. Spring is Venus or perhaps her goddess, Flora (p. 125), signaled by the flower given in the seasonal renewal of adolescent love. Triumphant Summer, hand on hip and crowned by a diadem of wheat (p. 123), is Ceres, goddess of grain, who retrieved her daughter from the Underworld to ensure the annual renewal of crops. Autumn holds a fruit behind her back, a shy Pomona who guides the harvest (p. 124). At her side a live branch stems from a dead trunk, a ubiquitous motif in landscape iconography whose meaning is self-evident, even without its occasional interpretation in contemporary emblems as rebirth or renewal. Winter is a veiled figure, which suffices in a mid-seventeenth-century Dutch personification of the season as a naked *putto* with veiled head; the conceit is

later expanded beautifully in Houdon's marble of a nubile, nude, and shivering Winter under a veil in the Metropolitan Museum of Art in New York. Like later sixteenth-century Venetian portrayals of women, these seasonal figures are lushly rounded, languidly mobile portrayals of real models. The background landscapes are aerial views like the first woodcuts in Estienne's book, now deep and changing with the seasons from barren winter to fruitful summer. They are certainly the work of a landscape specialist, probably Valesio working in tandem with Fialetti, who, judging by the figure and facial types in his other etchings, drew the figures.

The great portfolio of plates by Fialetti and Valesio opens with a title page that replaces van Kalkar's omnibus dissection tableau with female personifications of Anatomy, Diligence, and Incentive, guardians of an academic pursuit inspired by Vesalius. This learned atmosphere returns, along with an homage to Vesalius, in the first plate. Standing before a deep valley in which stands a ruined Roman bath recalling van Kalkar, a male nude stands by a column stub on a plinth framing an eye, ear, and nose. The organs of the senses, particularly important to the authors, are introduced as emblems of the senses in pseudo-hieroglyphics inspired by an Egyptian obelisk that had been recently erected in Rome.

Based on body types and actions, the remaining figures may be loosely gathered in groups of the decorous, the demonstrative, and the demented. The decorous are reasonably formed, offering their innards with accommodating modesty like chastened relatives of Berengario's figures. And they are exactly that, for the gift of their cadavers is their penance, an intent demonstrated by the shy deference of their gazes, which look away or down but never meet ours (frontispiece). In his guide to decorum in art, the sixteenth-century theorist Giovanni Paolo Lomazzo cautioned against unseemly agitation, "the errors of such as give quick motions unto dead parts" in portraying the dead who, as melancholy Children of Saturn, ought to appear with "head declining, eyes fixed upon the earth." The averted glance can be read as shame, a step toward atonement. By contrast, several cadavers show pride in their work. Eyes on heaven, mouths open as if breathing, they stand with fist on hip, elbow out, in the assertive posture of a warrior. It is a pose codified at the end of the sixteenth century in a model book by Jean Cousin the Younger, in use in Baroque body language as a gesture whose meanings range from assurance to arrogance. Demonstrated by a skeleton, the pose suggests the sin of excessive pride, but in this demure context it may well signify the corpse's important value to medicine.

The knee bent under the body in many of these engravings

offers an ambiguous but potentially more damning posture (opposite). Although natural, it is still not often found in Renaissance art, while early art theorists and writers on social manners condemned it as lacking grace. Writing in 1604, the Dutch writer Karel van Mander applied the Italian word *storpiato* to such contorted poses, a usage given later in the century in Baldinucci's *Vocabulario* of art terms. Inveighed against as bad manners and bad art, the folded leg does not appear so frequently here in error, but as a sign of error. It is introduced in the early sixteenth century as a posture of agonizing punishment in Marco Dente's engraved version of the Laocoön group, and retains just that meaning in tormented figures from Prometheus to St. Jerome.

The bent knee, sometimes supported on a peg, is also common to beggars and professional cripples, another category of the Children of Saturn and the companions of the hanged criminal. By the sixteenth century these mendicants had evolved into semi-ordered legions with their own codes and vocabulary. Having exhausted Christian charity and civil forbearance, they were excoriated by Luther as a demonic tribe and banned from urban centers as criminal paupers. Their number yields at least one of these hapless cadavers (opposite). Twisted beyond plausible grace on a ruined pedestal, he wears the soft helmet with ear flaps, long the familiar gear of begging cripples, peasants, and occasionally, painters. Blind, he was neither peasant nor painter nor innocent; posture tells all. In Renaissance physiology, outward beauty was taken at face value, while a body so drastically unlike a temple signaled a corrupt soul. Unlike Vesalius's mordant everyman, this acidic portrait has replaced the idealized fantasies of old romances with the cynical reality of the picaresque narrative, the art of the Renaissance with the Baroque of Caravaggio.

The most chilling invention in the *Tabulae anatomicae* falls between Mannerism and Modern, the stuff of Gothic horror tales, bad dreams, and drive-in movies. Simply a pair of legs walking, whole to the knees, bared muscle to the pelvis, and a truncated spinal column, it is a half-colossus that posits mindless spectral kinesis as a determined posthumous twitch (p. 30).

Opposite: Muscles of the thorax, abdomen, and arm, superficial dissection. Male figure in vivo, anterior view. From Giulio Cesare Casseri and Adriaan van den Spieghel, *De humani corporis fabrica libri decem*, 1627

TAB. XV.

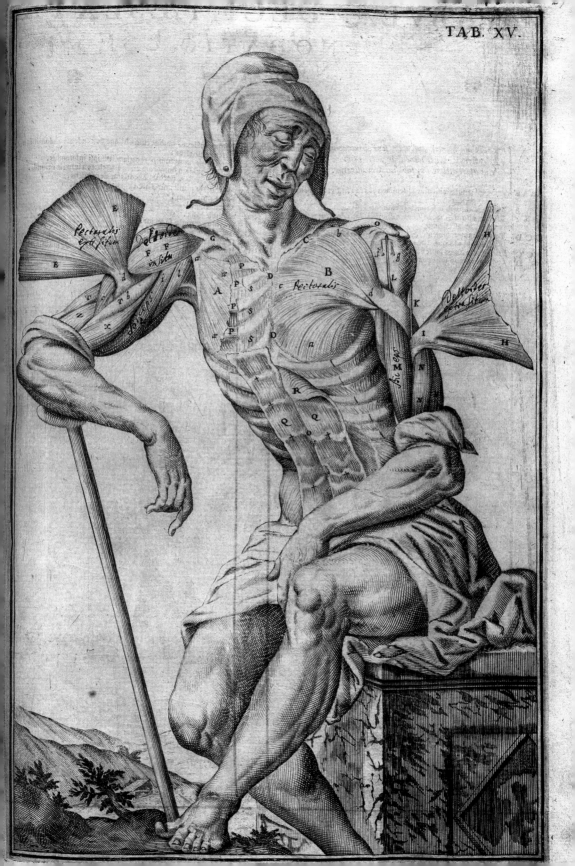

Few of the mid-seventeenth-century anatomies after Casserius, however admirable or lamentable their science, produced memorable images or even sound, complete views of the body. Increasingly specialized monographs concentrated on particulars like the anatomy of the eye, with illustrations geared for precision without art. Others were popular epitomes aimed at artisan surgeons, amateurs, and artists, adorned with makeshift assemblages of begged, borrowed, and stolen illustrations like the mélange illustrating Amé Bourdon's *Nouvelles Tables Anatomiques* of 1678: a clutter of poorly drawn bodies and body parts strewn across immense folio pages without context or integration (opposite). With the flattery of plagiarism, and indicative of this long dry spell, some of the Casseri plates were reworked. A paraphrase of Fialetti's dorsal nude stripping down to its muscles is resurrected in John Browne's late-seventeenth-century *Compleat treatise on preternatural tumors,* prancing on a pedestal before a rustic English lane, complete with cottage and garden gate!

By the end of the seventeenth century the old form of comprehensive anatomy had relocated to the art academies springing up in every major European court and city. Bernardino Genga's *Anatomia per uso et intelligenza del disegno,* a portfolio of fifty-nine large engravings issued posthumously in Rome in 1691 as models for artists, was prepared at the recently formed French Academy of Art in Rome by a classical scholar and scientist who taught anatomy at that school. It was illustrated with crisp, soundly rendered engravings after drawings by Charles Errard (1606–89), a founding member and one-time director of the Academy who had previously worked for Louis XIV at the Louvre. Basically, it was a modernized model book with a tacit academic imprimatur, a work designed for training in painting the grand heroic narratives of the Bible, antique letters, or history as grand-scale propaganda in the courts of Europe.

The Academy's emphasis on classical models and careful life study was reinforced by training based on study of the parts coupled with copies after the antique. In Genga's book the skeleton is illustrated in sections from several viewpoints to facilitate a three-dimensional grasp of its forms, and the muscles of the torso and limbs are isolated within the whole for greater clarity. Finally, there are plates of such well-known statues as the Farnese Hercules, the Borghese Warrior, and the Laocoön (without his two sons), all shown from several angles as they would be seen in the plaster-cast studio where

Opposite: Female figure, from Amé Bourdon, *Nouvelles tables anatomiques* (Cambrai, 1678). Bourdon was a physician in Cambrai, France, who made his own drawings for an anatomical atlas with large plates that could be combined to form complete figures. This would become a common format for popular works.

Table 8.^{me} Fig. 5

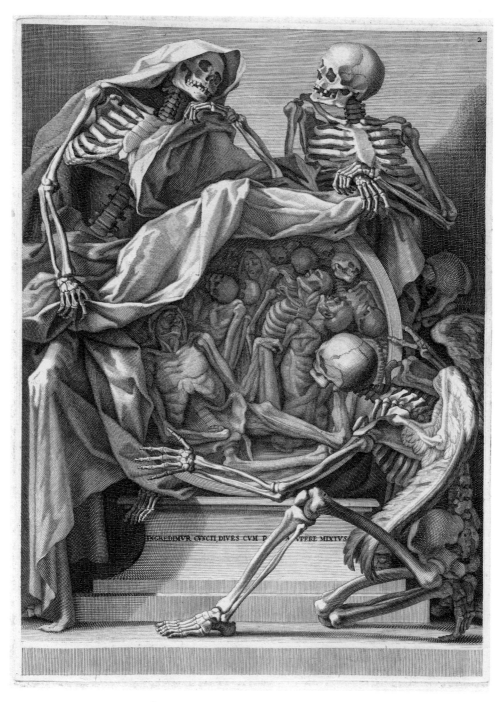

Frontispiece, from Bernardino Genga, *Anatomia per uso et intelligenza del disegno ricercata non solo su gl'ossi, e muscoli del corpo humano*, 1691

training began. Useful but unexceptional stuff, except for a single figure that stands, staff in hand, contemplating an antique sepulchre: *Et in arcadia ego* – "I, Death am also in Arcadia." The elegiac mood is an understandable Humanist conceit, a sigh for the past celebrated in an otherwise straightforward model book.

Genga's frontispiece (opposite) is no gentle effigy, but a presage of the expanded role of skeletons in the coming Gothic revival. Three convivially distracted skeletons, one a winged being other than human, unveil a compacted cameo of the dead identified as the rich and poor, who alike will go this route. This motif was developed from a border of skeletons around the title page of Casserius' book on the auditory organs, an homage to Casserius that was probably Genga's idea, although the design was by Errard, whose preparatory drawings for it survive (Florence, Uffizi). The evolution of the skeletal crew from hyperkinetic harbingers of death to indifferent civil servants marks a maturity of sorts for these ambulatory xylophones, as they progress from rounding up the dying to ushering in a new persona born with the Romantic sensibility.

The complex of ideas, attitudes, and sensations that would define much of the Romantic movement a century later were in fact already operative at the end of the seventeenth century. "Romantic" took its original connotation from the fantasies of medieval romances as applied to anything extreme, strange, or unnatural that provoked such heightened sensations as horror and awe. The term evolved among the literate and poetic as an affectation of light melancholia, a parlor form of the darker emotional range.

Some of the Romantic mood and motifs, the thrill of horrific death and afterlife, the terror of violently unkempt nature, and the pleasure of unexpected phenomena, were inspired by the *banditti*-infested wildernesses painted by the Neapolitan artist Salvator Rosa (1615–73), whose imaginative landscapes attracted many imitators. Rosa developed into a Romantic cult figure during the eighteenth century. One early critic characterized his work as "bizarre et extraordinaire," two defendable goals to the Romantics.

Early in the eighteenth century, Frederik Ruysch (1638–1731) published his *Thesaurus anatomicus primus,* an illustrated catalogue of the anatomy museum that he maintained in his house in Amsterdam and later sold en bloc to Peter the Great. Many of these specimens survive in the Museum for Anthropology and Ethnography in St. Petersburg, while a second collection that Ruysch created went to Jan Sobieski, King of Poland. These monarchs understood the value of a *Wunderkamer,* a room exhibiting "art and

RUYSCH:
THE ART OF
WONDERS

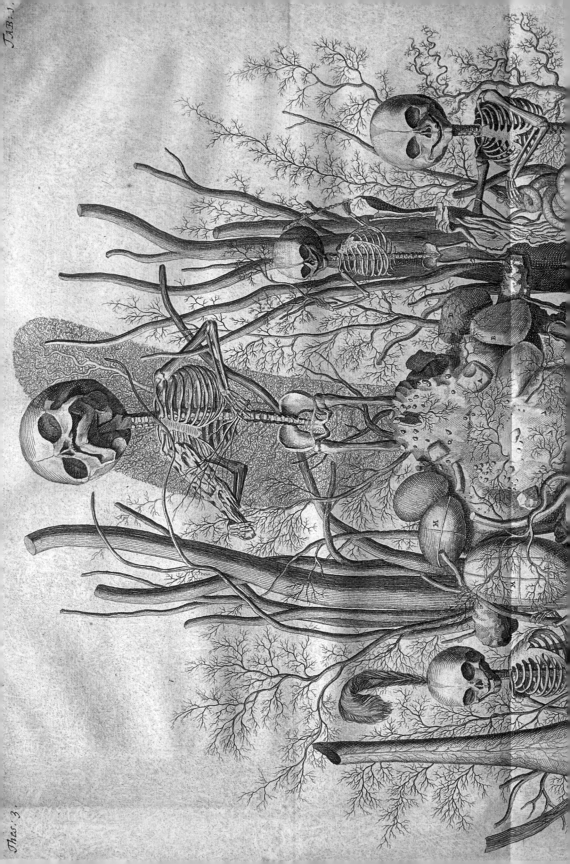

TAB. I.

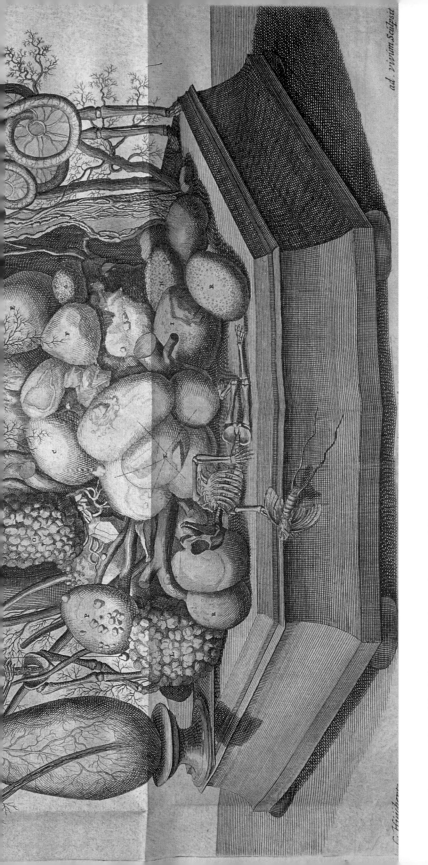

A composition of fetal skeletons with arteries resembling tree stumps after a forest fire. The central skeleton, that of a four-month fetus, is depicted chanting a lament *Ah fata, ah asapera fœta!* ("Ah fate, ah bitter fate!") to the accompaniment of a violin made of an osteomyelitic sequestrum with a dried artery for a bow. To the right is a smaller skeleton conducting with a baton set with kidney stones. Also on the right is a skeleton girdled with sheep intestines, grasping a spear made from an adult vas deferens. On the left is a vase made from the inflated tunica albuginea of the testis, behind which stands a skeleton with a feather protruding from its skull. In front lies another skeleton clutching a mayfly in its hand. Fetal membranes, meninges, and scattered skeletal remains complete the arrangement. From Frederik Ruysch, *Thesaurus anatomicus primus*, 1701–1716

wonders," that adorned the houses of the nobility and upper bour-
geoisie of the time as a manifest of their social and intellectual merit.
While the largest of these displays of art, exotica, and curiosities of
nature became international attractions, smaller collections might
serve particular functions. The young Rembrandt formed such a col-
lection to provide accessories for his history paintings.

Ruysch's collection was probably inspired by education at the
University of Leiden, where in 1664 he became a Doctor of Medicine.
Founded in 1575 during the Dutch war of independence from the
Spanish, the university was the intellectual standard for an emerging
national identity that strongly endorsed public instruction, including
dissections at Leiden's anatomy amphitheater. As the visiting
English diarist John Evelyn noted in 1641, this was part operating
room, lecture hall, and museum, a "theatre and repository . . . fur-
nished with natural curiosities; skeletons from the whale and ele-
phant to the fly and spider." Despite the public seating and the
refreshments of a popular entertainment, the Leiden amphitheater
was an important step toward the modern museum.

For his collection, Ruysch preserved body parts in alcohol
(p. 159), injecting the arteries and veins with red and white wax to
show clearly how the blood spread through the tissues. His jars of
preserved embryos suggested to one visitor a "perfect necropolis, all
the inhabitants . . . asleep and ready to speak as soon as they were
awakened." Today they sleep on in St. Petersburg, complete with the
tiny lace caps made for the stillborn infants by Ruysch's daughter
Rachel, herself the mother of ten children born during a long and
distinguished career as a still-life artist. These should not be dis-
missed as macabre whimsy or sentimental excess. Lace accouter-
ments were essentials for the burial of infants, who died quickly and
often. As we look at portraits of dead children of the period, and read
the laments of their mothers, barely safer themselves before sanitary
obstetrics, we understand Rachel's respectful gestures for the
unborn and stillborn.

Some hint of whimsy can be seen in Ruysch's large dioramas,
which were reproduced in three large engravings by Cornelis
Huyberts. These were mounted assemblages of fetal skeletons with
other mummified body parts set in landscapes (previous spread; pp.
154–55). An English visitor, Robert James, later recalled that Ruysch
"would beautify the scene . . . [with] mingled groves of plants, and
designs of shell-work with skeletons, and dismembered limbs . . .
animate the whole with apposite inscriptions taken from the best
Latin poets." These inscriptions were a memento mori – a warning
of mortality and the brevity of life. When attached to fetal skeletons

they formed a common emblem of vanity that their contemporaries understood in an instant. The homunculus skeleton weeping into a handkerchief of dried intestinal membrane was soon copied by Jacob Andreas Fridrich into a print of the *Garden of Eden* with the motto *Homo ex humo,* "From the earth, man."

These displays probably conveyed an undertone of humor, which was not ill-suited to moralizing. In the corners of some of Jan Steen's most raucous tavern scenes, high above the drunken canoodling, a putto will rest on a skull, blowing bubbles. The joke is *homo bulla,* life is a bubble. Such emblematic conceits and visual puns were part of the humor of the Dutch intelligentsia. Constantijn Huyghens, the widely gifted secretary to the Prince of Orange, indulged a passion for clever aphorisms and poetic confections of tripled meanings and obscure references, the verbal equivalent of the visual games played in Ruysch's dioramas. Both men were orthodox Calvinists who allowed for moral messages in properly erudite humor.

A more recondite jest may be lurking in the set-up of the dioramas. Each is a steep hillock made with gall stones and mummified bladders for rocks and boulders, on which fetal skeletons stand amid dried and stiffened arteries, sinews, and nerves, which form bare trees and incidental foliage. Obvious enough in detail, these are three-dimensional forest floors, the subject of a category of *vanitas* still life. Underlying this is an older, late-Renaissance vision of Mount Parnassus as the home of gods, poets, and philosophers. The mountain appeared frequently throughout the seventeenth century as a stage-setting for ballets and as a cenotaph to the departed. It was a lovely idea, this anatomical Parnassus in an Amsterdam hall, the work of a brilliant father and daughter, an artistic scientist whose drawings were valued by succeeding generations, and a scholarly daughter, whose art advanced the cause of nature.

Anatomia humani corporis, by Govaert (Govard) Bidloo (1649–1713), was published twice in the Netherlands, first in Latin in 1685 and again in Dutch in 1690. Both editions failed: the elephantine folio of one hundred seven copper-plate engravings by Abraham van Blooteling after drawings by Gérard de Lairesse was too technical for artists, too inaccurate for surgeons, and too expensive for everyone else. About three hundred sets of the prints without the text were sold to the British anatomist William Cowper, who with a few adjustments and new text reissued the set in 1697 under his own name. During the next century, the plates influenced the work of Bidloo's student Albinus, and their English incarnation helped equip the Romantics.

BIDLOO:
ET IN
BATAVIA EGO

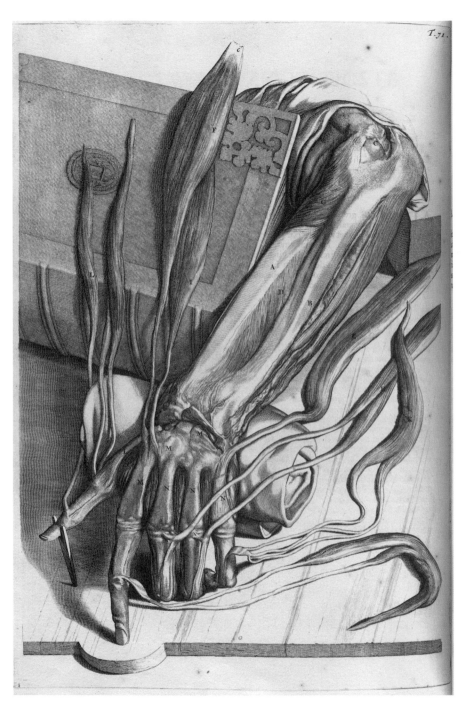

Bones, muscles and tendons of the forearm and hand, shown in isolation, deep dissection. Hand shown pronated. Radius, ulna, carpal bones, and metacarpal bones visible. From Govaert Bidloo, *Ontleding des menschelyken lichaams,* 1690

Bidloo was a brilliant and mercurial character. Born in Amsterdam, he studied with Ruysch at Leiden, then finished his doctorate in 1682 at Franeker, in Friesland. He taught briefly at The Hague and later off and on at Leiden. He switched political allegiance from the Republic to the House of Orange after its restitution in 1672, and in 1689 joined William III as his personal physician in England, where he published an account of the king's death in 1702. He set up military hospitals during a war with France, and found time to write plays and restructure the Amsterdam theater while preparing his book on anatomy. Bidloo embraced a vogue for French culture that transformed native Dutch forms in his generation. In 1684, the year before publication of *Anatomia humani corporis*, he adapted a tragedy by Pierre Corneille as *De dood van Pompeius – The Death of Pompey*. Later he wrote "ornamented" versions of the tragedies of the greatest Dutch poet, Joost van de Vondel, in which the solid conviction of Vondel's Dutch is filtered through French syntax and meter and embellished with incidental songs and dances in the French manner. No wonder Bidloo is best known for the *Anatomia humani corporis*, although it is only the medically useless plates that are remembered. The drawings for these plates were the work of Gérard de Lairesse (1640–1711), who shared Bidloo's Neoclassical leanings. Lairesse had studied with Rembrandt, but soon dismissed his teacher's strong emotional realism in favor of a regulated, classical decorum. However, imported refinement could not entirely obliterate ingrained Dutch predilections, and the plates flicker adventurously between Dutch realism and French idealism.

In smaller moments, Lairesse remained a student of Rembrandt, who twice painted dissections in progress. Lairesse's view of a properly veiled female cadaver open from stomach to thorax (p. 130) is drawn straight on, repeating the dramatic format of Rembrandt's *Anatomy Lesson of Dr. Joan Deyman* (1656; Amsterdam, Amsterdams Historisch Museum). A dissected arm emerging from a heavy tome (opposite) is a curious nod at the portrait convention for anatomists seen in Rembrandt's early *Anatomy of Dr. Nicolaes Tulp* (1632; The Hague, Mauritshuis). Here Tulp dissects an arm as did Vesalius in a woodcut in *De humani corporis fabrica* and Casserius in the portrait engraved for his work on the auditory organs. Bidloo's title page features a book with a skull resting on it, a traditional image of *vanitas* that appears elsewhere in these plates and was still common in Victorian painting. A book makes an odd base for an arm; this strange image may be a joke on Bidloo's haste in setting out mounted dissections for Lairesse to copy without further advice, one reason for the many errors in these plates. It might also be an oblique hom-

age to literate anatomists, and a promotion of Bidloo to their ranks.

Two further plates showing dissections of the head and mouth (pp. 140–41) show an original strain that surpasses the technical requirements of illustration and mocks the boundaries of genre. The angle of vision, close rendering of surface, and strength of contrasted shading create a drama of mordant realism that will give rise, during the later eighteenth century, to an autonomous genre of art, the macabre still lifes of dissected and dismembered parts painted by such artists as Géricault just before 1820. Lairesse's prints feature the tightly focused penumbras of Rembrandt's simple etching of a seashell (B. 159), a drama in style apart from theme. In smaller matters, Lairesse, the proponent of Neoclassicism, was a closeted Baroque Romantic.

There is little hidden about two poorly constructed skeletons. One holds a winding sheet by an open grave (p. 134), the other an hourglass by an open tomb. They represent death itself, of an old lineage without new baggage; but the world seen behind them through the arch of a crypt entrance is no longer the unbounded vistas of old, but the closer quarters of a park. One includes an urn on a pedestal and an obelisk mounted on a sphinx, specific references to pre-Christian burial customs well ahead of the Egyptomania of the coming century. The other shows a large mounted sepulcher and a chapel among cypresses. These elements complete a funerary context where sepulcher, vase, and cypress trees stand for despised death. The park setting is a cemetery, a formal garden for the dead, the final Eden as Paradise on Earth. A park is also a fitting stage for the robust nudes who recall a small drama in another garden. Both are ideal types based on the Apollo Belvedere and the Cyprian Aphrodite front and back (opposite), but more likely derived from a Renaissance intermediary such as Albrecht Dürer's engraving of Adam and Eve (B. 1). The settings are minimal but important: trees, architectural pilasters, and large vases, the accoutrements of a garden later illustrated in a chapter on landscape in *Het Groot Schilderboek*, Lairesse's treatise on art published in 1707.

The country house with a garden park was a fashion among the urban wealthy at the end of the century, endorsed by Virgil's *Georgics* and sanctioned by the emblematist Jacob Cats's pious notion that "Adam was told to build Paradise, in order to behold the creator in that beautiful Bower." Even Bidloo's nephew Nicolaas, physician to

Opposite: Female figure, posterior view. From Govaert Bidloo, *Ontleding des menschelyken lichaams*, 1690

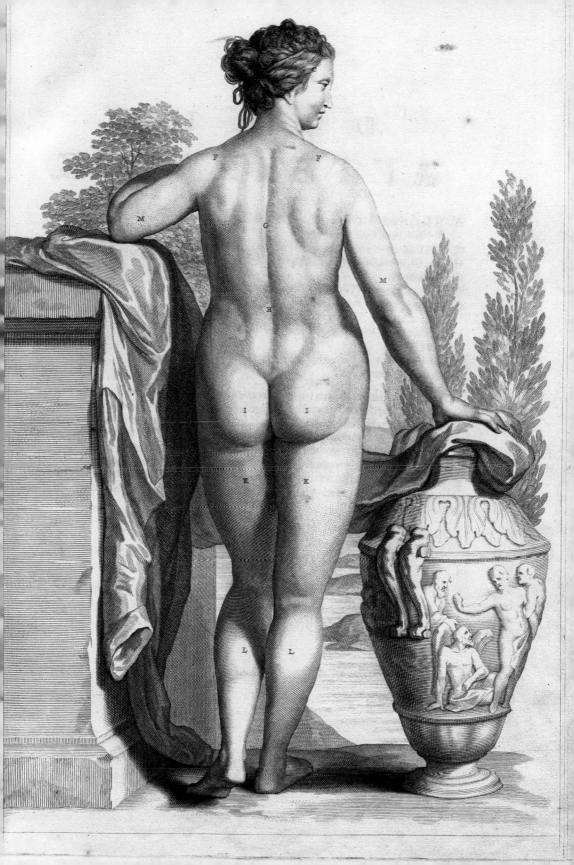

Skeleton of a chimpanzee, from William Cheselden, *Osteographia, or the Anatomy of the Bones*, 1733

Peter the Great, wrote a treatise on gardening, which was particularly appreciated by his family's Mennonite belief in natural science as a form of reverence for divine creation. In the illustrations for Bidloo's *Anatomia humani corporis*, these simple garden settings suggest that Arcadia or Eden was located here in the country estates of Batavia, now called The Netherlands.

Lairesse's generation expected lessons everywhere, even in accessory vases. A subtle caution attaches to a vase beside a callipygian woman (p. 47), for its relief frieze shows Chronos, or Father Time, and Eros, the team that gives and curtails fleeting joy. In the frontal view of this Aphrodite or Eve, the vase is tumbled as a symbol of lost virtue, while for the male – Apollo, Adam, or a hired hand – it is covered in a curious show of improbably virginal restraint. In fact, a garden motif begins the book: the frontispiece shows a formal, arcaded garden behind an enthroned, Athena-like figure of *Anatomia*, scalpel in hand, while Chronos flees with his hourglass across a fallen scythe. The hope is that here in a setting that recalls the common political simile of the Netherlands as a walled garden ruled by Athena, Bidloo's learning might yet banish death.

When he died at sixty-four in 1713, Bidloo's Leiden colleagues, annoyed by his frequent absences and irascible temper, were in no mood for a funeral oration. Only a year later, on the eve of the publication of *Anatomia*, an old laudatory poem by Jan Antonides van der Goes reappeared in print ("On the Anatomical Wonders of Govard Bidloo" [*Alle de Gedichten*, ed. 1714, 218]). Its import was that Bidloo's art surpassed nature itself so that dissection humbled the heart and bent the knees in admiration of God. It is clear that van der Goes and Bidloo still conceived of science and religion as the same pursuit of truth in an integral world.

Neither scientific objectivity nor Neoclassical refinement could quell the nascent Romantic strain, as we see in the dichotomy between method and mood in William Cheselden's *Osteographia, or the Anatomy of the Bones*, published in 1733 in London. Cheselden (1688–1752), whose textbook on anatomy was used into the next century and was in the library of Samuel Taylor Coleridge, engaged two obscure Flemings as engravers for the large folio plates of the bones whole, in situ, and in the details isolated fully modeled against blank backgrounds. Cheselden probably did most of the technical drawings, but the others were possibly the work of the two engravers who are barely mentioned in contemporary sources. The plates of full skeletons have Vesalian landscape settings that include such niceties as a skeleton kneeling in prayer (p. 162), a fallen quiver, and a skull

CHESELDEN: THE ANATOMY OF BONES

(p. 175). Cheselden emphasized accurate proportions, introducing animal skeletons for comparisons of form or scale (pp. 172–73). One chimpanzee skeleton (p. 48) recalls the earlier controversies about the nature of man and ape, which had been revived by the recent publication of Edward Tyson's *Orang-Outang, Sive Homo Sylvestris* in 1699. Jonathan Swift made hay of the controversy in *Gulliver's Travels,* in which Gulliver visits a centuries-old couple who have slyly reversed human evolution through senility to the state of apes.

Cheselden's vignettes give good evidence of his working method, particularly a scene of an artist drawing a suspended skeleton at a distance, viewing through a long box (p. 163). This is apparently a *camera obscura,* a closed box with an aperture (often fitted with a lens) in one wall, which casts an inverted, reflected image on the opposite wall. The one used by the artist may also have incorporated some form of grid screen to establish relative scale and relationships between parts.

The last page shows a broken obelisk on a base ornamented with a skeleton on a hillock, barren but for two dead trees, with the caption *Finis* inscribed below. The dread isolation of this ruined place recalls the evocative landscapes of Salvator Rosa, and indeed, the book's title page offers a direct quotation. Purported to show Galen contemplating a skeleton in the wilderness, the theme echoes that of an etching by Rosa – *Democritus in Meditation,* which shows the philosopher studying scattered bones – and the figure of Galen is an almost exact quotation from another Rosa etching, *Diogenes Throwing Away the Cup.* Cheselden's science is rational, the illustrations are factual, but the title page introducing it all is pure Romanticism.

ALBINUS:
A MATTER OF
VALUES

Bernard Siegfried Albinus (1697–1770) was the son of a professor of anatomy at the University of Leiden, where Albinus himself trained and eventually succeeded his father, teaching there uninterrupted until his death. He explained his purposes clearly in his own writings: to construct an ideal figure, based on many cadavers, "not like a carpenter dismantling a house, but with an architect's thorough knowledge of the whole structure." In this he was aided by a twenty-year collaboration with the engraver Jan Wandelaar (1690–1759), which culminated in *Tabulae Sceleti et Musculorum Corporis Humani,* twelve plates of the skeleton and muscle layers first published in 1747 and, after six more years, *Tabulae Ossium Humanorum,* illustrating the bones in separate detail. Along the way, this team participated in new editions of Vesalius and Eustachi, with Albinus providing new text and Wandelaar newly engraved replicas of the original prints.

Born in Amsterdam, Wandelaar had trained with several Dutch

artists, including Gérard de Lairesse, while also matriculating in anatomy at Leiden. An artist of great skill, he prepared the drawings and engravings for books on botany and a new edition of Ruysch's collected works, in addition to painting an occasional portrait. He was praised almost universally from the first for the scientific accuracy and artistic polish of the twelve engravings in the *Tabulae Ossium Humanorum* or, as translated for the pirated edition that appeared in 1759 in London, *Tables of the Skeleton and Muscles of the Human Body*. Like van Kalkar's woodcuts for Vesalius, Wandelaar's engravings are still in print for the use of art students.

Albinus assures his readers that the skeletons were not capriciously drawn, but studied with a technical stratagem, and that he had closely supervised Wandelaar's work. Thus he extols Wandelaar's skill while also claiming responsibility for the "correctness of the figures" and their "neatness and elegance." From the scarce cadavers and skeletons available he had chosen a young man of middle height and agile build, whose skeleton was suspended next to a slender male cadaver for a comparison of the external pressure points of the bones on the body. His preference for a tall, slender type expresses the aesthetic imperative of the lithe body ideal that replaced the weighty forms of the Baroque.

Albinus set a squared grid in front of the skeleton to be drawn, while at a distance of forty feet another grid was set with smaller squares that would correspond to the first at this distance, permitting closely studied details to be matched to their proper place in the whole. Beyond this, nothing was left to chance, or drawn freehand. Parts were traced and double-checked to avoid any inadvertent distortion from foreshortening, so that Wandelaar "reproduced everything with truth and accuracy . . . all the smallest details." He shows "marvelous refinement of skill . . . and even more important, draws the pictures on copper after the objects themselves." This last was quite important, and Albinus took pride in training Wandelaar to the task, as the elimination of intermediary drawings substantially reduced errors, as did Albinus's procurement of expensive papers and skilled printers to avoid distortion.

Having fixed the proportions and outlines of the subject figure, it remained to give it an illusion of three dimensions through shading and contrast with the background. For this, Albinus states that Wandelaar "required a certain color around the pictures and, to this end, tinted the parts that make up the ornamental frame. It was for this reason particularly that he added the ornaments . . . [that] preserve the proper light of the picture." By "color," Albinus meant what we now call "value," the scale of light to dark in shading. He certainly

understood the uses of color, that is, hue, in modeling and actually pursued several experiments in that direction before settling on the value system alone.

Color printing had a long ancestry, developing rapidly as a multi-block woodcut process in the sixteenth century. This process was supplanted at the end of the seventeenth century by a new innovation: the color mezzotint. A mezzotint is printed from a copper plate that has been made rough throughout by abrasion with a fine mesh of regular burrs, and then selectively polished. The smoothest areas cannot hold ink – and thus print as white – while the roughest retain a good deal. Depending on the polishing, these plates can print in fine gradations of tones from deep black to dead white. Jacob Christoph Le Blon (1670–1741), a peripatetic German artist, adopted the recently invented mezzotint to a multi-plate color process. By sequentially inking a plate in yellow, blue, and red for progressive overstrikes, he achieved a register of blended colors. His one experiment in anatomy was a lulu: an enormous penis in full flesh tones.

During the mid-1730s, while work with Wandelaar was already underway, a former Le Blon journeyman named Jan Ladmiral (1698–1773) offered this color process to Albinus. For the rest of the decade Albinus and Ladmiral produced plates and commentaries on the vascular system, in red and blue for arteries and veins, and a work on the pigmentation of the skin that included a color mezzotint of an African woman. Here planes of juxtaposed colors create the illusion of form in space, just as a carefully modulated use of black to white values will, but while color and value usually support each other in creating form, one must be dominant for the system to work. Albinus ultimately chose the finesse of Wandelaar's engravings and his superb control of values gradations.

According to Albinus, Wandelaar set his background tones according to the shading of the skeletons or muscles. In fact, he went a bit further to achieve an uncanny illusion of the projection of his main figures away from their background setting. He did this in two ways. First, the backgrounds were kept in a middle gray tonality and shaded with small strokes that seem slightly unfocused. By contrast, the figures are tightly defined in strongly hatched shading that polarizes the darker and lighter extremes, which gives the effect of close focus against distant focus without an intermediary transition. Later, a number of nineteenth-century French academic painters adapted

Opposite: Deep muscles of the body, deep dissection. Ribs, intercostal muscles partly removed to show diaphragm. Viscera removed to show psoas muscles. Bones of the arm and leg shown. Male figure, in vivo, anterior view. From Bernard Siegfried Albinus, *Tabulae sceleti et musculorum corporis humani,* 1747

TAB. IV.

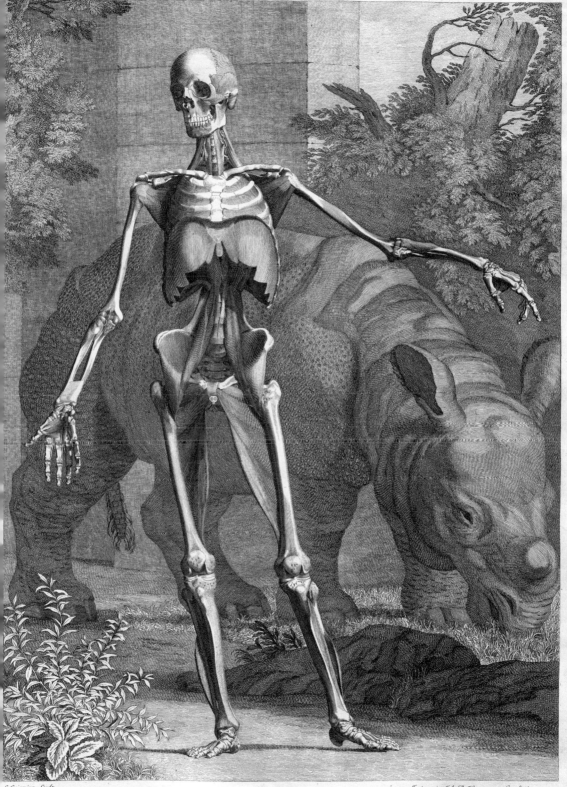

C. Grignion Sculp. Impensis J. & P. Knapton Londini. 1747.

the same method to color and brushwork to create a strong sense of projection in their figures. The device greatly irritated Cézanne, who thought it a technical tour de force and nothing more.

To a modern eye, Albinus's backdrop settings subvert his scientific neutrality with a surprisingly Romantic aesthetic. There is a pair of academic allegories of mortality: a flying Genius, the guardian spirit of a person, place, or talent, clears a drapery from a skeleton as Time Revealing Truth (p. 176). Another skeleton stands before a sepulcher with the reclining river deity of the River Styx (p. 182), an acknowledgment that the elegant strollers in this park are quite dead. There are blighted trees, tangled undergrowth, ruined walls, a broken urn, and neglected tombs. In the powerful setting for the figure showing a rear view of the outermost muscles, there are the mountain crags central to the Romantic vision.

Beyond the Romantic settings, there is still one more pleasure to be found in Wandelaar's plates, one that delights immensely without reason: on a shallow stage confined by background masonry stands the anterior figure for the fourth order of muscles in the company of a calmly grazing rhinoceros (p. 53), who then walks away from the back view of its companion. The flayed cadaver is anonymous, but the rhinoceros was once a celebrity. She arrived in Rotterdam in the summer of 1741, quite young and sweetly tame. She was drawn by Wandelaar the next year for these engravings, which were soon available as loose sheets. Painted by Longhi in Venice and drawn by Oudry in France and many others during her long years touring Europe on exhibition, she died in London in 1758 without much notice.

Albinus included the rhinoceros because "we thought the rarity of the beast would render these figures of it more agreeable than any other ornament." She is not meant to convey any specific message beyond the wonder of nature and its divine creation, but that is the message of the science of anatomy up to Albinus. In a rather sad way, this is the last expression of a vision of creation as shared as a whole by the arts, sciences, and faith, which would all soon go their separate ways.

Albinus's book marked the end of a line that began with Alberti's Renaissance injunction that "painting contains a divine force that not only makes absent men present . . . but makes the dead seem alive." Several issues were at stake around 1750, and their resolution determined the look of anatomical illustration from then on. Right off, landscape settings were deleted for good. The flayed Apollos lost their tormented wildernesses, elegiac parks, vistas, and hillocks to the divorce of science from the romanticized world of the dead.

From here on the science of subject would show the dead as just that, dead, while the art of setting would never again conjure up the cadaver in environments of moral, poetic, and theological imagery. After this, when the youthful poet Albrecht von Haller saw the Alps that had inspired the Romantics' awe, he could wax optimistic with faith in an eternal God. When the mature Albrecht von Haller, protégé of Albinus's, anatomist, and bibliographer, prepared his own anatomic illustrations, he pared them down to simple figures on a blank field.

Apart from landscape context, the major reservations about Wandelaar's achievement concerned his techniques of duplicating reality in illusion. The objections voiced by Pieter Camper, a former student of Albinus and contributor to later works on obstetrics, seem trivial, but they indicate the nature of this crisis. Camper thought Wandelaar's remarkable illusionism a distortion of factual information on a flat page, prescribing instead the structural scheme of a mechanical diagram. His suggestion proved a stillborn digression in taste and technique, but it well expressed a desire to free scientific illustration from the domain of evocative art.

The use of either engraving or mezzotint, with or without color, resurrected an old aesthetic debate between line and color as agents of form. This required a conscious decision during the 1750s, as assessed by the peripatetic French surgeon Charles Nicholas Jenty in defense of his use of mezzotint for *The Demonstration of a pregnant uterus full term in six tables large as nature* and a quartet of immense hand-colored mezzotints of anatomies done during a stay in London. Mezzotints, he wrote, "may want the smartness of engraving, but the softness that they possess may approach nearer to the imitation of nature." Conversely, it might be argued that softness is a painter's effect, but that one needs the crisper definition of engraving for anatomical data.

Color printing, considered by Albinus and set aside, raised its specter again in two very different fashions. Hand coloring, which had developed into a demanding discipline during the eighteenth century, was applied by the publisher to a printing of Eustachi's *Tabulae anatomicae* (Rome, 1783) to enhance the images. Yet despite these color washes and accents in basic red, yellow and blue, the engravings were literal, dry, and devoid of setting and meaning. The newly recovered anatomical drawings of Leonardo da Vinci only made them look worse. Eustachi's prints are closer in effect to the pallid lithographs created in the early nineteenth century by Louis Courtin for Sarlandière's *Anatomie méthodique* (Paris, 1829), an accurate but uninspiring catalogue of multiple body parts lined up

for display. But early mezzotint color could not adequately print the crisp details needed for anatomy illustration. The nineteenth-century invention of lithography, which printed from a drawing made directly on a smooth, wet stone with oil crayons that retained oil inks that the remaining surface repelled, was capable of detail in color and soon became the favored medium for technical illustration.

GAUTIER
D'AGOTY:
THE PAPER
ANATOMY
THEATER
Le Blon's color mezzotint process, carefully explored by Ladmiral with Albinus, was also exploited by the Frenchman Jacques Fabian Gautier d'Agoty from Marseille (1717–85) for a series of ambitiously immense, full-color anatomies that began to appear in various interlocking campaigns around the mid-century. With an eerie mixture of passable science, provided by the surgeon Jacques-François-Marie Duverney, and Gautier's own strained preliminary paintings and drawings, the Gautier atelier created a genre of its own, akin to the large anatomy portfolios of the day, but a world apart from them. Each set contained a number of immense sheets that could be joined two or three together to form an almost life-size figure. Early on, in the popularly named "Flayed Angel" (opposite), plate XIV in *Myologie complètte en couleur et grandeur naturelle*, 1746 (60.5 x 46 cm or roughly 24" x 18"), there is a haunting beauty and conviction of color and scale, an impressive achievement in controlling the pull of such large plates under the pressure of the press. The red wings are muscles pulled away, slightly lurid in contrast to the green background. This color contrast has a history of its own: from Bosch to Rubens, Northern artists had deliberately made use of the harsh contrast in the juxtaposition of any primary color – yellow, red or blue – with a secondary – orange, purple, green – made from the remaining two. In the early nineteenth century, the French chemist and color theorist Eugène Chevreul codified these empirical observations as an optical law of simultaneous contrast, of great interest to Delacroix, who used this same system, termed "color counterpoint" by Baudelaire, throughout his paintings. In a letter to his brother, Vincent van Gogh observed the distressing psychological effect of some of these contrasts, which he used deliberately to invoke a specific mood. Similarly, operating room scrubs are traditionally green as a contrasting clarification for the patient's reds.

Gautier's dramatic showpieces were meant for display, perhaps on the walls of surgeons, pharmacists, or midwives. Their scale and virtuoso technique belie their consistently garbled anatomy and amateurish drawing. In the end, they seem more like carnival posters than scientific drawings.

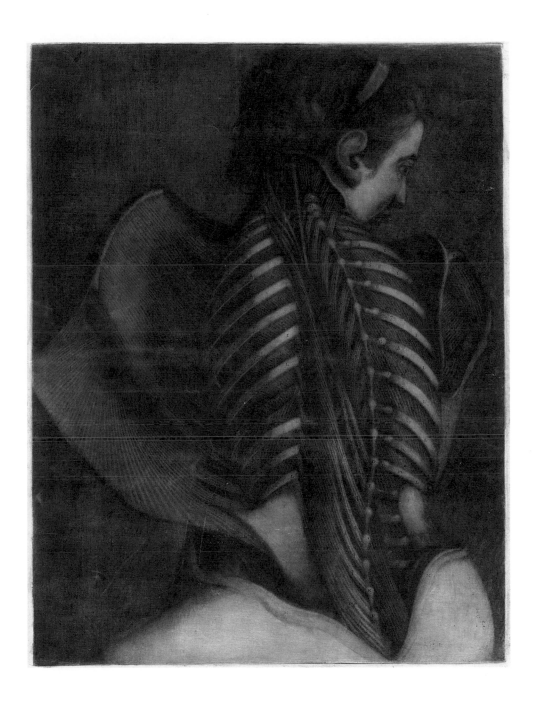

"The Flayed Angel" (back muscles, deep dissection) from Jacques Fabian Gautier d'Agoty, *Myologie complètte en couleur et grandeur naturelle*, 1746

TAB.XXIII

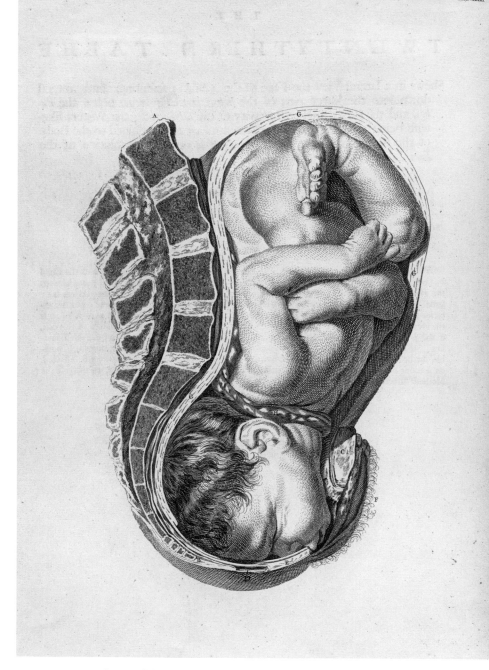

Delivery of the fetus, shown in isolation with uterus, spine, pubic bone, and vulva. Pelvis in sagittal section, fetus presenting anteriorly. Umbilical cord wrapped around the neck of the fetus. Lateral view. From William Smellie, *A Sett of Anatomical Tables, with Explanations, and an Abridgment, of the Practice of Midwifery,* 1754

The best science and the best art in the second half of the eighteenth century applied lessons learned from Albinus and Wandelaar in two British manuals on obstetrics, a new field for surgeons, who had previously left birthing to midwives. It is clear from contemporary reports by midwives that many of these surgeons were quite young, ill trained, and inept, resulting in maimed mothers, decapitated babies, and fatal post-operative infection. The English midwife Sarah Stone complained of these "boyish pretenders" to no avail; and Martha Ballard, her counterpart in New England, suffered a particularly incompetent and opinionated bother from a surgeon named Benjamin Page, whose social standing prevailed over his surgical blunders.

Surgeons were necessary in difficult births requiring Caesarean section or when a mother died in labor leaving her fetus alive but unborn. Pregnancy was a dangerous business, and the death rate was staggering. Rembrandt's wife, Saskia, delivered four infants, with only one survival. Then she died, aged thirty. Mary Wollstonecraft, author of *A Vindication of the Rights of Woman*, died as the immediate consequence of the "physician and man-midwife" who butchered her after the birth of her daughter Mary Godwin, who, as Mary Shelley, would deliver four babies of her own, only one of whom survived infancy. These are severe but common statistics. The remedy lay in improved instruction on all sides, which the Scot William Smellie (1697–1763) and his student William Hunter (1718–83) hoped to provide.

Teacher and student worked toward the publication of two epochal works on obstetrics. Both believed ardently in improving birthing techniques. Smellie greatly improved the accuracy of anatomical detail and useful measurements, and introduced case histories for teaching method and manner. His student, Hunter, became the most famous and competent "man-midwife" of his day. Rejecting the excessive use of instruments in aiding birth, Hunter took the reasonable position that "nature does more of this work than art can do, both for the mother and child, and therefore no art should be used." He recommended a reassuring bedside manner that included family and friends in support of the mother. In Jan van Rymsdyk he found "a very able painter" whose large-scale paintings and finely finished red chalk drawings would provide the models for most of the engravings in the books of both teacher and student.

Smellie's *A Sett of Anatomical Tables, with Explanations, and an Abridgment, of the Practice of Midwifery* appeared in 1754 with engravings after van Rymsdyk's drawings by Charles Grignion. These were carefully built up in varied hatching patterns of subtly modulated

middle tones that mimicked the tangible nuances of flesh in van Rymsdyk's softly modeled red chalk drawings (Glasgow, Hunterian Museum). In a few, body parts are blocked out in hard dark and light and seen from above like an architectonic maze. These were after Petrus Camper, who abhorred the softer naturalism of Wandelaar's engravings, but they were not repeated when van Rymsdyk's drawings were again reproduced in Hunter's great work some twenty years later.

Handsomely printed by the type-founder John Baskerville in 1774, William Hunter's *The Anatomy of the Human Gravid Uterus* serves with Smellie as the basis of modern obstetrics. The engravings were done by a team of French specialists under the supervision of Hunter's friend Sir Robert Strange. Strange was also familiar with Wandelaar's plates. As a young apprentice he had worked on a plagiarized edition of Albinus: "What fell my province was the ostiology, and two plates of the external muscles."

In effect, there was not much difference in the two sets of engravings of the pregnant womb, Grignion's being slightly drier and more evenly shaded, Strange's more softly swaddled in penumbra. But these cozy cocoons are set as autonomous units isolated on a blank page, a far cry from the obstetric figures of the Seasons by Odoardo Fialetti in van den Spieghel's *De formato foetu*. In this way, the majority of the female torsos are without external connotation, with the single exception of several remarkable engravings of distended genitalia. Almost the same in all pertinent details in both sets of engravings, these close-ups join a purpose quite other than ostensibly intended.

It is an odd irony that the little-known van Rymsdyk should become so well known for these plates. He was a good artist but a discontented one, feeling "ill used and betrayed." After these efforts he "took a dislike to the anatomical studies . . . I submitted, did not resist, and I fell." Many atelier assistants have harbored resentments of their employers, but "I submitted, did not resist, and I fell" suggests something like a seduction, an illicit task, and a ruined reputation. It is an elusively dark moment that arouses our curiosity.

There is a telling analogue for these genital portraits in a painting from 1866 by Gustave Courbet, *The Origin of the World*. In a delicately honed review, Maxime du Camp praises the work obviously "painted *con amore*, the last word in realism, but for an inconceivable oversight: working from nature the artist forgot to represent the feet, legs, thighs, stomach, hip, chest, shoulders, arms, hands, throat, neck, and head." Painted for a Turkish client in Paris, the work was kept in a small cabinet for pornographic amusement, hardly the

intent of van Rymsdyk's drawings. But although made after cadavers and meant for obstetrical study, and without any trace of secondary meaning, Rymsdyk's haunting, delicate beauty has recently received the homage of facsimile publication.

The engravings after van Rymsdyk's drawings appeared in London just after the publication of John Cleland's *Fanny Hill: Memoirs of a Woman of Pleasure* in 1749. More than any of the other suppressed novels of the age, this book included graphic explanations of sexual action, which, accompanied by Rymsdyk's precise pictures could give a neophyte a very good how-to manual. Nor were *Fanny Hill* and similar novels the only books suppressed during the early eighteenth century. John Marten's *Gonosolgium Novum: New System,* a second-rate medical diatribe on venereal disease, was similarly punished. But suppressed or not, the dawn of outright sexual pornography was at hand, and unlike earlier expressions that ridiculed religion and politics, the new erotica was meant to arouse and was frequently illustrated. Few examples survive, leaving us a shadowy notion of the illustrations that were perused and then, like Samuel Pepys's copy of *L'École des Filles,* consigned to the fire. "I submitted, did not resist, and I fell" remains a cry from oblivion.

There is a history yet to be written on the influence of older anatomy books on the Romantic artists of the early nineteenth century. Despite the revival of Leonardo in technical illustrations, the study of anatomy inevitably led many artists into these old tomes. A possible connection between Gautier's colored mezzotints and Delacroix's color and figure types, for example, is hard to dismiss. Géricault prepared the *Raft of the Medusa* with numerous oil studies of cadaver parts that recall Lairesse's drawings for Bidloo, and he quite possibly also knew the work of the last major French anatomist-artist before the Revolution, Jacques Gamelin (1738–1803).

Gamelin worked in Rome, producing genre pictures, battle scenes, and historical subjects. His *Nouveau receuil . . . pour l'utilité des sciences et des arts* appeared in 1779, providing illustrations of écorché (flayed) figures, skeletons, and individual bones. The title page, an academic allegory out of Salvator Rosa, gives the book the imprimatur of antique authority, which would degenerate by Gamelin's death into a formulaic requisite. Despite a series of fairly accurate skeletons and muscle figures, Gamelin's appeal is his good-humored recasting of Dance of Death themes, gallant vignettes including a skeletal intrusion in a *salon de toilette* (p. 223), a satire on fashionable dress with a skeletal orchestra. Other aggrieved skeletons recline, start up at the trumpet of Last Judgment (p. 222), or

GAMELIN:
DIALOGUES
AUX MORTS

kneel deep in the study of ancient tomes (p. 218). They arrive from the Gothic Revival of newly built turrets, synthetic ruins, and Walpole's *Castle of Otranto* (1764), in which statues bleed and skeletons weep. Some of the muscle studies refer to the romanticized Catholicism of the immediate pre-Revolution: a Christ Crucified écorché (opposite), another kneeling in prayer (p. 225).

A single plate of two formally dressed citizens contemplating a cadaver on a worktable (p. 224) presents the act of dissection as a *vanitas*, but it also reflects the rational realism of the contemporary *philosophe*. Despite an increasingly detached exactitude of science in Gamelin's generation, he and others to follow still developed works of art from their knowledge of anatomy. His immense 1779 painting of the Deluge, for a church in his native Carcassonne, with its entwined souls clustered before the fatal rush of water, anticipates Géricault's *Raft of the Medusa*, which, for all its references to current events, is also about clusters of drowning souls, painted after extended study of cadavers. The shift from the classical Romanticism of Gamelin's Biblical history and the Romantic realism of Géricault's contemporary history provides a paradigm for the changes in intellectual pretexts after the Revolution. One flood is eternally general and the other locally specific, but both draw themes about the elemental forces of nature, death, and hope, and both tell their story with accurately drawn, anatomically persuasive figures.

GRAY:
THE ELGIN
MARBLES On a morning in January 1808, shortly before his twenty-second birthday, the English painter Benjamin Robert Haydon entered a damp storage shed off London's Park Lane to experience an epiphany that would alter his life. Here he saw for the first time the marble sculpture from the Parthenon, which had been brought from Athens to London by Lord Elgin. These works had been dismissed by the reigning connoisseur of antiquity, Richard Payne Knight, as Roman copies. Haydon knew better. "I fixed my eyes on . . . the wrist of a figure in one of the female groups, in which were visible . . . the radius and ulna . . . I darted my eye to the elbow, and saw the outer condyle visibly affecting the shape as in nature. . . . My heart beat!" Haydon had seen the contrast of emphatic tensor action and relaxed tissue that create the reality of movement in these figures, "with all the essential detail of actual life." This simple observation would provide a basic principle to his work, a key argument for the authenticity of the marbles, and a method of teaching through the study of the body.

Haydon had early aspired to be an artist, reading avidly and drawing constantly, and as a boy he had bought a copy of Albinus. Later he recalled: "Oh, the delight of hurrying it away to my bed-

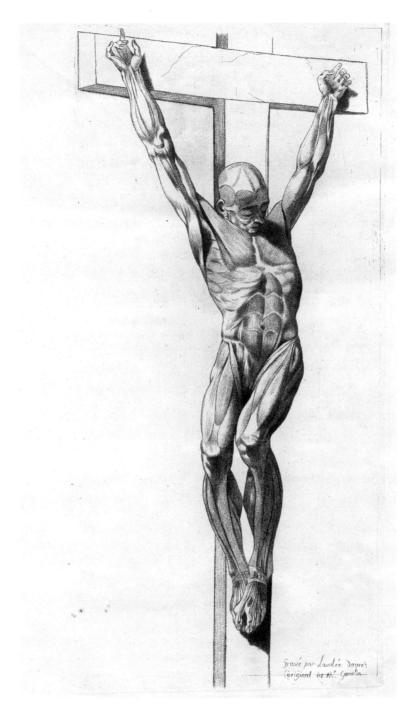

Christ Crucified écorché (flayed), from Jacques Gamelin, *Nouveau receuil d'ostéologie et de myologie dessiné après nature,* 1779

room, turning over the plates, copying them out, learning the origin and insertion of the muscles. . . [M]y sister . . . and I used to walk about the house . . . she saying 'How many heads to the deltoid?' 'Where does it rise?' 'Where is it inserted?' and I answering." It was from this knowledge that he championed the Elgin marbles.

Haydon was part of a remarkable circle in Georgian London that included John Keats, Charles Lamb, and William Wordsworth. Keats was himself no stranger to anatomy when he met Haydon in the fall of 1816, the occasion of his sonnets "Great spirits now on earth are sojourning" and "Haydon! Thou'rt born to Immortality!" Keats had just completed his first year of medical residency at Guy's hospital, but was on the verge of turning to poetry full-time, which was to be only five more years. He enjoyed looking at art with Haydon, pouring through folios of prints at his studio, and after the purchase by the crown of the Elgin Marbles, going in the spring of 1817 to see them together. Haydon never stopped arguing the importance of anatomy to idealized nature in high art, and Keats, the former medical student, certainly knew exactly what Haydon meant.

A similar observation on anatomy, truth, and beauty was propounded at that moment with great authority by William Hazlitt. Writing "On Imitation," Hazlitt lauds the beauty of a dissected "stomach laid bare" – not everyone's choice – and then extols the myriad mechanisms of the body. Overcoming repugnance and pain, he gains "an entire new set of ideas . . . It is the same in art as in science . . . truth, nature, beauty, are almost different names for the same thing." Anatomy thus provides a grounding in specific truthfulness to nature for all idealized beauty.

The publication of Keats's *Ode on a Grecian Urn* in 1820 epitomized this union of art and science, palpable in the relationship of art and anatomy, to that single overworked, misunderstood, but endlessly appealing line "Beauty is truth, truth beauty." As a specific reference this line anchors in a few words the Renaissance aspiration of human existence in mind and spirit as a union of the real and ideal. Despite the changing usage of vocabulary, Keats's words aligned Renaissance aesthetics with Romantic sensibilities.

The dispute between science and art continued to grow during the Romantic era. In the same March of 1817 when they visited the Elgin Marbles, Keats and Haydon attended a dinner party in London. Opposite Haydon, a weedy-looking young man stopped sawing at a piece of broccoli to insult the Christian faith – bad enough for the devoutly Episcopalian Haydon – and then to challenge the Christian sincerity of Raphael and Shakespeare, which was intolerable. Haydon and the poet Percy Bysshe Shelley argued all night. A year

The anatomist is instructing a group of art students, using a dissected cadaver, from Francesco Bertinatti, *Elementi di anatomia fisiologica applicata alle belle arti figurative*, 1837–39

the latter to the pectineal line, a few fibres pass upwards and inwards beneath the inner pillar of the ring, to the linea alba. They diverge as they ascend, and form a thin, triangular, fibrous band, which is called the *triangular ligament*.

In the aponeurosis of the External oblique, immediately above the crest of the os pubis, is a triangular opening, the *external abdominal ring*, formed by a separation of the fibres of the aponeurosis in this situation; it serves for the transmission of the spermatic cord in the male, and the round ligament in the female.

Fig. 163.—The External Oblique Muscle.

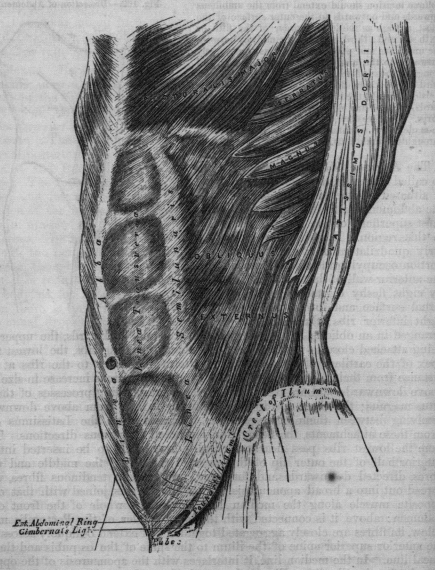

This opening is directed obliquely upwards and outwards, and corresponds with the course of the fibres of the aponeurosis. It is bounded, below, by the crest of the os pubis; above, by some curved fibres, which pass across the aponeurosis at the upper angle of the ring, so as to increase its strength; and, on either side, by the margins of the aponeurosis, which are called the *pillars of the ring*. Of these, the external, which is, at the same time, inferior, from the obliquity of its direction, is inserted into the spine of the os pubis. The internal or superior

later Mary Shelley published *Frankenstein: The Modern Prometheus* anonymously, with a preface by her husband. Although the book's central event is reduced to a manipulation of rags, books, and bones, it does propose that science might create a living being. Haydon was already at work on an answer: an immense painting of *The Raising of Lazarus* that would make it clear that divinity alone could master life over death. The war between religion – and art – and science had begun.

The divorce of art and science was clear by 1858, when Henry Gray and his illustrator H. V. Carter produced his *Anatomy Descriptive and Surgical*. Precise in description, its neutral, gray-toned vignette illustrations, engraved in woodblock and later printed from steel-faced plates, share Leonardo's aversion to stylistic distortion. Already in its twentieth edition by 1918, Gray is still sometimes used in medical schools, but never in an art class, where its didactic isolation of viscera offers little help in modeling a figure.

In Gray's day, artists still pursued anatomy with a zeal equal to a scientist's, but with different goals. As a contemporary critic noted, "an artist should be something of a geologist to paint rocky scenes correctly, as he should be a botanist to paint flowers, and an anatomist to paint the human form." This upheld a Romantic ideal of Truth to Nature that was currently encouraged by John Ruskin's Pre-Raphaelite views of scientific accuracy in observation.

It is a perfectible truth that similarly absorbed the American artist Thomas Eakins. Eakins dissected extensively, made casts from cadavers for use in teaching at the Pennsylvania Academy, and twice painted the disconcerting realities of surgery as a heroic venture. His dictum that art consisted only of perspective, reflection, and anatomy was harshly distant from the heartbreaking empathy of his best portraits of women, but he was speaking of the natural science of realistic illusion, without which that empathy could not be conveyed. With simple directness, he painted life as an apparent truth expounded with implicit faith in its value and the efficacy of science and art. Today Eakins remains a guide for looking around in joyful wonder. In innumerable life-drawing classes, students still prop their drawing pads on their laps, their shirts still stained with charcoal, as they strain to make sense of the knee and the angle of an arm, features of anatomy that are still there to be truthfully explained.

Opposite: "The External Oblique Muscle," from Henry Gray, *Anatomy, Descriptive and Surgical*, 1858

HVMANI COR- PORIS OSSIVM CAE

TERIS QVAS SV- *STINENT PARTIBVS*

LIBERORVM, SVAQVE *SEDE POSITORVM EX*

latere delineatio.

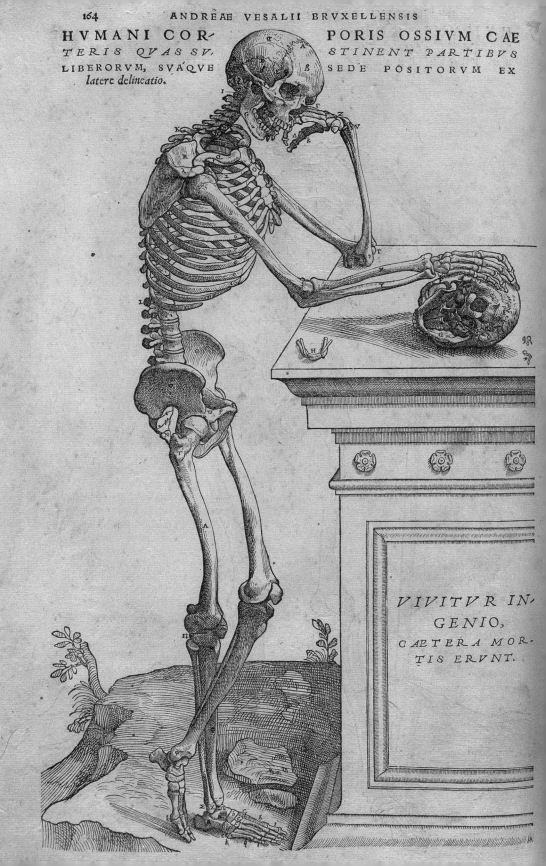

VIVITVR IN-

GENIO,

CAETERA MOR-

TIS ERVNT.

Andreas Vesalius (1514–1564)
Jan Stefan van Kalkar (d. 1568) and others, artists

De humani corporis fabrica libri septem
Basel, 1543

ANDREAS VESALIUS, born in Brussels of an accomplished medical family who had come from the German city of Wesel, was only twenty-eight years old when he wrote the most influential anatomy atlas in history: *De humani corporis fabrica*. He was professor of anatomy at the University of Padua at the time, but his fame as a master of dissection (a skill, no doubt, augmented by his experience as an army surgeon in France) had preceded him to that city.

If we think of the Renaissance as being torn between the rediscovery and veneration of classical learning and new discoveries, Vesalius's achievement comes into focus. In the case of anatomy, the most prestigious ancient authority, Galen, was also the roadblock in the path of discovery, since his anatomical teaching was inaccurate, often based – as Vesalius was able to show – on the dissection of mammals other than humans. As a writer, Vesalius confusingly mixed plagiarism with critique in his treatment of Galen, and his words have left little imprint on posterity. But his courageous illustrations, possibly based on his own sketches and entrusted by him to the best artists, woodcutters, and publisher money could buy, have echoed down the centuries, proclaiming the power of unbiased observation and precise rendering to overwhelm received opinion.

In *De fabrica*, Vesalius named various parts of the body and explained their structure, function, and pathology. He also included anecdotes about his own grave-robbing and dissection experiences, and expressed the hope – amply fulfilled in the following centuries – that his figures would prove useful models for painters and sculptors, as well as for physicians.

Unlike a work of comparable significance published in the same year, Nicolaus Copernicus's *De revolutionibus orbium coelestium* (*On the Revolutions of the Heavenly Spheres*), which proposed that the earth orbits around the Sun, the publication of *De fabrica* brought its author fame and fortune in his lifetime. As personal physician to Charles V, Holy Roman Emperor, Vesalius traveled widely, dying at age forty-nine after being shipwrecked returning from a pilgrimage to the Holy Land.

Opposite: Skeleton shown in a landscape, elbows resting on a pedestal bearing the legend: *Vivitur ingenio, caetera mortis erunt* ("Genius lives on, all else is mortal"). A skull lies on the pedestal, held in place by the skeleton for examination.

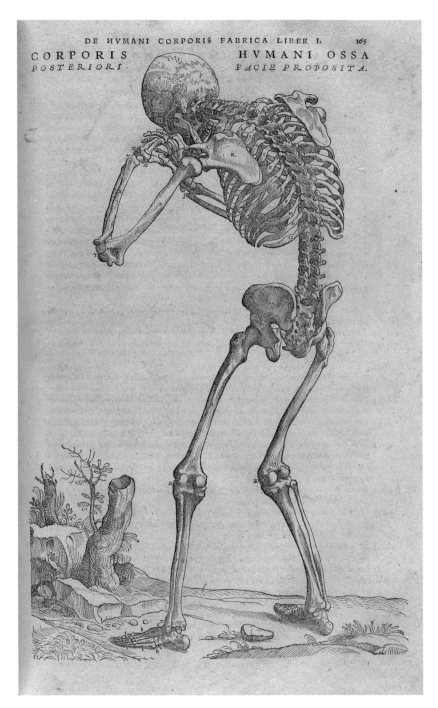

Mourning skeleton in a landscape, in vivo, posterior view

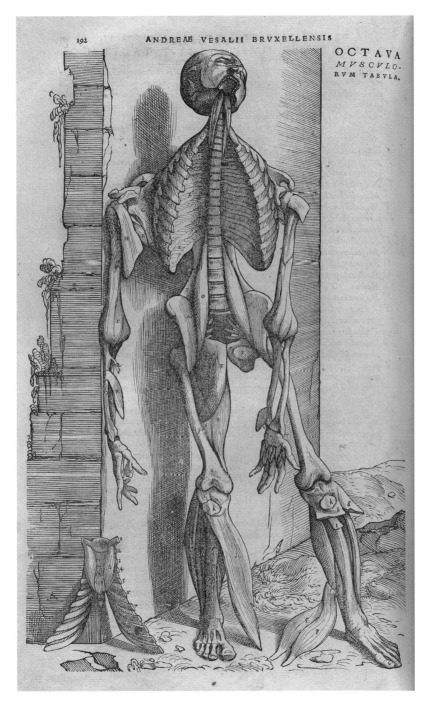

OCTAVA
MVSCVLO-
RVM TABVLA.

Deep muscles of the body. Ribs divided and removed with sternum.
Intercostal muscles shown. Male figure, in vivo, anterior view

PRIMA
MVSCVLO.
RVM TA-
BVLA.

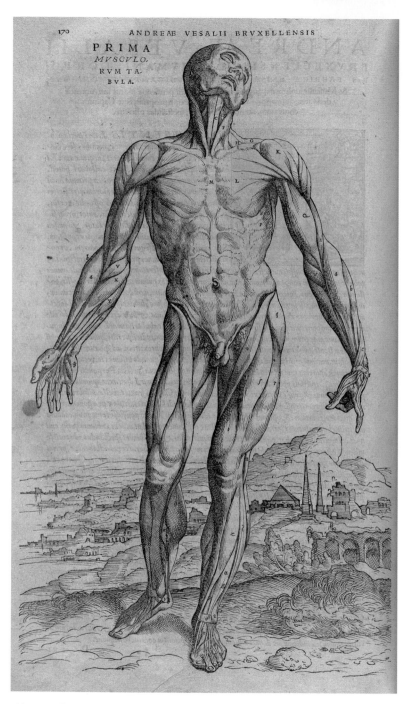

Above and opposite: Muscles of the body, superficial dissection. Male figures,
in vivo, anterior views

PRIMA MVSCV-
LORVM TABVLA.

Q CHA

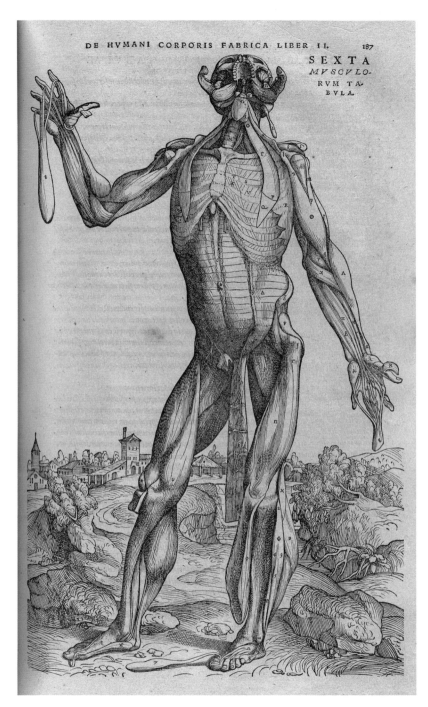

Muscles, deep dissection. Dissection of the mouth, mandible divided and reflected to show palate and tongue. Male figure, in vivo, anterior view

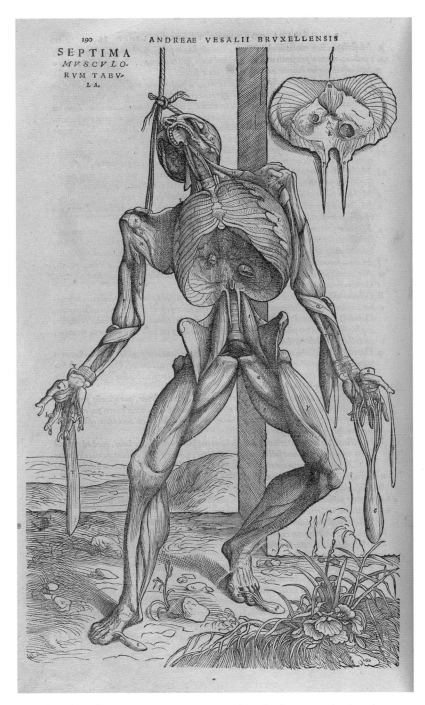

Muscles, deep dissection. Respiratory muscles; diaphragm is displayed on a wall behind the figure. Viscera removed. Male figure, hanging from a rope through the zygomatic bones of the skull, anterior view

INTEGRA ET AB OMNIBVS

PARTIBVS *LIBERA AC*

nuda uenæ cauæ delineatio.

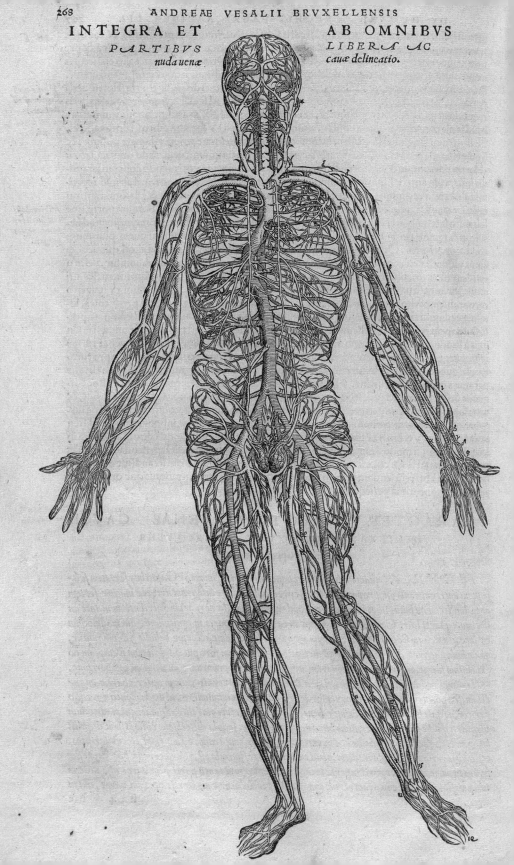

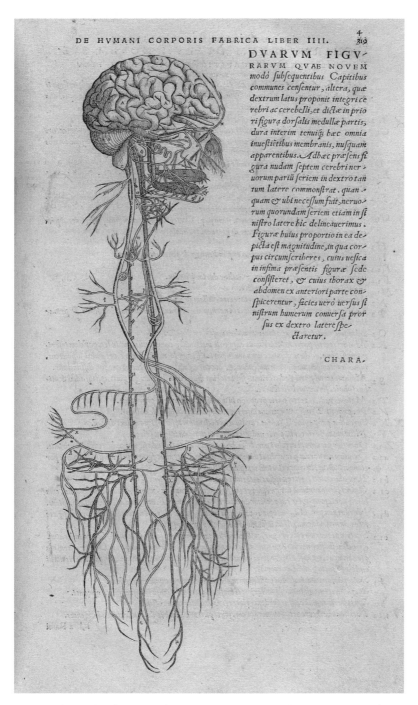

DVARVM FIGV-

RARVM QVAE NOVEM
modò subsequentibus Capitibus
communes censentur, altera, quæ
dextrum latus proponit integri ce
rebri ac cerebelli, et dictæ in prio
ri figura dorsalis medullæ partis,
dura interim tenuiq; hæc omnia
inuestietibus membranis, nusquam
apparentibus. Adhæc præsens fi
gura nudam septem cerebri ner-
uorum pariū seriem in dextro tan
tum latere commonstrat. quan-
quam & ubi necessum fuit, neruo-
rum quorundam seriem etiam in si
nistro latere hic delineauerimus.
Figuræ huius proportio in ea de-
picta est magnitudine, in qua cor-
pus circumscriberes, cuius uesica
in infima præsentis figuræ sede
consisteret, & cuius thorax &
abdomen ex anteriori parte cō-
spicerentur, facies uerò uersus si
nistrum humerum conuersa pror-
sus ex dextro latere spe-
ctaretur.

CHARA-

Brain and peripheral nerves, shown in isolation. Cranial nerves, nerves of the
respiratory and digestive systems, lateral view
Opposite: Veins of the body, shown in isolation. Anterior view

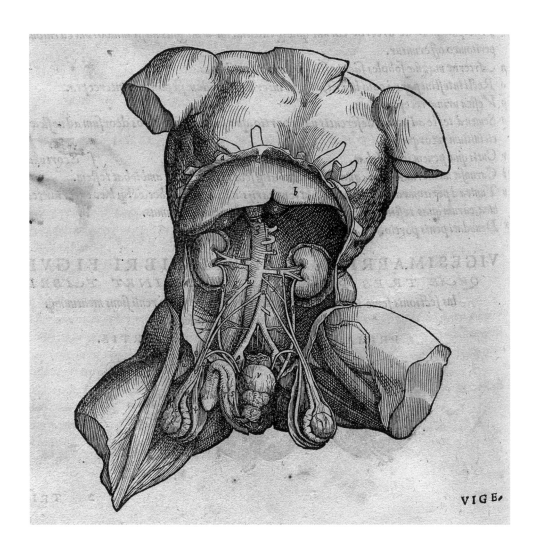

Male urogenital system, organs shown in situ. Intestines removed to show liver, kidneys, and blood supply. Genitalia dissected to show bladder, prostate, and penis; testis and epididymis shown in dissected scrotum with testicular artery. Anterior view

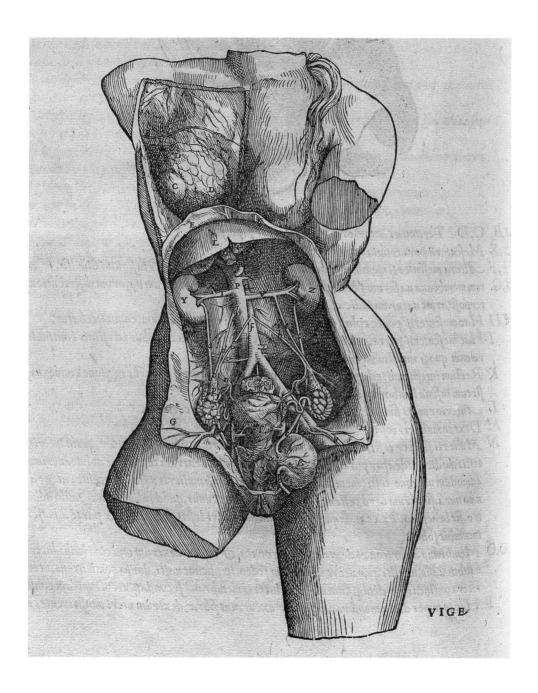

Female urogenital system, organs shown in situ. Intestines removed to show liver, kidneys, and blood supply. Genitalia dissected to show bladder, uterus, Fallopian tubes, ovaries, and ovarian artery. Anterior view

nis serie succedit. Habet enim dissectũ peritonæum, & omentum quoq̃ in hac ablatũ est, & hic
costas aliquot etiã effregimus, quo iecoris cauũ opportunius delineari posset. Hic namq̃ conspi
citur uniuersum iecoris cauũ, ipsiusq̃ iecoris forma. Dein uẽtriculi quoq̃ apparẽt orificia. Inte
stina autẽ perinde ac uentriculũ in sinistrũ latus depressimus, ut in cõspectu esset mesenterij pars,
ac uenæ portæ in ipsum series: dein bilis meatus in intestinũ insertio, et si quæ sint reliquaquæ cha
racteribus seriatim adnotabimus, mox atq̃ quid decima tertia ostendat figura, expresserimus.

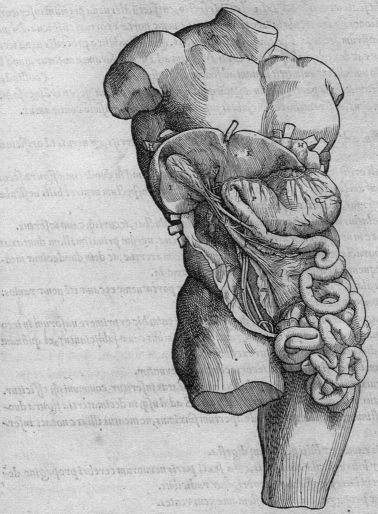

DECIMATERTIA QVINTI LIBRI FIGVRA,

NVDAM BILIS VESICVLAE EIVSDEMQVE
meatuum delineationem exprimens.

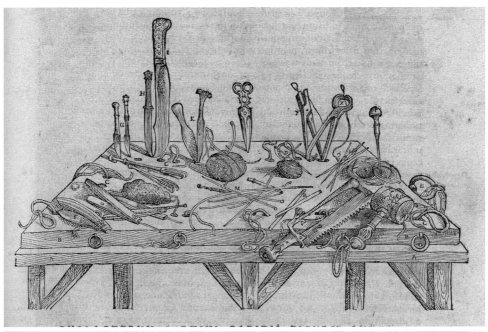

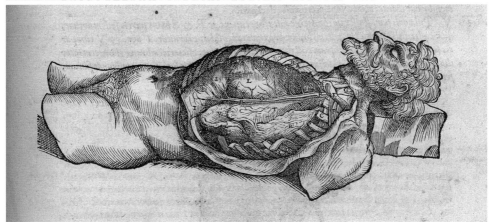

Top: Table with dissecting or surgical instruments
Bottom: Thorax, with ribs divided and removed to show lungs. Male figure, lateral view
Opposite: Dissection of the abdomen, showing liver, stomach, intestines and mesenteries, gallbladder, and bile ducts. Male torso, with liver reflected upward to show gallbladder, bile ducts, and intestines. Antero-lateral view

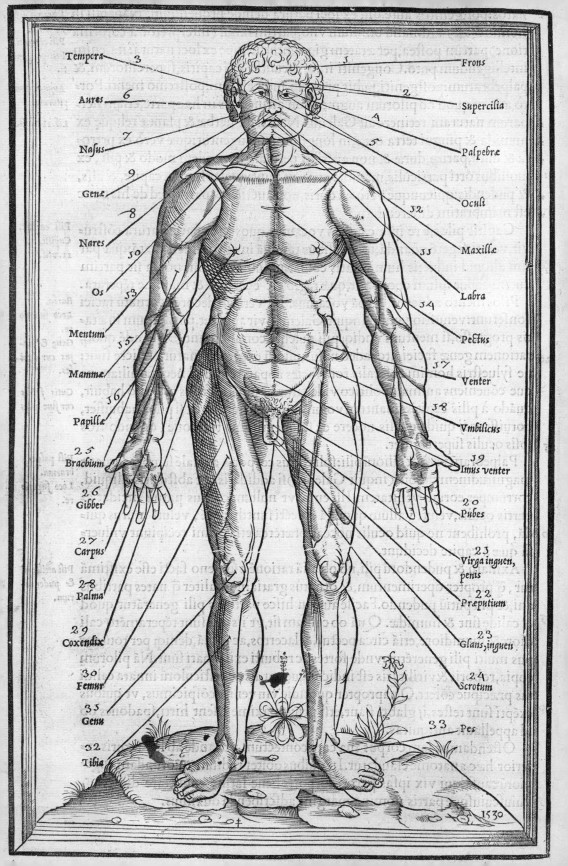

Tempora 3
Aures 6
Nasus 7
Genæ 9
8
Nares 50
Os 53
Mentum
55
Mammæ
56
Papillæ
25
Brachium
26
Gibber
27
Carpus
28
Palma
29
Coxendix
30
Femur
35
Genu
32
Tibia

3
2
A
5
32
55
54
57
58
39
20
23
22
23
24
33

Frons
Supercilia
Palpebræ
Oculi
Maxillæ
Labra
Pectus
Venter
Vmbilicus
Imus venter
Pubes
Virga inguen, penis
Præputium
Glans, inguen
Scrotum
Pes

1530

Charles Estienne (ca. 1504–ca. 1564)
Étienne de La Rivière (d. 1569), drawings
Jean "Mercure" Jollat (fl. 1530–1545), woodcuts

De dissectione partium corporis humani libri tres
Paris, 1545

CHARLES ESTIENNE (also known by the Latin name Carolus Stephanus) was born into a Parisian family of great intellectual distinction. Printers in the rue Saint-Jean de Beauvais, the Estiennes produced influential editions of the Bible and a durable Latin dictionary, as well as many other works of scholarship. As a physician with a thorough humanistic education, Charles wrote widely on medical, agricultural, and classical topics.

Thanks to the particular circumstances surrounding the publication of *De dissectione partium corporis humani libri tres* (*On the dissection of the parts of the human body*), Estienne is sometimes portrayed as the man who might have taken the laurels as the first modern anatomist instead of Vesalius, but it is doubtful that the world would have acknowledged his book's primacy. He certainly lacked the disciplined vision of his putative rival, and the modern viewer is apt to think that his mind was more cluttered than adorned by its intellectual furnishings on the evidence of his illustrations, although his text reveals that Estienne was a competent anatomist. The figures in his book are imaginatively drawn but with less accuracy than those in Vesalius's work; moreover, the bodies are accompanied by various props, such as vases, trees, walls, and other nonessential objects in the background. A number of the plates were adapted from images made for non-medical purposes, which explains the existance of small inserts showing anatomical features into figures whose postures seems disconcertingly provocative.

Estienne worked with surgeon and artist Étienne de la Rivière and woodcutter Jean Jollat, but fell out with de la Rivière. The work was complete in 1538, but a lawsuit between the men delayed publication until 1545, two years after Vesalius's *De fabrica*, which had far greater impact on the world. Six years later, in 1551, Estienne took over the family printing business, which ultimately failed, in spite of – or perhaps because of – his appointment as printer to the king. He died in the debtors prison in the Châtelet.

Opposite: Muscles and bones of the body, superficial dissection. Male figure, anterior view

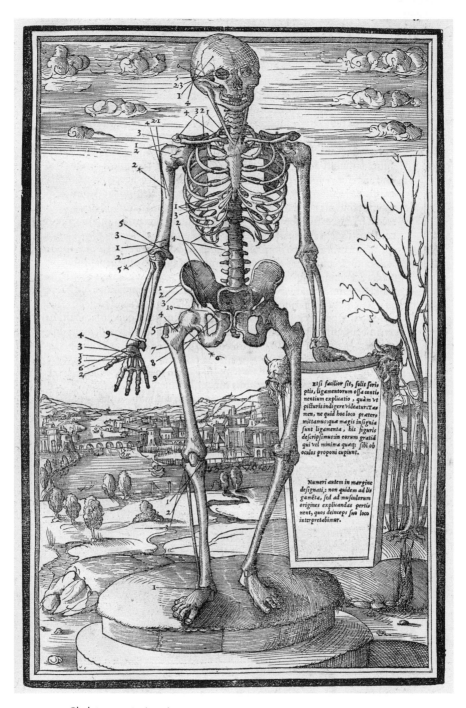

Skeleton, anterior view
Opposite: Nerves of the body, with skeleton, anterior view. Mandible removed from the skull and held in the hand. Spinal nerves, some cranial nerves, brachial plexus, and lumbar plexus shown

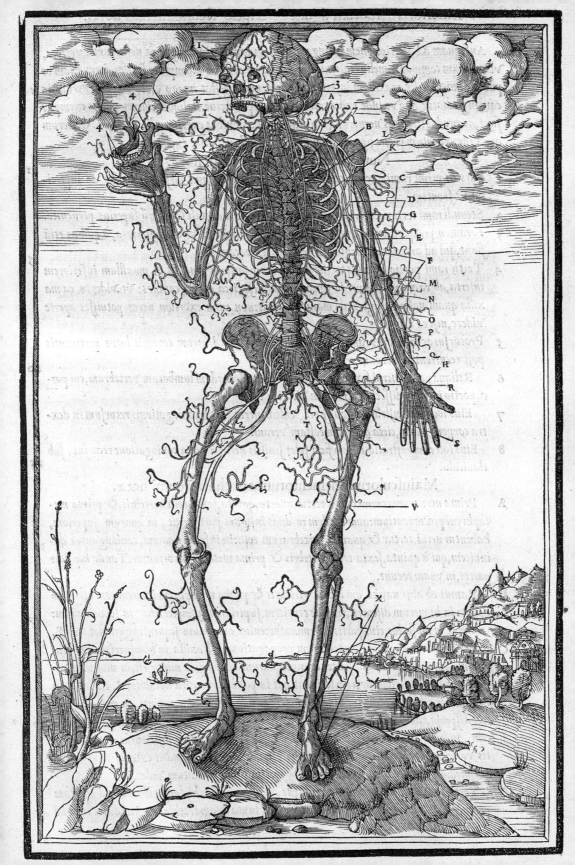

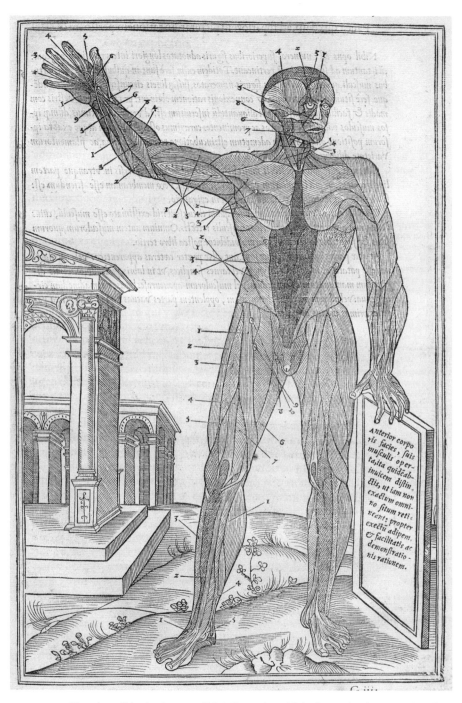

Muscles of the body, superficial dissection. Male figure, in vivo, anterior view

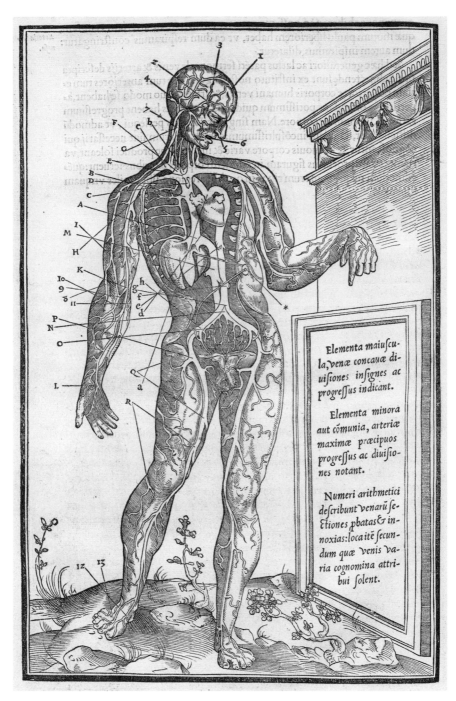

Veins and arteries of the body, shown with heart and liver. Male figure, in vivo, anterior view

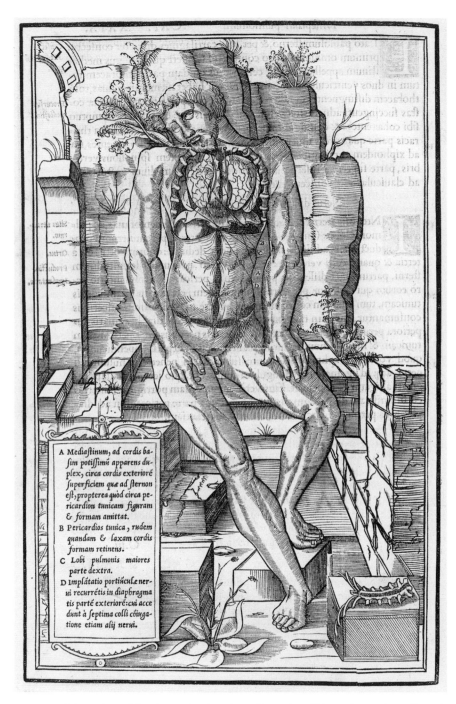

A Mediaſtinum, ad cordis baſim potiſſimũ apparens duplex, circa cordis exteriorẽ ſuperficiem quæ ad ſternon eſt, propterea quòd circa pericardiõs tunicam figuram & formam amittat.
B Pericardiõs tunica, rudem quandam & laxam cordis formam retinens.
C Lobi pulmonis maiores parte dextra.
D Implãtatio portiũculæ nerui recurrẽtis in diaphragmatis partẽ exteriorẽ:cui accedunt à ſeptima colli cõiugatione etiam alij nerui.

Dissection of the thorax, in situ, deep dissection. Skin and muscles reflected, ribs divided and reflected to show mediastinum and diaphragm. Heart and lungs visible. Male figure, anterior view

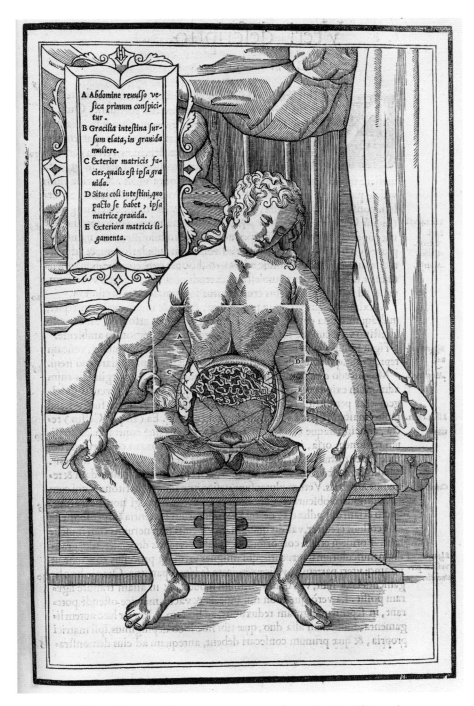

A Abdomine reuulſo ve-
 ſica primum conſpici-
 tur.
B Gracilia inteſtina ſur-
 ſum elata, in grauida
 muliere.
C Exterior matricis fa-
 cies, qualis eſt ipſa gra
 uida.
D Situs coli inteſtini, quo
 pacto ſe habet, ipſa
 matrice grauida.
E Exteriora matricis li-
 gamenta.

Dissection of the abdomen of a pregnant woman, shown in situ. Skin and muscle wall reflected to show uterus, bladder, and intestines. Female figure, in vivo, anterior view

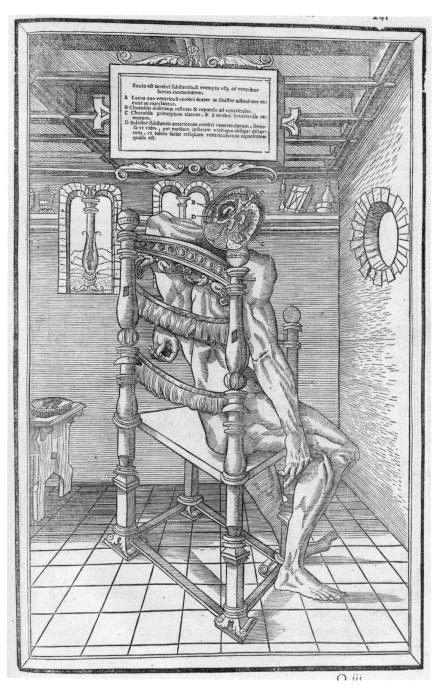

Dissection of the brain, in situ. Brain in transverse section to show lateral ventricles, with choroid plexus indicated, postero-superior view. Removed section of brain displayed on a table. Male figure, posterior view
Opposite: Dissection of the brain, in situ. Brain in transverse section to show cerebellum, third cerebral ventricle and pineal body, antero-superior view. Removed section of brain displayed on a table. Male figure, antero-superior view

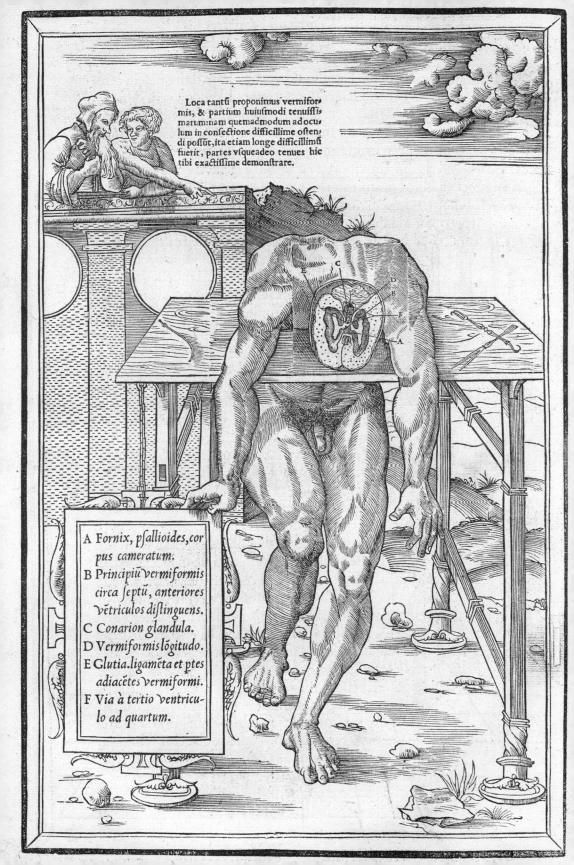

Loca tantū proponimus vermiformis, & partium huiusmodi tenuissimarum:nam quemadmodum ad oculum in confectione difficillime ostendi possūt,ita etiam longe difficillimū fuerit, partes vsqueadeo tenues hic tibi exactissime demonstrare.

A Fornix, psallioides, corpus cameratum.
B Principiū vermiformis circa septū, anteriores vētriculos distinguens.
C Conarion glandula.
D Vermiformis lōgitudo.
E Glutia.ligamēta et ptes adiacētes vermiformi.
F Via à tertio ventriculo ad quartum.

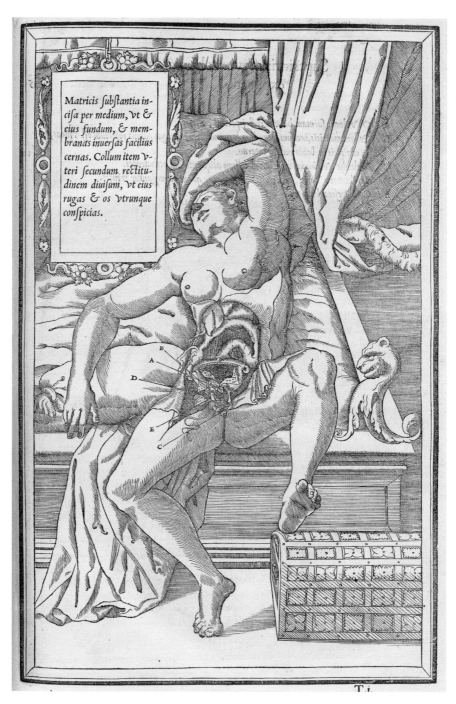

Matricis substantia incisa per medium, vt & eius fundum, & membranas inuersas facilius cernas. Collum item Vteri secundum reŭitudinem diuisum, vt eius rugas & os vtrunque conspicias.

T.i.

Dissection of the female genitalia, in situ, deep dissection. Uterus dissected to show interior, vagina dissected to show interior and cervix. Colon and vulva indicated. Female figure, in vivo, anterior view

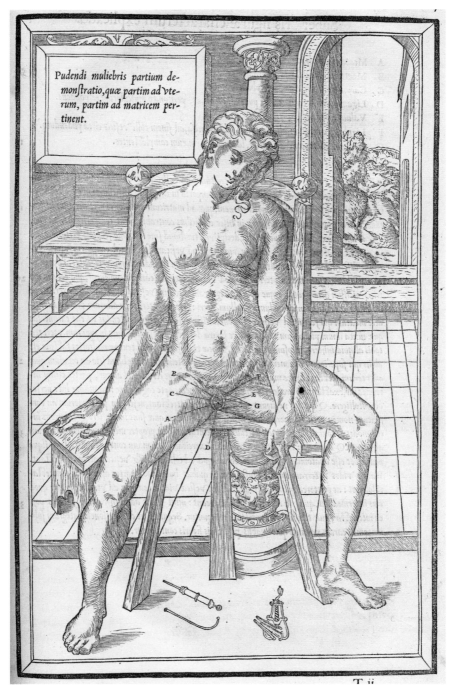

Pudendi muliebris partium de-
monſtratio, quæ partim ad ute-
rum, partim ad matricem per-
tinent.

Female genitalia, in situ, external vulva shown. Instruments possibly used to examine the vagina shown. Female figure, in vivo, anterior view

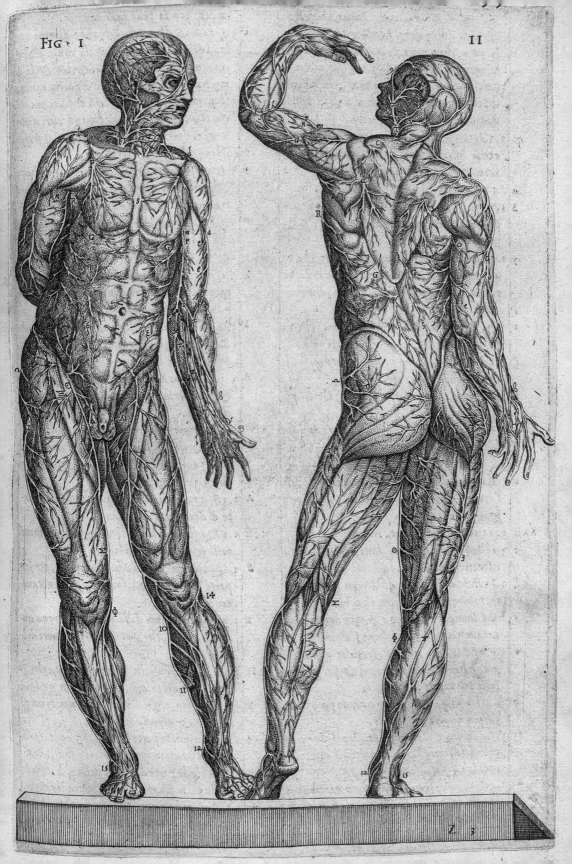

Juan Valverde de Amusco (ca. 1525–ca. 1588)
Gaspar Becerra (1520?–1568?), drawings
Nicolas Beatrizet (1507?–1570?), engravings

Anatomia del corpo humano
Rome, 1560

LIKE THE NEW VISION of the place of the earth in the universe that was slowly gaining adherents, the new vision of man and woman enshrined in Vesalius was controversial in conservative religious circles. Furthermore, anatomists who wanted to make their mark in the immediate post-Vesalian world needed a position from which to attack him, and that was provided by Vesalius's mild attack on the stature of Galen.

It is not surprising that one of these controversialists should have been Spanish, given that Spain was the bastion of Catholic traditionalism and the most dangerous place in Europe to espouse new ideas on controversial topics. The Spaniard Juan Valverde de Amusco trained in Padua under Realdo Columbo, an assistant of Vesalius, and Bartolommeo Eustachi, whose *Tabulae anatomicae,* published posthumously, follows next in this volume. Little is known about Valverde; Vesalius, who was justifiably resentful that Valverde's best-known book, *Historia de la composicion del cuerpo humano,* first published in Rome in 1556, consisted of numerous plates copied from *De fabrica,* said that Valverde was no veteran of the dissecting room, which is possibly true. Ironically, Valverde, who portrayed himself as a Galenist, was, thanks to his act of plagiarism, intrumental in spreading the Vesalian vision.

Valverde "borrowed" all but four of his forty-two copperplates from Vesalius, and in the selection that follows, the ones that are copied from *De Fabrica* are noted in the captions. It is conventional to prefer Vesalius's woodcuts, but Valverde's crisp copperplate engravings are appealing in their own right. Especially notable is the famously phallic-looking Vesalian vagina (p. 101), which must represent a triumph of cultural attitudes over observation.

Opposite: Veins and muscles, superficial dissection. Two male figures, in vivo, anterior and posterior views

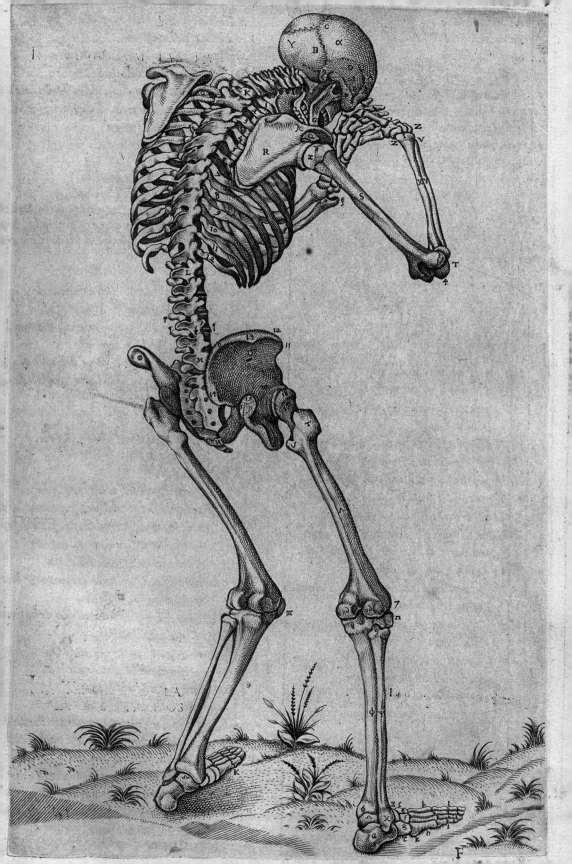

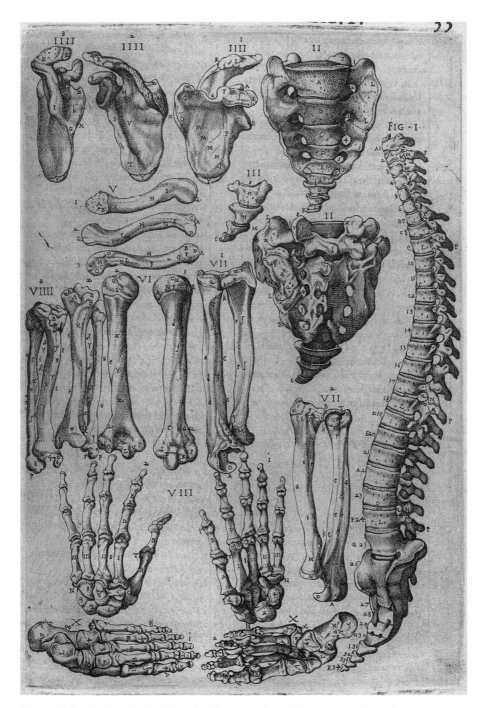

Bones of the skeleton in isolation, in fifteen numbered illustrations. Scapula, anterior, posterior, and lateral views. Sacrum, anterior and posterior views. Spine, lateral view. Bones of the upper extremity. Foot bones
Opposite: Skeleton. Adapted from Vesalius (see p. 70)

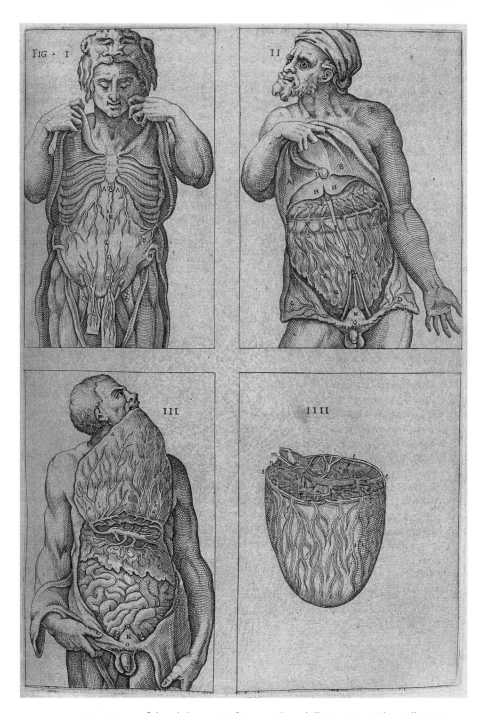

Structures of the abdomen in four numbered illustrations. Three illustrations show peritoneum, omentum, and portal system in situ. Male figures, in vivo, anterior view. One illustration shows isolated omentum and portal system *Opposite*: Organs of the digestive system shown in situ, in five illustrations. Stomach, liver, intestines, peritoneum, mesenteries, and omentum shown. Section of small intestine, dissected. Anterior views

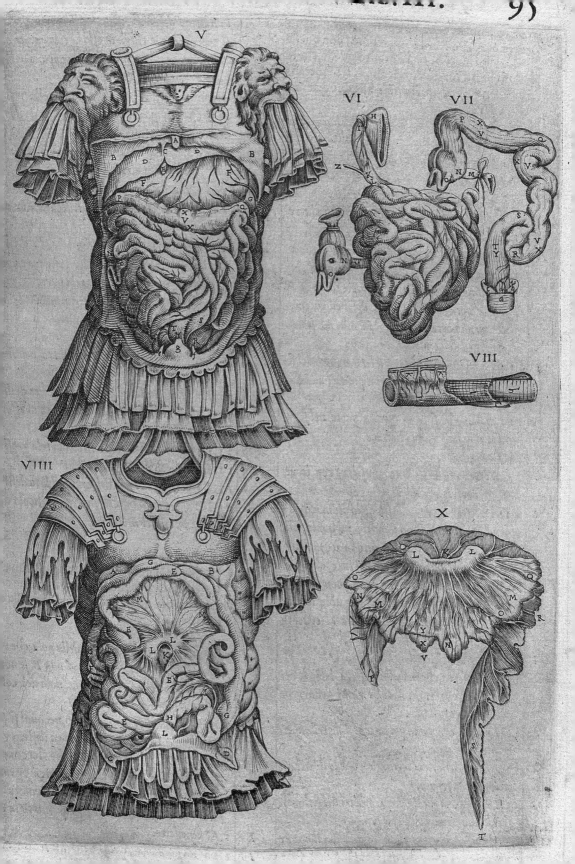

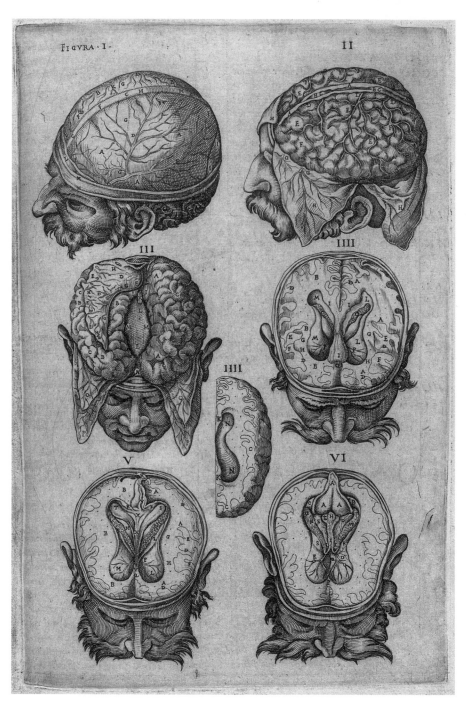

Dissection of the brain, in seven numbered illustrations. Brain shown with dura mater in place, and with dura mater reflected, lateral views. Transverse sections showing the cerebral ventricles, superior views. Adapted from Vesalius

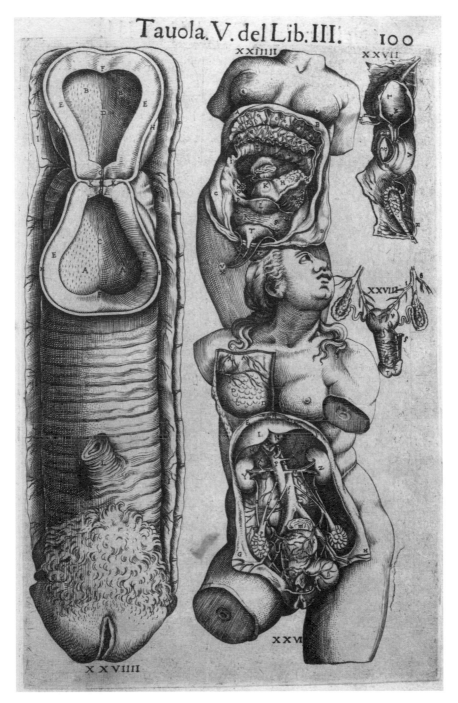

Organs of the abdomen in two female figures, shown in situ and in isolation, in five numbered illustrations. Stomach and intestines removed to show liver, and blood vessels to the urogenital system. Isolated structures of female urogenital system, dissection of the vagina, uterus, and ovary. Anterior and superior views. Adapted from Vesalius

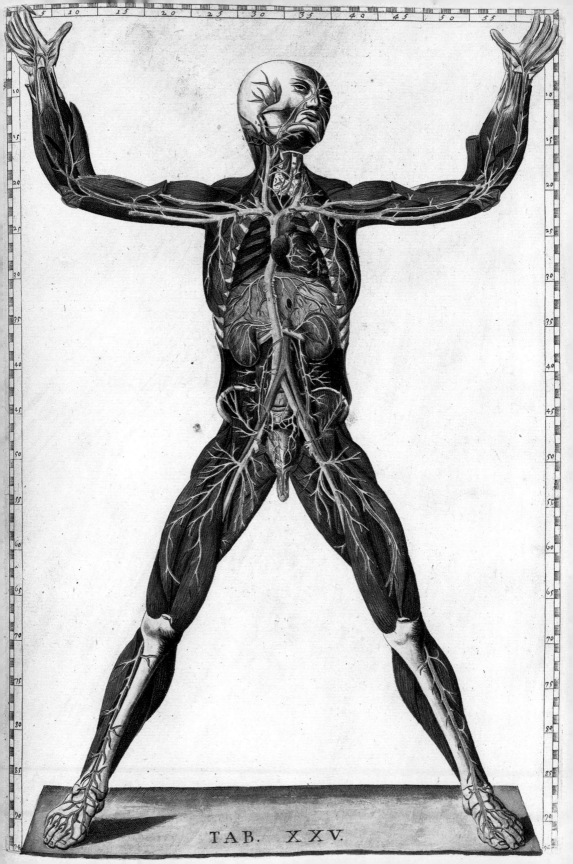

TAB. XXV.

Bartolommeo Eustachi (d. 1574)

Pietro Matteo Pini (b. ca. 1540), drawings
Giulio de' Musi (fl. 1535–1553), engravings

Tabulae anatomicae

Rome, 1783

LIKE VALVERDE, BARTOLOMMEO EUSTACHI – also known as Eustachius – considered himself a defender of Galenic physiology against the innovations of anatomists like Vesalius, but this did not stop him from making numerous medical discoveries of his own, including the Eustachian tube (named after him), the thoracic duct, and the adrenal glands. He also gave the first accurate description of the uterus, as well as the laryngeal muscle and the origin of the optic nerve. Like many academic quarrels from the past, the controversy between Galenists and Vesalians does not seem to have had much substance from this remove.

Eustachi probably studied medicine in Rome and Padua and had a distinguished career as a physician, first serving the Duke of Urbino and then Cardinal Giulio Della Rovere in Rome, where he lectured on anatomy. He was considered the most exacting medical investigator of his day, and tradition has it that he introduced the practice of postmortem examinations to Roman hospitals.

The plates seen here have a romantic history, in that they were lost to the world for more than 130 years. In 1564, Eustachi published his *Opuscula anatomica,* containing eight anatomical plates – focusing mostly on the kidneys and vascular system; thirty-eight other copperplates that he had prepared for a more ambitious work had not been printed at the time of his death. In a plot worthy of a mystery novel, they remained forgotten in the Vatican Library until they were discovered by the pope's physician, Giovanni Maria Lancisi, who had them published in 1714 under the title *Tabulae anatomicae (Anatomical Tables).* The illustrations seen here, from an edition of 1783, were beautifully colored by hand.

Eustachi clearly wanted to avoid cluttering his illustrations with numbers or letters keyed to identifying text, so he created a system of coordinates determined by rulers printed around his images that is often used on maps today. His plates have a stiff, graphic quality that has been attributed to the draftsmanship of Giulio de' Musi, who is known only for architectural prints. Certainly, Eustachi possessed a more subtle sensitivity to human anatomy than these plates reveal.

Opposite: Muscles, organs of the thorax and abdomen, and arteries and veins of the body, deep dissection. Heart, diaphragm, kidneys, and bladder shown. Male figure, in vivo, anterior view

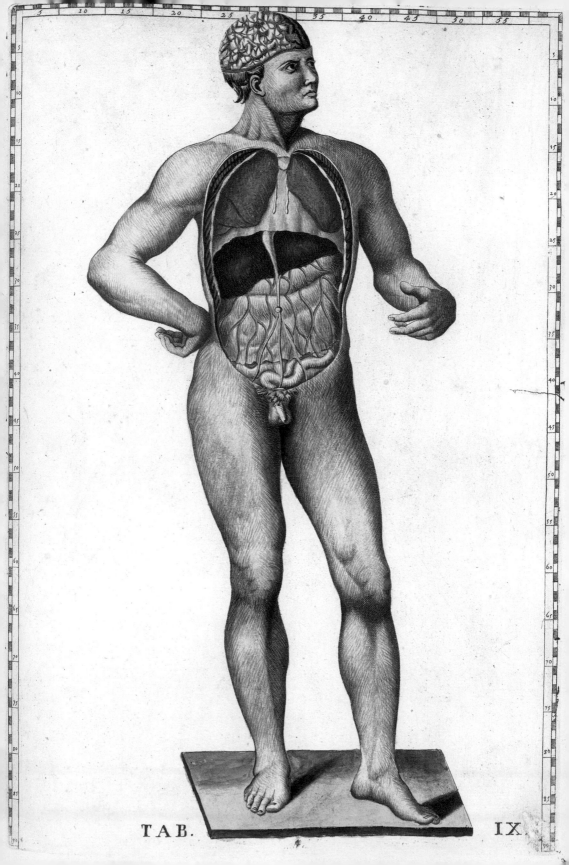

TAB. IX

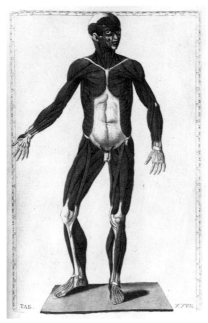
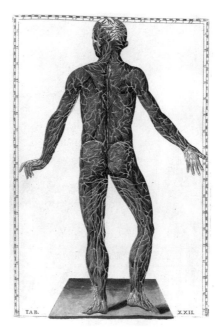
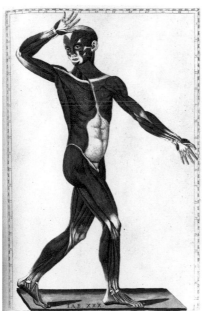
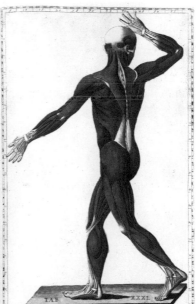

Top left: Muscles of the body, superficial dissection. Male figure, in vivo, anterior view

Top right: Muscles and subcutaneous arteries and veins of the body, superficial dissection. Male figure, in vivo, posterior view

Above, left and right: Muscles of the body, superficial dissection. Male figure, in vivo, antero-lateral view and postero-lateral view

Opposite: Dissection of the head, thorax, and abdomen, showing lungs, liver and peritoneum. Skull cap and dura mater removed to show brain. Male figure, in vivo, anterior view

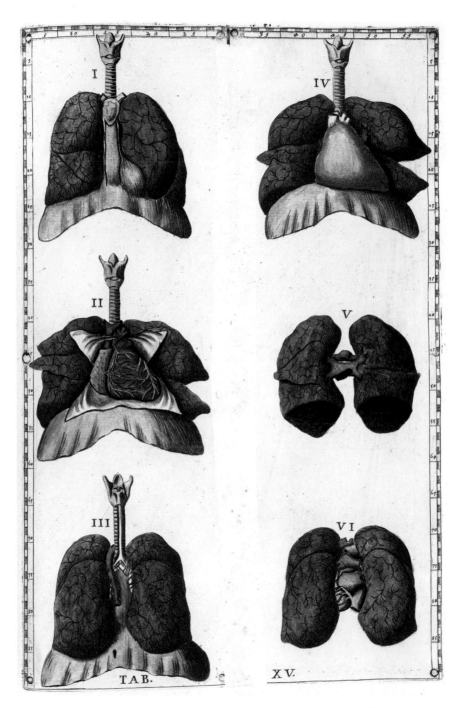

Heart, lungs, trachea, and laryngeal cartilages, shown in isolation, in six numbered illustrations. Heart, lungs, and blood vessels, in anterior and posterior views. Trachea and laryngeal cartilages in anterior views

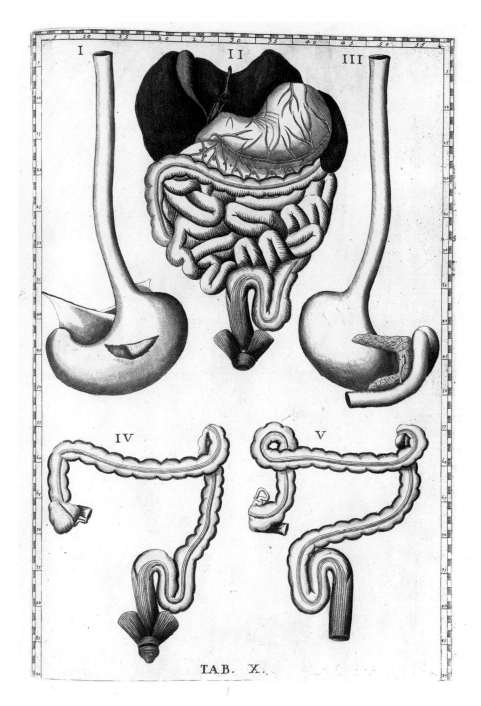

Organs of the gastrointestinal system, shown in isolation, in five numbered illustrations. Stomach, liver, gallbladder, pancreas, and intestines shown

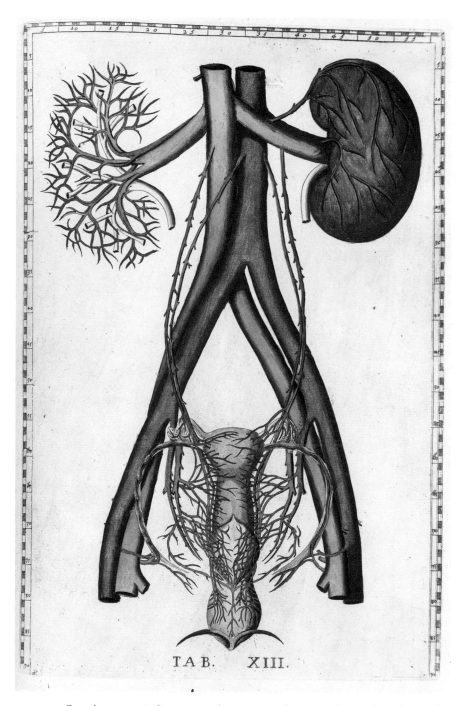

TAB. XIII.

Female urogenital system, shown in isolation. Kidneys, blood vessels, ureters, bladder, uterus, Fallopian tubes, ovaries, and clitoris shown. One kidney shown whole, the other shown as blood vessels only. Anterior view

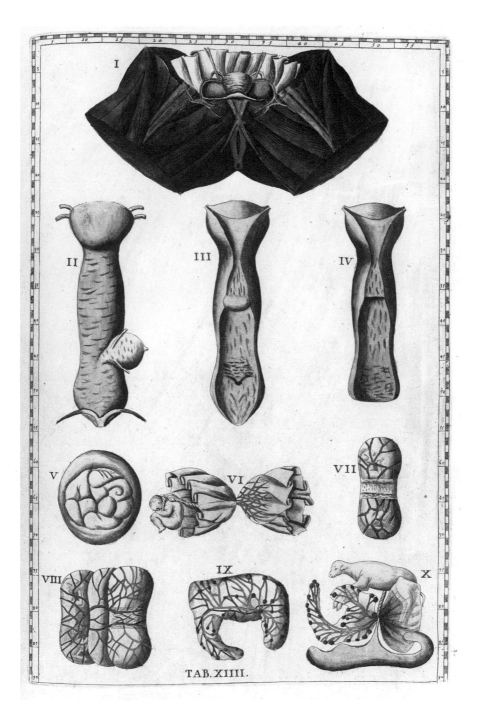

Female genitalia, shown in isolation, in ten numbered illustrations. Uterus, vagina, and anus shown in situ, with pelvis. Uterus and vagina shown with bladder, and dissected to show interior, anterior, and posterior views. Placenta shown with fetus. Uterus and fetal membranes of a dog and a sheep, with sheep fetus shown

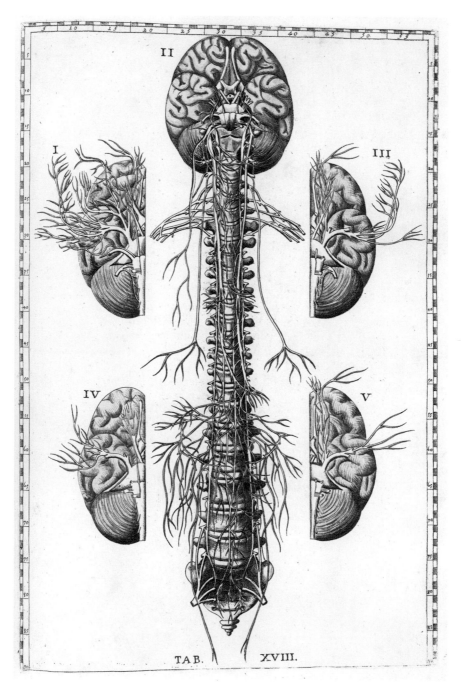

Brain, cranial nerves, peripheral nerves, and spine, shown in isolation, in five numbered illustrations. Brain with cranial nerves, shown in isolation, inferior views. Brain with spine, showing cranial nerves, brachial plexus, sacral plexus, branches of vagus nerve (cranial nerve X), antero-inferior view
Opposite: Bones and muscles of the head, thorax, and arm, deep dissection, posterior view. Four illustrations of the eye, showing oculomotor muscles and optic nerve

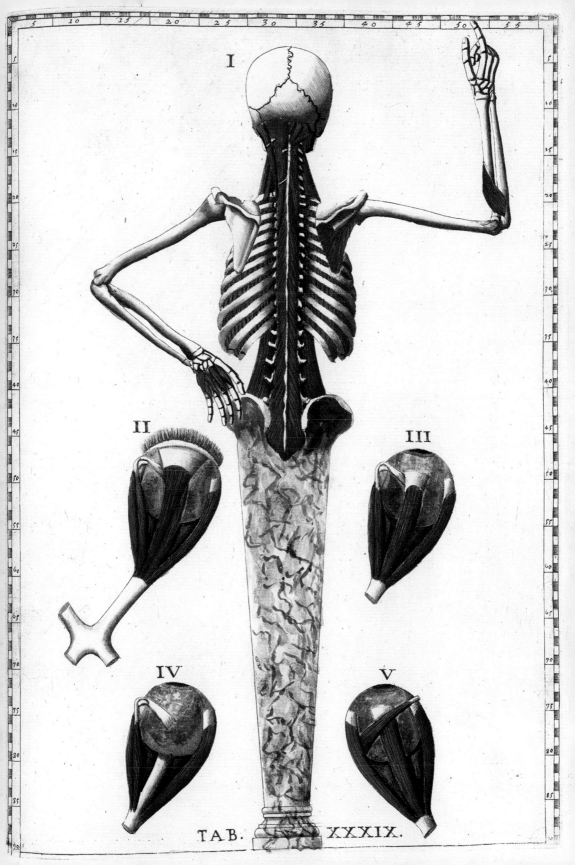

I

II III

IV V

TAB. XXXIX.

TAB. I.

FIG. II.

FIG. III.

FIG. IV.

Giulio Cesare Casseri (ca. 1552–1616) and
Adriaan van den Spieghel (1578–1625)
Odoardo Fialetti (1573–1637/8), drawings
Francesco Valesio (b. ca. 1560), engravings

De humani corporis fabrica libri decem
Venice, 1627

De formato foetu
Padua, [1626]

IT IS NO COINCIDENCE that three of the first four anatomical atlases featured in this book were the creations of physicians who taught or trained at the University of Padua in Italy. In the sixteenth century, Padua was the most advanced center of medical science in the world, thanks in part to the legacy of Vesalius. Meanwhile, its proximity to Venice, with its sophisticated community of artists, printers, and publishers, ensured Padua's faculty access to superb facilities for rendering and printing their illustrations. When, around mid-century, the technology of copperplate engraving, with its ability to register greater detail in a smaller compass, began to replace woodcuts in precision printing, the faculty of Padua stood ready to use it.

It is possible to discern, in the histories of the volumes under discussion here, a faint echo of the intense gravitional force exerted on families orbiting the sun of this great academic institution. The story begins with Giulio Cesare Casseri, born in the mid-sixteenth-century and impoverished by his father's untimely death. Casseri financed his medical studies at Padua by becoming the servant of another student. From these humble beginnings, he rose to a chaired professorship in anatomy and surgery. Casseri, who became known for his work on the vocal and auditory organs, must have been an extraordinarily talented anatomist and a man of great artistic culture. He assembled a marvelous team of artist, Odoardo Fialetti, and engraver, Francesco Valesio, to work with him on plates for anatomical atlases.

Casseri's plates remained unpublished at the time of his death in 1616, possibly because of political jockeying by his predecessor on the faculty in Padua. His successor to the chair in Padua, his cosmopolitan student Adriaan van den Spieghel, was a prolific writer on medicine and botany. Two of Spieghel's anatomical books – a

Opposite: Surface anatomy of the eye, ear, and nose, in three numbered illustrations, from *De humani corporis fabrica libri decem*

general treatise and one on the development of the fetus – remained unpublished at his death in 1625.

It fell to a German physician and student of Spieghel's named Daniel Bucretius, and to Spieghel's son-in-law, the Paduan physician Liberalis Crema, to unite the legacies of Casseri and Spieghel. As executor of Spieghel's will, Bucretius negotiated with Casseri's heirs to acquire the rights to the splendid copperplates in his estate. These became the nucleus of the illustrative material for Spieghel's anatomical treatise *De humani corporis fabrica libri decem*, published in Venice in 1627: Bucretius commissioned an additional twenty plates by Fialetti and Valesio to accompany the original seventy-seven from Casseri. Meanwhile, Crema purchased a set of plates illustrating fetal development from Casseri's grandson, and published them in Padua at his own expense, with Spieghel's text *De formato foetu,* in 1626.

Thus, the family and friends of two great doctors cooperated in publishing projects that combined art, medical science, and commerce, to ensure that their works were not lost to posterity.

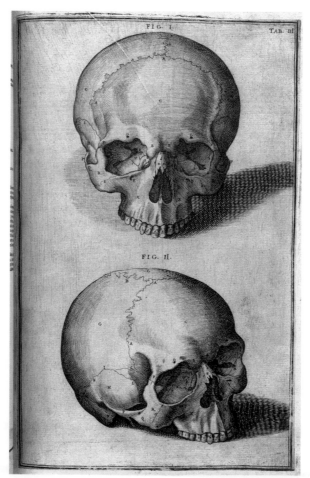

Two views of the skull

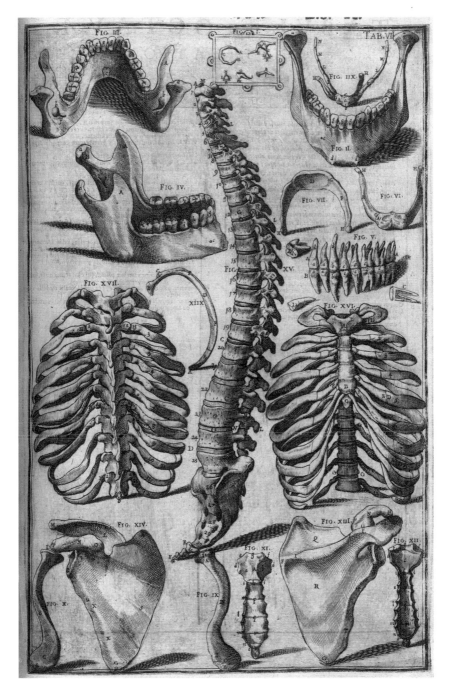

Bones in isolation, in twelve numbered illustrations. Mandible, anterior, posterior, and lateral views. Ear ossicles, shown in a small inset. Hyoid bone, anterior and posterior views. Teeth, lateral and superior views, one cross-section. Clavicle, anterior and posterior views. Sternum, anterior and posterior views. Bones, in six numbered illustrations. Spine, lateral view. Ribs, attached to the spine, with sternum, anterior and posterior views. Scapula, anterior and posterior views

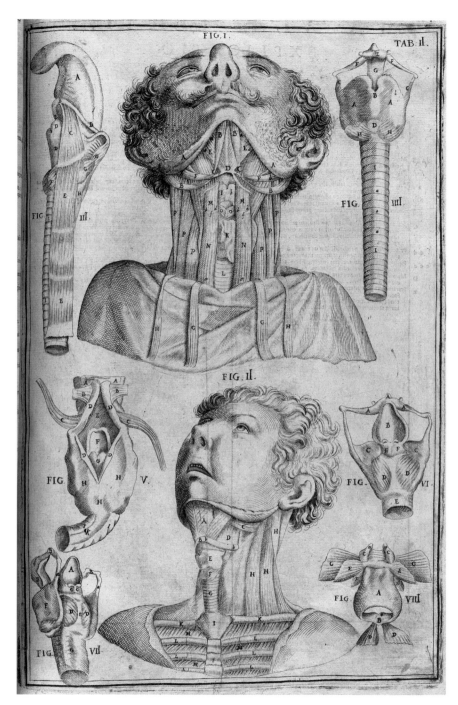

Neck muscles, trachea, laryngeal cartilages, deep dissection, in two numbered illustrations. Anterior and antero-lateral views of male figures, one with dissection of the chest to show ribs, sternum, and intercostal muscles. Laryngeal cartilages and trachea, with attached neck muscles, shown in isolation, in six numbered illustrations. Anterior, posterior, and lateral views

TAB. XVII.

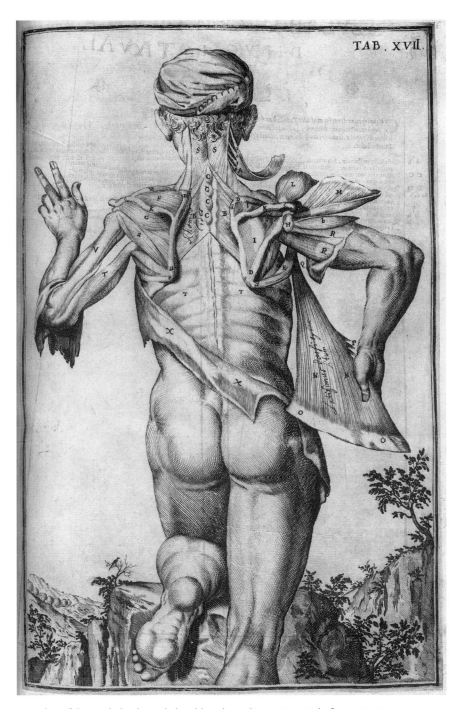

Muscles of the neck, back, and shoulder, deep dissection. Male figure, in vivo, posterior view

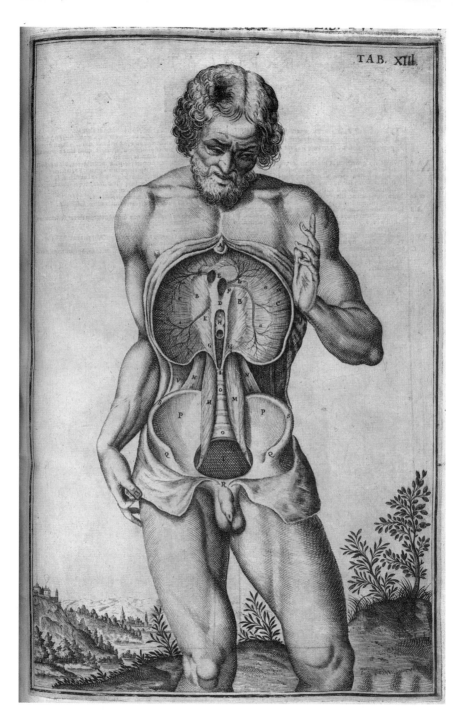

TAB. XIII.

Abdomen, viscera removed. Diaphragm reflected to show crus. Psoas muscle and pelvic bones visible. Male figure, in vivo, anterior view

Opposite: Dissection of the abdomen, showing omentum, large and small intestines, mesenteries, epigastric arteries, and urachus. Male figure, in vivo, anterior view

TAB. VI.

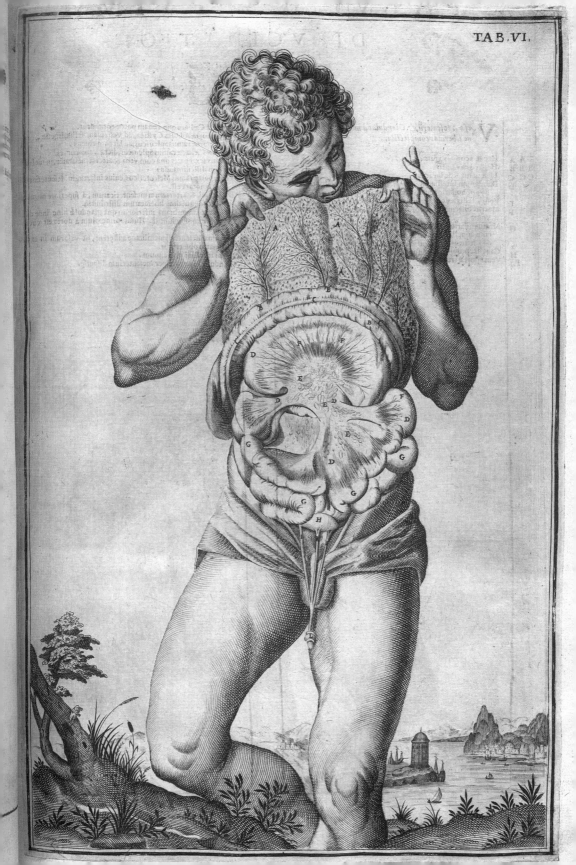

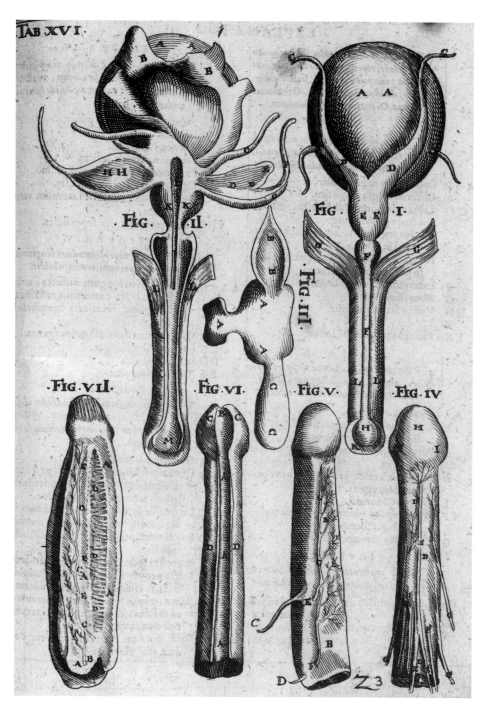

Male urogenital system, shown in isolation, in seven numbered illustrations. Dissection of the bladder, prostate, and penis, including blood supply to the penis

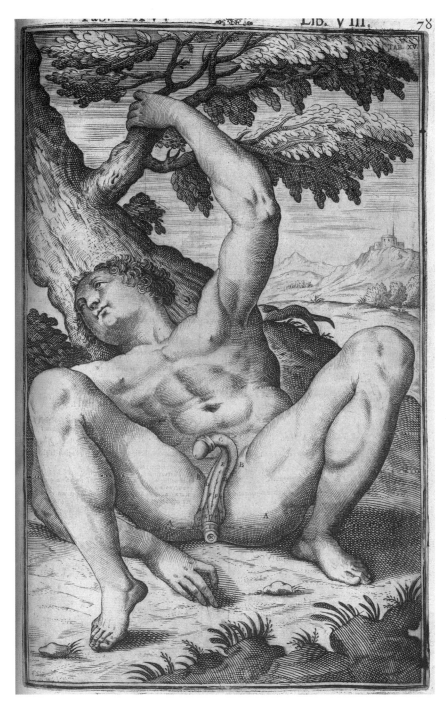

Male genitalia. Dissection of penis and anus, testes removed. Male figure, in vivo, antero-inferior view

De humani corporis fabrica libri decem ● 121

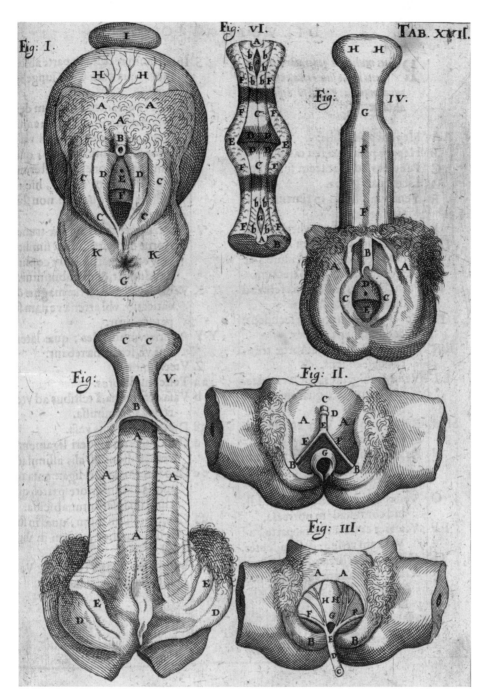

Female urogenital system, in isolation, in six numbered illustrations. Dissection of uterus and external genitalia, including blood and nerve supply to the clitoris

Opposite: Urogenital organs shown in dissection of the abdomen, stomach and intestines removed. Kidneys, renal arteries and veins, inferior vena cava and aorta, ureter, bladder, uterus, and ovaries. Liver and gallbladder, iliac arteries, and veins. Female figure, in vivo, anterior view

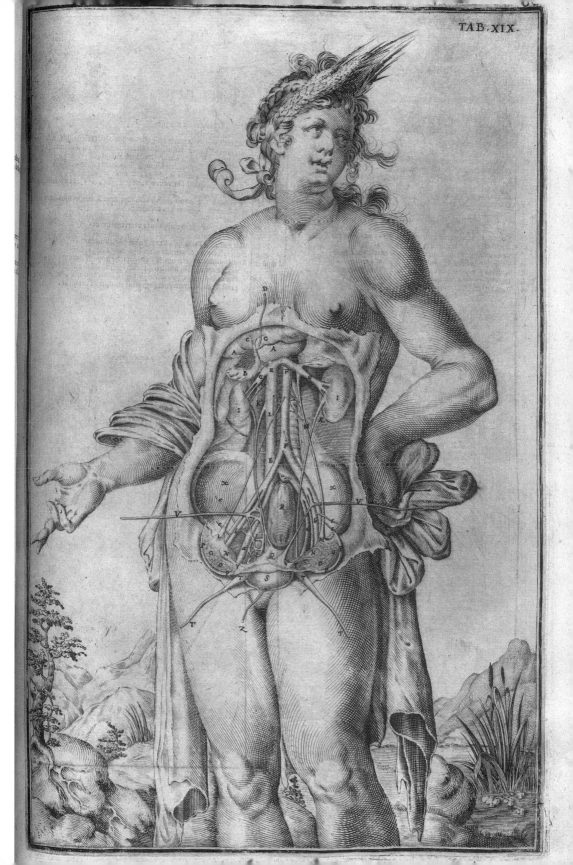

TAB. XIX.

Tab. III.

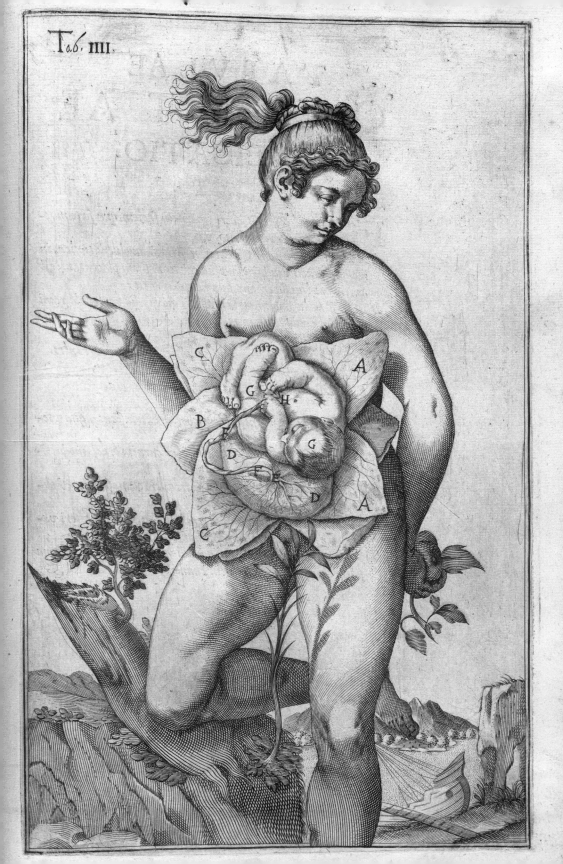

Tab. III

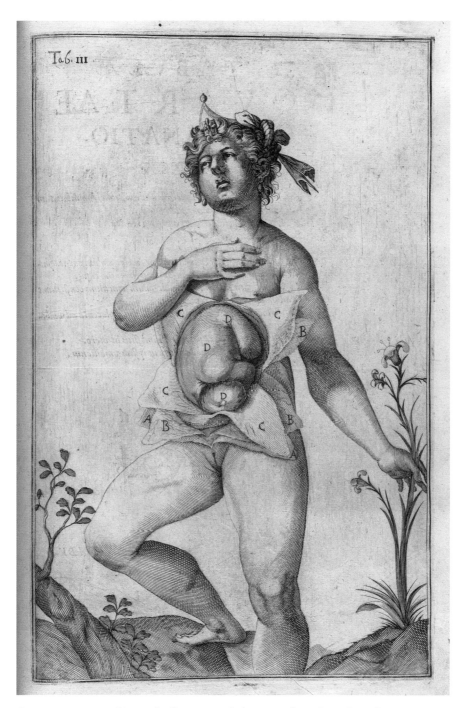

Pregnant woman, skin, wall of uterus and chorion reflected to show fetus. Female figure, in vivo, anterior view

Opposite: Pregnant woman, skin, wall of uterus, and chorion reflected to show fetus with umbilical cord, and placenta. Female figure, in vivo, anterior view

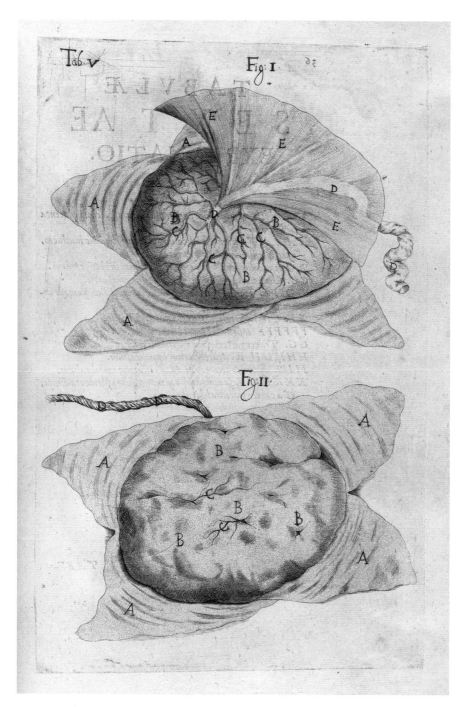

Placenta, fetal membranes, and umbilical cord, shown in isolation, in two numbered illustrations. One illustration includes the amnion

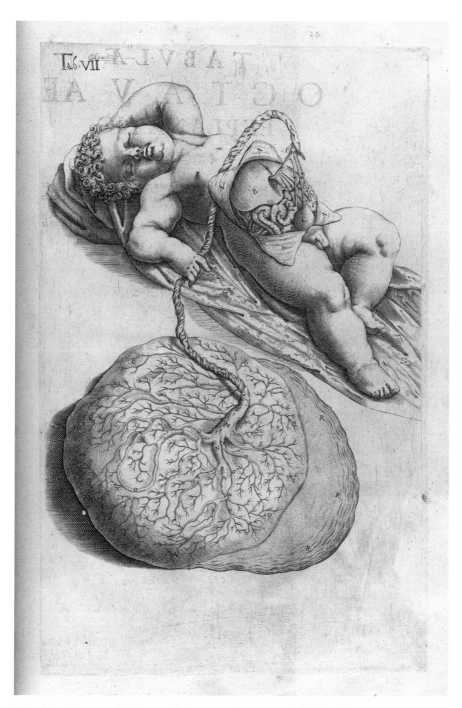

Blood circulation in the fetus and placenta, showing umbilical cord, umbilical arteries and veins, liver, urachus, and bladder. Male fetus, abdomen dissected to show circulation, lateral view

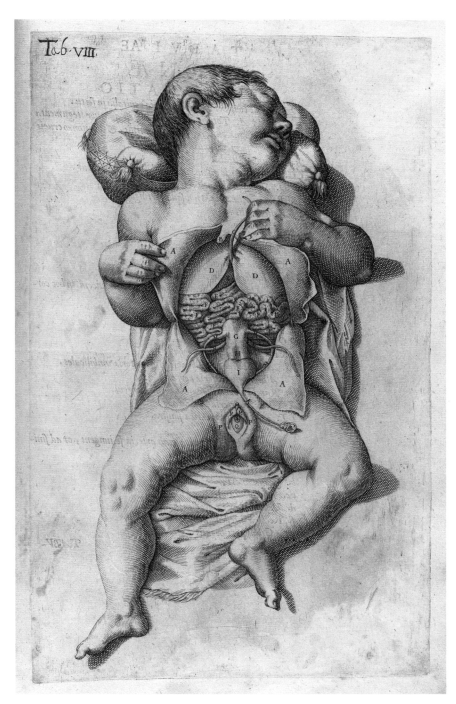

Urogenital organs of female fetus. Dissection of abdomen to show umbilical
cord, umbilical arteries, urachus, bladder, uterus, intestines, and liver

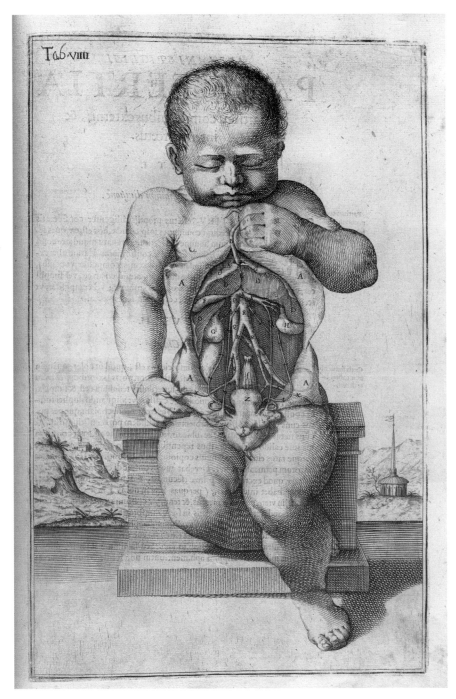

Urogenital organs of female fetus. Dissection of abdomen to show umbilical cord, umbilical arteries, bladder, uterus, intestines, kidneys, liver, and gallbladder. Aorta, inferior vena cava, renal arteries, iliac arteries, and veins also shown. Anterior view

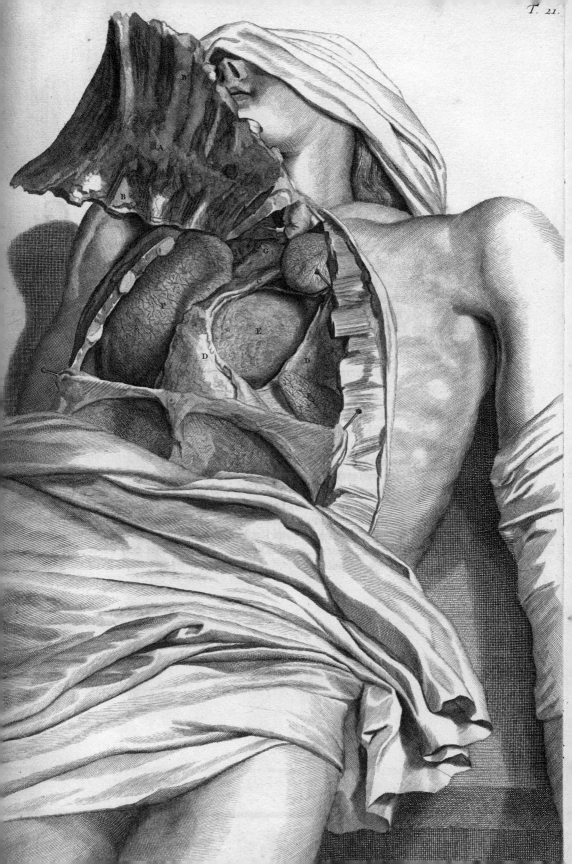

Govaert (Govard) Bidloo (1649–1713)
Gérard de Lairesse (1640–1711), drawings
Abraham Blooteling (1640–1690) and Peter van Gunst
(1659?–1724?), engravings

Ontleding des menschelyken lichaams
Amsterdam, 1690

William Cowper (1666–1709)
Henry Cook (1642–1700), drawings (new plates)
Michiel van der Gucht (1660–1725), engravings (new plates)

The Anatomy of Humane Bodies
Oxford, 1698

WE HAVE COME TO THE END of the seventeenth century, and are about to enter the dissecting room. In most of the illustrations that we have seen up to now, anatomists and their hired artists have labored to transfer their observations from the dissecting table to standing or seated figures in landscapes or rooms or simply posed to best display their viscera. The exceptions, such as Valverde's picture of a corpse dissecting another corpse (p. 24), seem to have been used as secondary visual devices to remind the viewer of the process by which the primary images were made. But, in addition to employing the traditional Vesalian figure-in-a-landscape, Govaert Bidloo is proud to show us his specimens as they looked on the table, pinned and tied to reveal anatomical form and structure. (The Dutch excelled at dissection and made many innovations in technique: the great Dutch physician Jan Swammerdam, a contemporary of Bidloo's, invented a way to inject specimens with a concoction of talc, white wax, and cinnabar, which highlighted and preserved details that otherwise collapsed into invisibility.) These are obviously still lifes, as remarkable in their way as the better-known pictures of flowers and fruit that are among the miracles of the Dutch Golden Age. Certainly in this case, while Bidloo may or may not have performed the dissections himself, credit for the illustrations must go largely to his artist, Gérard de Lairesse. Looking at his illustrations, one feels his intense effort to picture exactly what he sees, and his reluctance

Opposite: Dissection of the thorax, organs removed. Ribs divided and reflected to show thoracic cavity. Ribs, intercostal muscles, and spine shown. Antero-lateral view. From Bidloo, *Ontleding des menschelyken lichaams*

to dissipate that effort in further attempts to abstract it coherently.

Bidloo, born in Amsterdam, trained as an anatomist but also wrote plays and librettos in his youth. He was appointed Professor of Anatomy at The Hague in 1688, moving on to the university in Leiden in 1694, where he taught until his death, although he was often absent: he served a stint as personal physician to King William III of England, who was Dutch by birth.

Bidloo's most famous work, *Anatomia humani corporis* (*Anatomy of the Human Body*), a book of 107 copperplate anatomical illustrations, was published in 1685 in Amsterdam. The large book sold poorly, as did a Dutch edition (*Ontleding des menschelyken lichaams*) of 1690. It's possible that the relative paucity – and the mediocrity – of the plates showing musculature made the book unenticing for artists, while the "still life" style of depicting organs was not meaningful to physicians at a time when interest in the systematic study of anatomy was expanding.

Enter, now, William Cowper, distinguished London physician and member of the Royal Society. The Sussex-born Cowper had followed the typical career path of apprenticeship to a London surgeon, admittance into the London Company of Barber-Surgeons, and private practice; at the age of twenty-eight he had published a well-received book on the muscles. After the failure of the Dutch edition of Bidloo's *Anatomia,* Bidloo's publisher sold three hundred of the extra printed plates to Cowper, who used them, unattributed, in his 1698 *Anatomy of Humane Bodies* (although he did acknowledge "Figures Drawn After the Life by Some of the Best Masters in Europe"). Cowper's text was not plagiarized, and it was incisive. Cowper had even added some plates of his own (from which the selection reproduced here have been chosen), and it is possible, of course, that he was open with Bidloo's publisher about his intention to reuse Bidloo's illustrations in his own work.

Needless to say, however, Bidloo, who was notoriously irascible, was incensed, and in the war of pamphlets that ensued accused Cowper of plagiarism. Cowper countered with the absurd claim that Bidloo had purchased his plates from Swammerdam's widow and thus they were not his creation in the first place. Fortunately for both parties, pamphlets are a safer way to duel than sabers.

Both men were competent scientists. Bidloo argued correctly that nerves were not tubes, as his contemporaries believed. Cowper was the first to prove the existence of capillaries in higher mammals, to describe the essential physiology of aortic valvular disease, and to recognize the characteristics and consequences of heart disease.

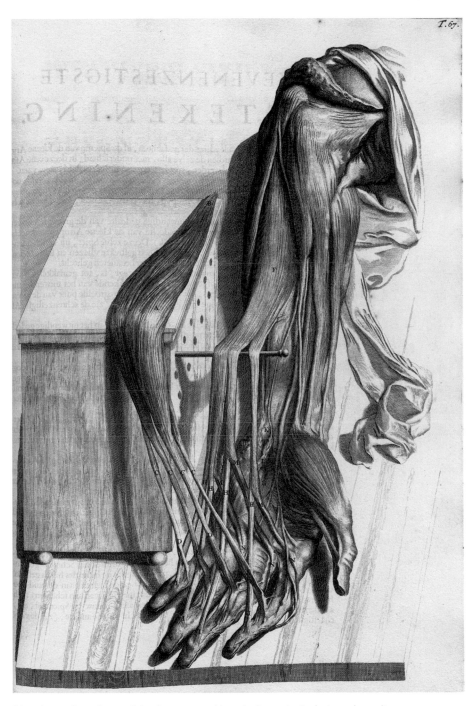

Muscles and tendons of the forearm and hand, shown in isolation, deep dissection. Hand shown supinated. Median nerve shown

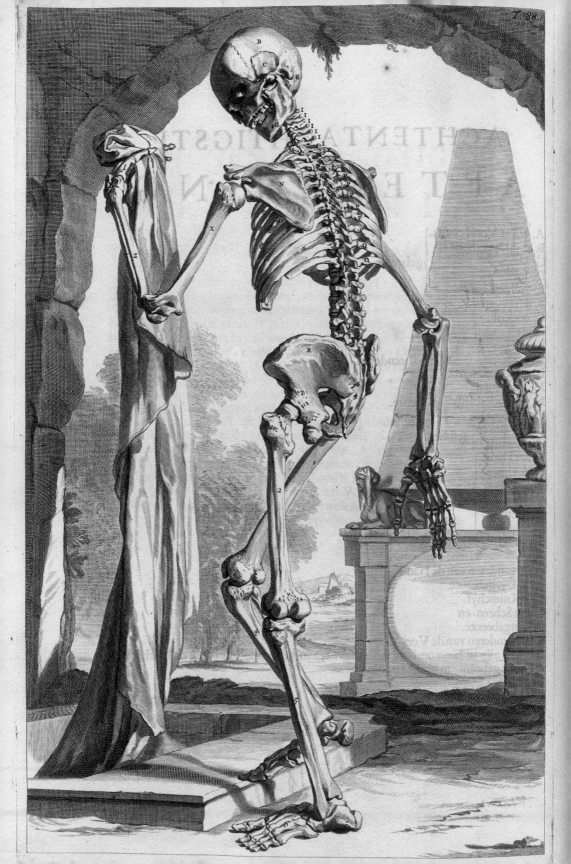

Skeleton of a full-term fetus, indicating fontanelles. Anterior view
Opposite: Skeleton emerging from the grave, postero-lateral view

Skull, mandible, and teeth, and hyoid bone, shown in isolation, in nine numbered illustrations. Skull with mandible, anterior view. Base of skull without mandible, inferior view. Mandible, anterior and lateral views. Hyoid bone, posterior view. Teeth, adult dentition, lateral and superior views, cross-sections shown

Bones of the hand, shown in isolation, in nineteen numbered illustrations.
Metacarpals and carpals shown assembled in anterior and posterior views.
Carpal bones shown each in isolation

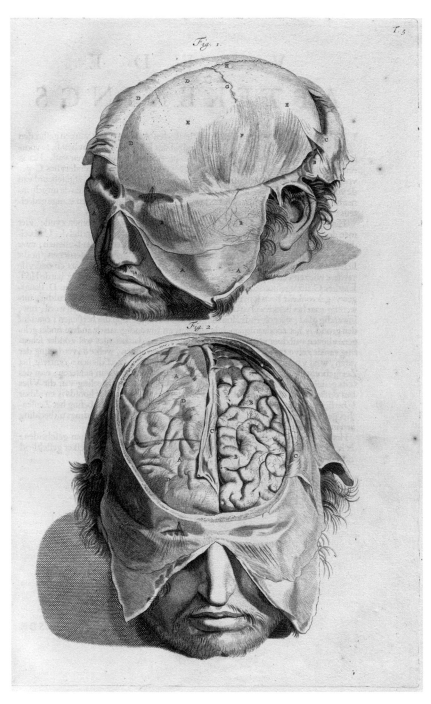

Dissection of the head and brain, in two numbered illustrations. Skin reflected to show skull and temporalis muscle, antero-lateral view. Skull cap removed to show dura mater in place; dura mater reflected on left side to show gyri. Anterior view

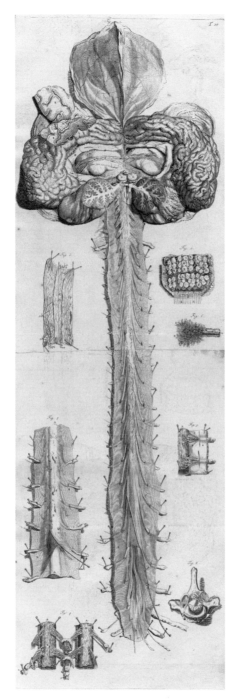

Spinal cord, with dura mater reflected to show spinal nerves, posterior view. Sections of the choid plexus, medulla oblongata, and spinal cord shown in isolation. Dissection of a nerve and the surface of the brain viewed under a microscope. First thoracic vertebra, inferior view

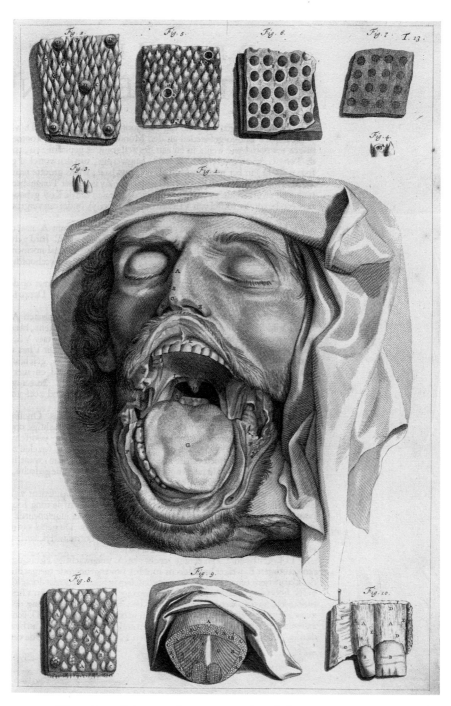

Dissection of the mouth, in ten numbered illustrations. Structures of the mouth shown in situ, partly dissected, showing palate, gums, and teeth, and tongue. Sections of the surface of the tongue, viewed under a microscope, showing papillae. Section of the gums, viewed under a microscope. Cross-section of the tongue, showing the muscles

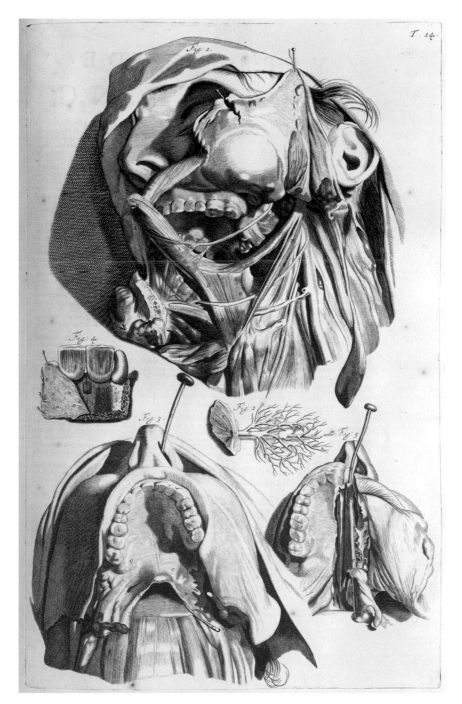

Dissection of the mouth and pharynx, deep dissection, in five numbered illus-
trations. Dissection shows neck muscles, pharyngeal muscles, carotid artery,
trigeminal nerve (cranial nerve V), palate, teeth, and tongue, lateral and infe-
rior views. Section of the palate with central incisors shown in isolation.
Salivary duct shown in isolation. Palate dissected to show nasal concha.
Inferior view

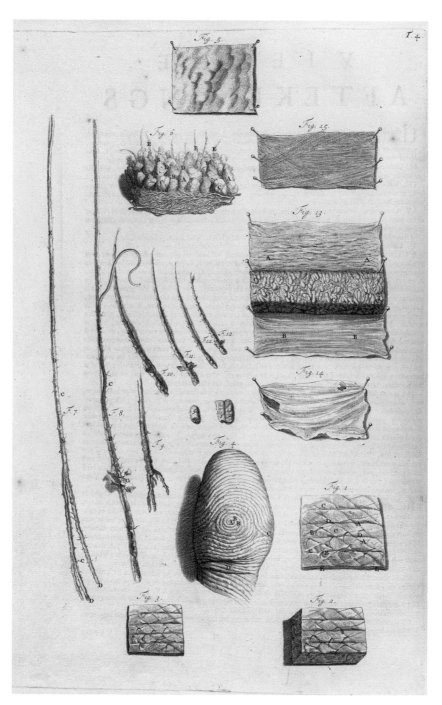

Epidermis and dermis, in eighteen numbered illustrations. Skin shown in blocks, hairs shown in isolation. One illustration of fingertip, enlarged to show fingerprint

Opposite: Eye, shown in situ and in isolation, in twenty-four numbered illustrations. External eye, in life and dissected. Dissection of the eye in isolation, showing sclera, oculomotor muscles, lacrimal glands, lens, and vitreous humor

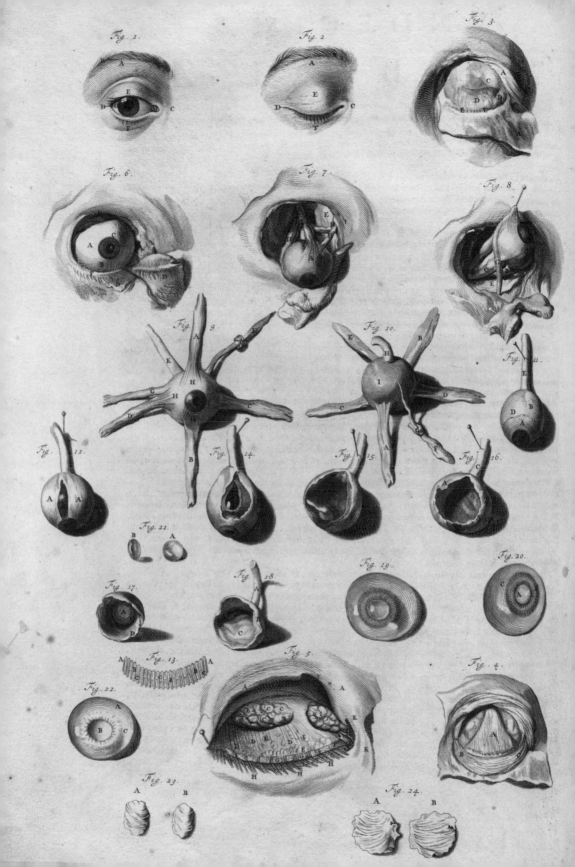

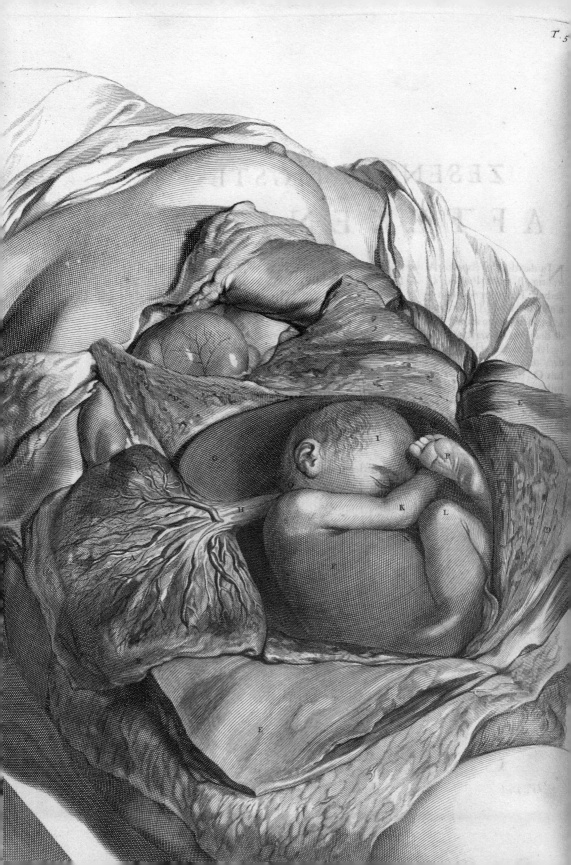

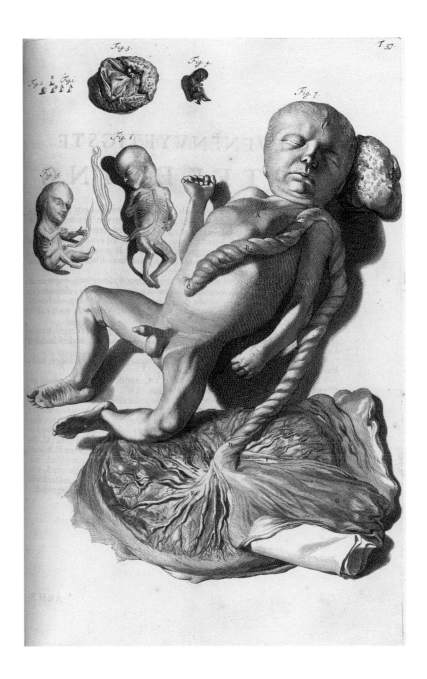

Ovum, fetus, fetal membranes, placenta, and umbilical cord, shown in isolation, in seven numbered illustrations. Ovum shown fertilized and unfertilized. Fetus shown at twenty-five days gestation with placenta, membranes, and umbilical cord. Male fetus shown at forty days gestation and ten weeks gestation with umbilical cord. Male fetus shown at eight months gestation with placenta, fetal membranes, and umbilical cord. Anterior and lateral views *Opposite*: Abdominal organs, uterus, placenta, and fetus of a pregnant woman, shown in situ. Uterus dissected to show the placenta and fetus. Antero-lateral view

Fig: 1.

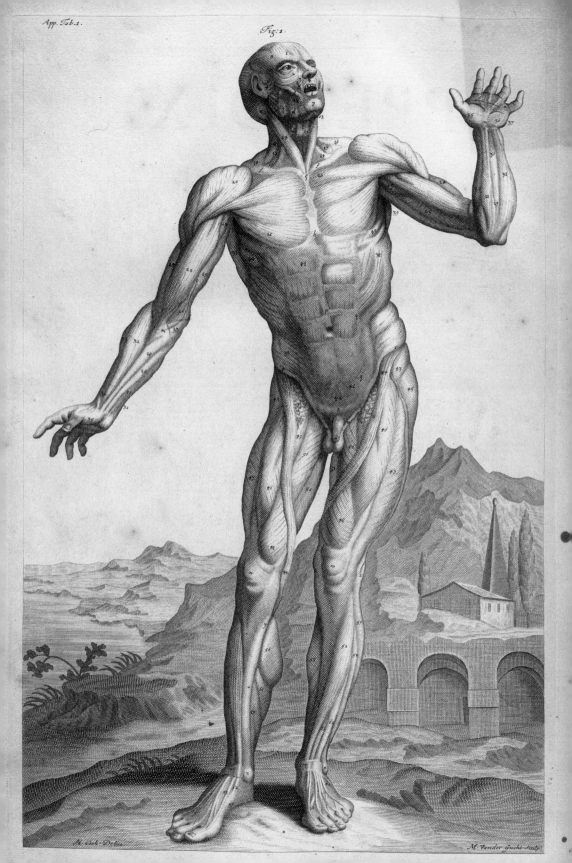

A. Schÿnevoet Delin.

M. Vander Gucht Sculp.

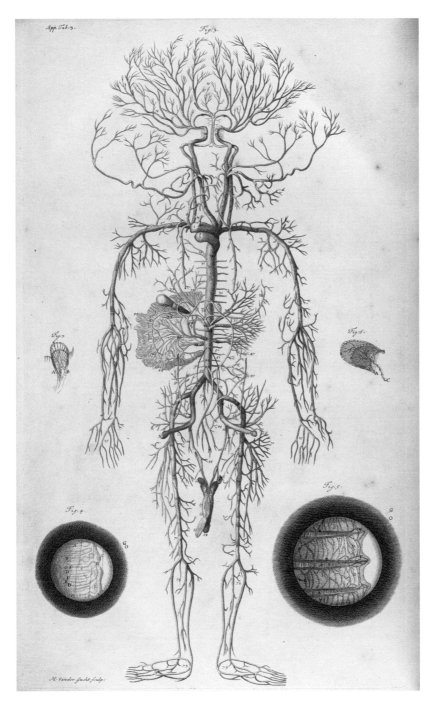

The circulatory system.
Opposite: Muscles of the body, superficial dissection. Male figure, in vivo, anterior view

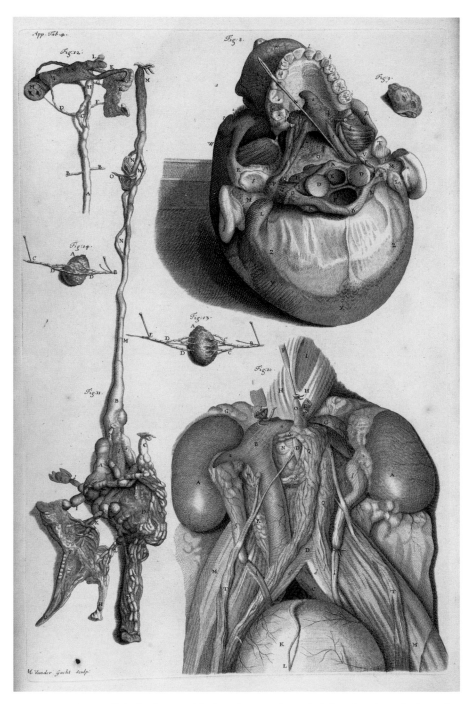

Base of skull, shown with the atlas vertebrae, inferior view. Lymphatic nodes and ducts, thoracic duct, tonsil, shown in isolation, in five numbered illustrations. Abdominal organs, shown in situ; diaphragm, kidneys, adrenal glands, ureters, bladder, and inferior vena cava. Anterior view

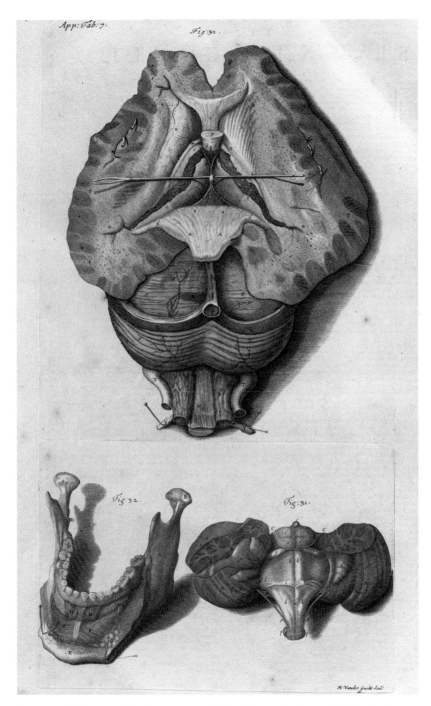

Fig: 30.

Fig: 32.

Fig: 31.

M: Vander Gucht Scul:

Brain, cerebellum, and brainstem; mandible with teeth, shown in isolation, in three numbered illustrations. Brain in transverse cross-section to show ventricles, fornix, sinuses, superior view. Brainstem and cerebellum shown in isolation, with pineal gland, corpora quadrigemina, anterior view. Mandible with fragment of ligament attached and reflected, adult dentition. Supero-lateral view

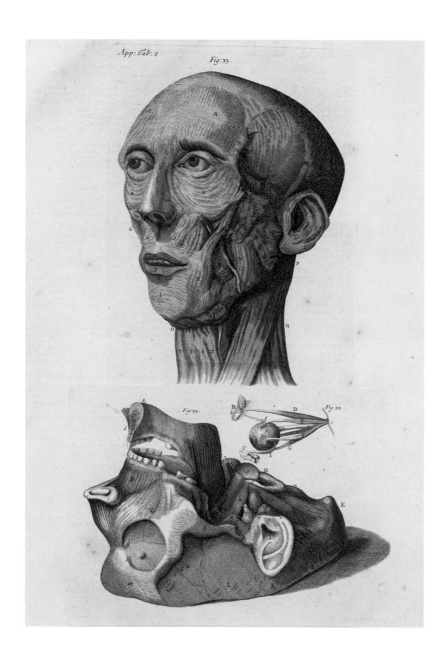

Facial muscles, masticatory muscles, neck muscles, oculomotor muscles, in three numbered illustrations, printed from two plates. Head and neck shown with skin removed, antero-lateral view. Masticatory muscles shown on dissected head, displayed upside down, lateral view. Inset illustration of oculatory muscles with eye, lateral view

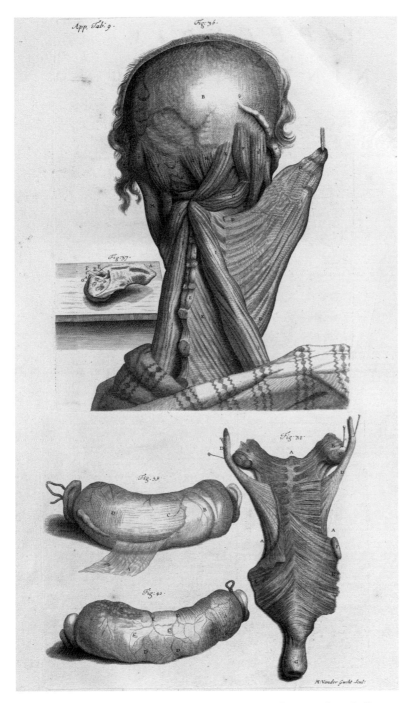

Neck muscles, pharyngeal muscles, intestines, in four numbered illustrations, printed from two plates. Neck muscles, deep dissection, posterior view. Pharyngeal muscles, shown in isolation, anterior view. Sections of the intestines, duodenum, and jejunum shown

The Anatomy of Humane Bodies • 151

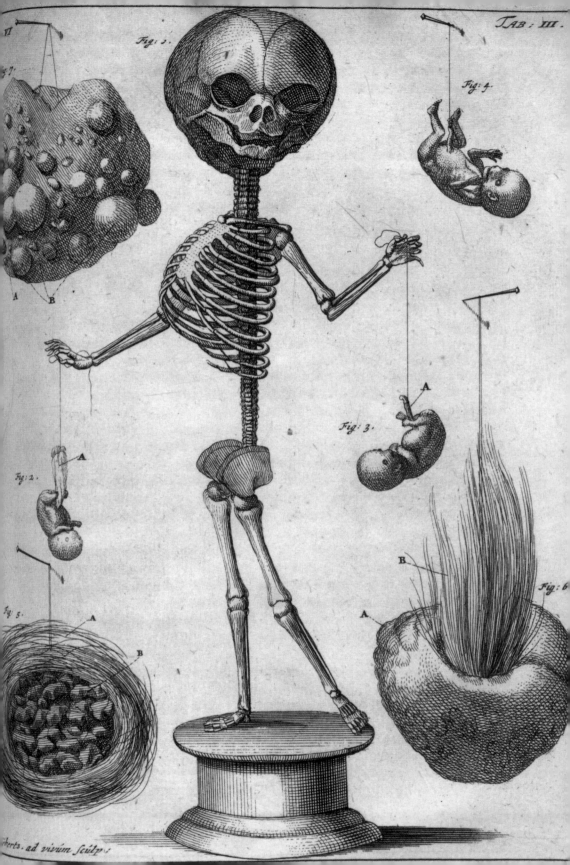

TAB: III

Fig: 1.

Fig: 4.

Fig: 7.

A B

Fig: 3.

A

Fig: 2.

A

B

Fig: 5.

A

B

A

B

Fig: 6.

...berts. ad vivum sculp:

Frederik Ruysch (1638–1731)
Cornelis Huyberts, engravings

Thesaurus anatomicus primus
Amsterdam, 1701–1716

IN THE CULTURAL MILIEU that encouraged Bidloo to illustrate his dissections as still lifes of specimens on a dissecting table, it was a short leap to the collection and display of actual specimens themselves. Frederik Ruysch might have been considered slightly odd in any society, but his preoccupations would have seemed far more natural in baroque Holland than they would in today's world, where he might uncomfortably remind people of the villain in a Thomas Harris thriller.

Ruysch's medical career was conventional enough, combining two by-now familiar strands of accomplishment: the teaching of anatomy at a professional level (in his case, for the Amsterdam Surgeon's Guild) and attendance on royalty. Ruysch's appointment to the court appears to have abetted his extracurricular interests, since it afforded him access to cadavers of executed criminals and victims of infanticide.

It was however, more as a collector of the rare and the marvelous than as a physician that Ruysch made his mark on history. Like Swammerdam, he advanced the art of dissection; he perfected an embalming liquid (black pepper was one ingredient) to better-preserve his specimens, the recipe for which he kept secret in the spirit of an artist rather than a scientist. Frequently, he composed his delicate specimens in assemblages oddly premonitory of the work of the contemporary English artist Damien Hirst. These he exhibited in his own private museum in his house in Amsterdam, and eventually his collection became famous and was dispersed chiefly into royal collections in Russia and Poland.

Thesaurus anatomicus is a catalogue of this unusual collection. Three memorable plates illustrate assemblages of fetal skeletons standing on rock formations made up of kidney, bladder, and gall stones. Ruysch's daughter, Rachel, embroidered lace garments for his preserved infants.

Opposite: A fetal skeleton, carrying fetuses suspended on strings, surrounded by calculi and other artifacts from Ruysch's collection

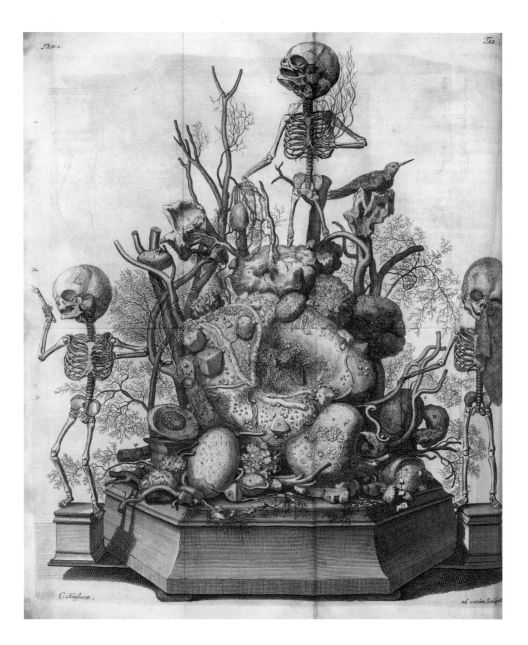

A composition of fetal skeletons with vascular trees, in which a small bird is perched. The uppermost skeleton, that of a four-month female fetus, holds a string of pearls in her hand. The skeleton on the left holds a miniature scythe. The skeleton on the right is holding a string of calculi, and weeps into a mesentery. The captions associated with this plate express the transitory and miserable nature of life. They include: *Cur ea diligere velim, quae sunt in mundo?* ("Why should I long for things that are of this world?"); *Homo natus de muliere, brevi vivens tempore, repletur multis miseriis* ("Man that is born of woman lives but a short time and is full of misery"); and *Nec parcit imbellis juventae poplitibus* ("Death does not spare even innocent youth").

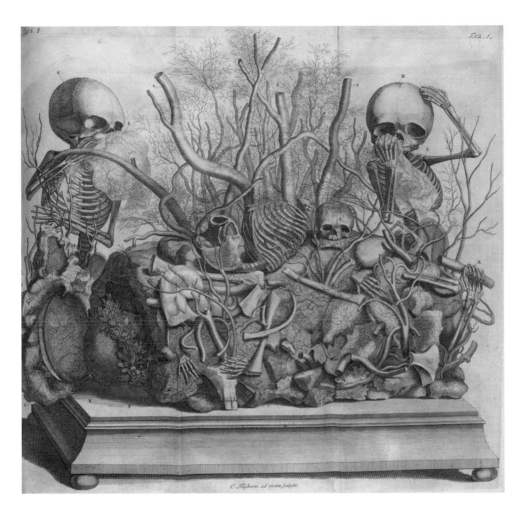

A composition of dried human and bovine tracheas and bronchial tubes, set between a pair of twins who are sobbing into mesentery or chorion "handkerchiefs" with delicate patterns of blood vessels

Nipple and milk ducts of a woman and a whale, shown in isolation, in nine numbered illustrations

Opposite: Eye of a whale and a human, shown in isolation, in nine numbered illustrations. Dissection of the sclera shown

Fig. 1.

Fig. 2.

Fig. 3.

Fig. 4.

Fig. 5.

Fig. 6.

Fig. 7.

Fig. 8.

Fig. 9.

C: Huyberts. ad. vivum. Sculpsit.

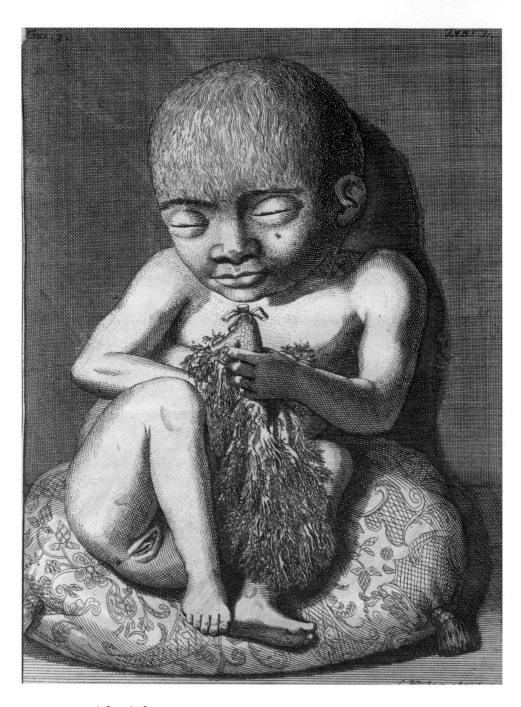

A female fetus
Opposite: Arm, shown preserved in a jar

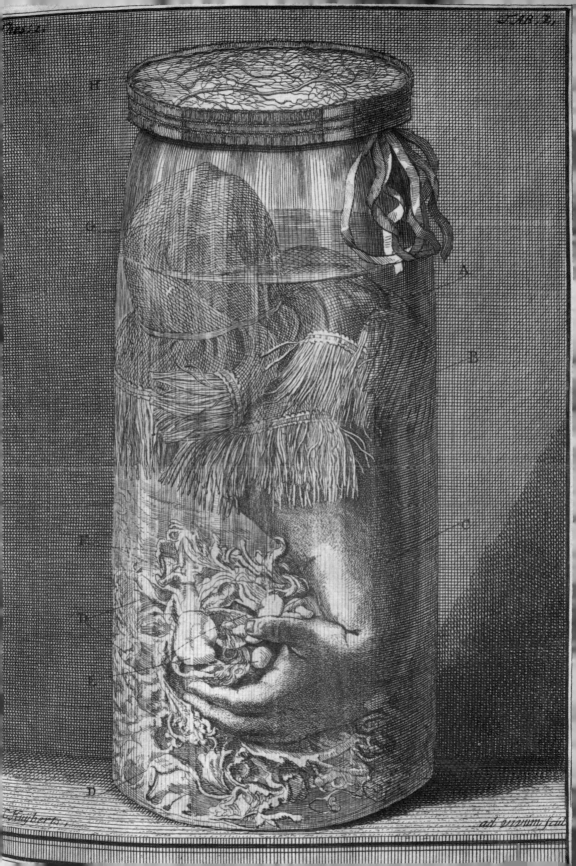

Tab. 2.

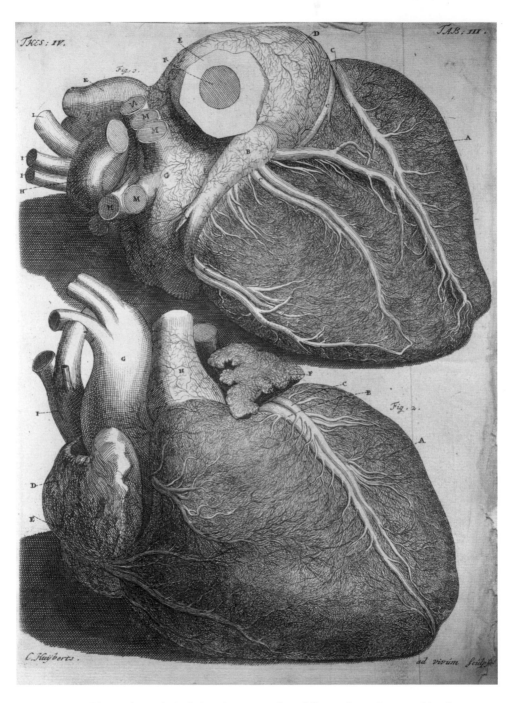

Heart, shown in isolation, in two numbered illustrations. Coronary blood vessels shown. Anterior and posterior views

Uterine lining, teeth and lips, prolapsed uterus, section of the esophagus of a tortoise, and the genitalia of a hermaphrodite. Shown in isolation, in five numbered illustrations

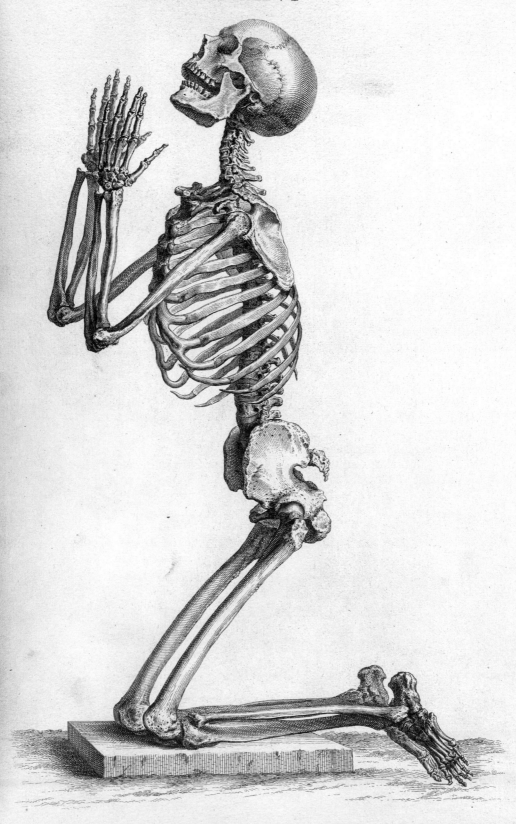

William Cheselden (1688–1752)
Gerard Van der Gucht (1696–1776) and Mr. Shinevoet (d. before 1733), engravings

Osteographia, or the Anatomy of the Bones
London, 1733

WILLIAM CHESELDEN, from Leicestershire, was William Cowper's most distinguished anatomy student. Like his teacher, he was admitted to the London Company of Barber-Surgeons and subsequently was elected to the Royal Society. He was a pioneer of modern surgical practice, a specialist who invented a successful technique to remove bladder stones, an operation called a lithotomy. Cheselden was said to be so fast and confident with a knife that he could remove a stone in less than a minute. It was said that more than ninety percent of his patients survived in an age when only ten percent survival was the norm.

He was a serious student of anatomy – that he know where to cut certainly improved the chances of his patients – at a time when barber-surgeons had little formal training. Cheselden broke with this tradition and set up a private anatomy school for the training of surgeons, which led to his estrangement from the London Company. But it was to be the wave of the future, as private medical academies proliferated in London to be the bridge between the time-honored apprenticeship/guild system and modern medical school method of training physicians.

In 1733, Cheselden published *Osteographia, or the Anatomy of the Bones,* illustrating human and animal skeletons in a spirit of both scientific exactitude and play. A beautiful book with copperplate images, it shows the bones of the human body lifesize, "and again reduced in order to shew them united to one another." Cheselden's team used a camera obscura – a device that projects the image of a three-dimensional object onto a two-dimensional surface – to draw many of the bones, and illustrated the device on the book's title page (above). As we shall see over and over again, anatomical illustration pushes visual artists to use innovative techniques for the precise rendering of three-dimensional objects on paper.

Opposite: The skeleton of "a very robust man" kneeling in prayer

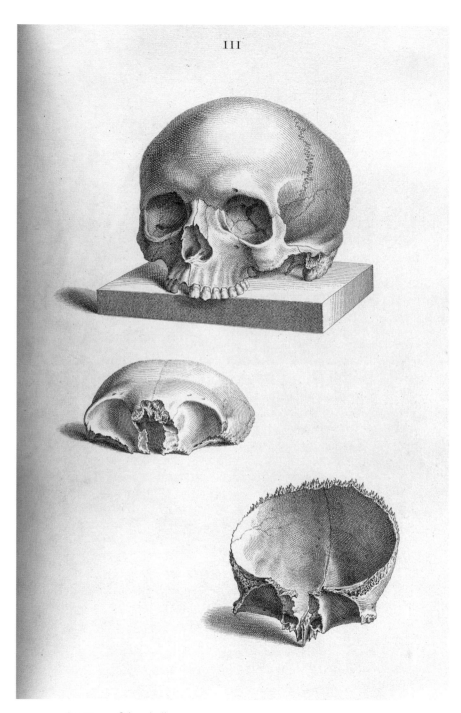

Sections of the skull

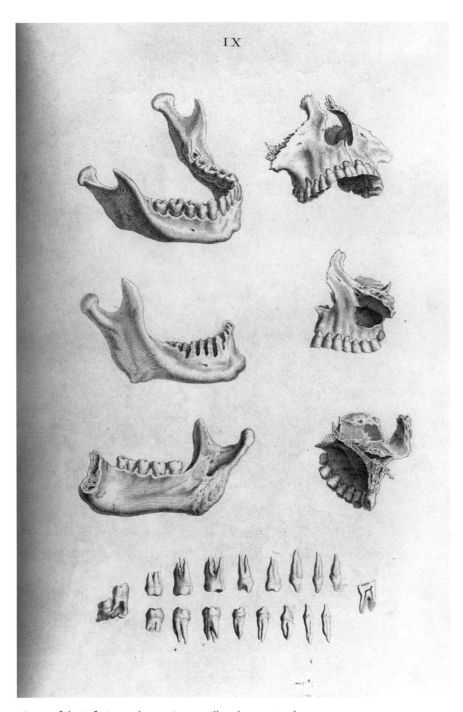

Views of the inferior and superior maxillary bones; teeth

X

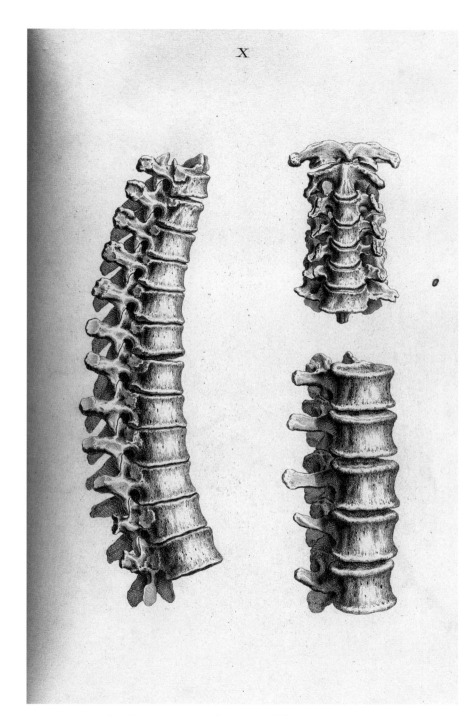

Lateral and anterior views of sections of the spine
Opposite: Eleven views of individual vertebrae

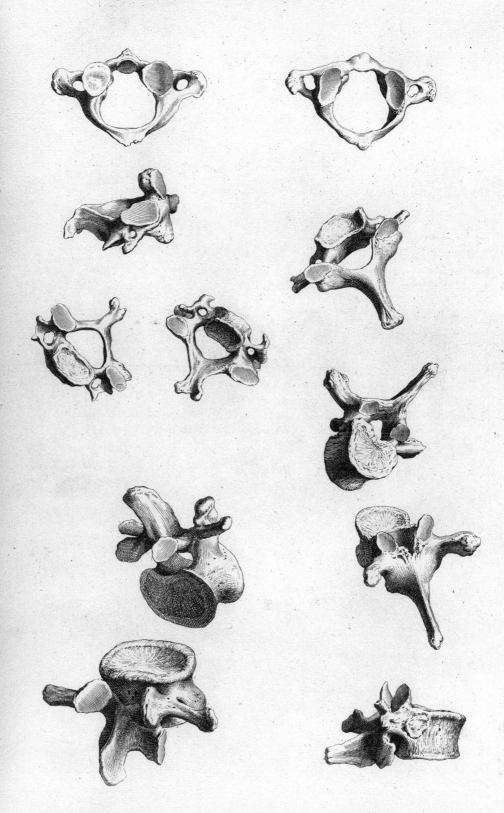

Thorax, clavicle, sternum, vertebrae, and pelvis. Anterior view

XX

Thorax, vertebrae, and pelvis. Posterior view

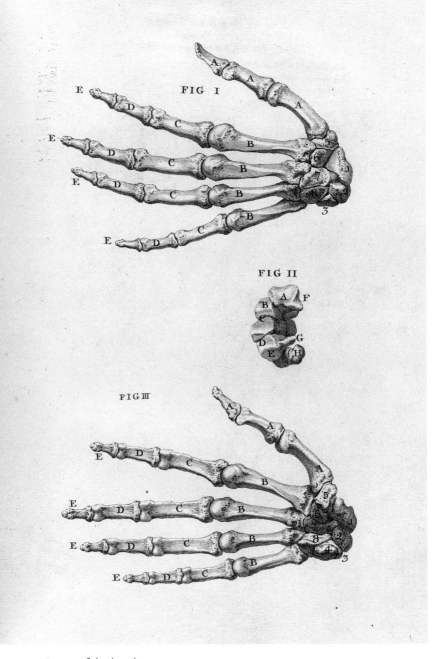

Bones of the hand

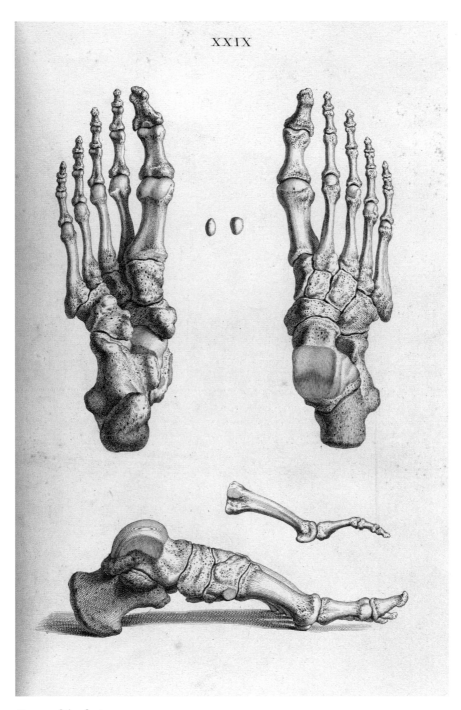

Bones of the feet

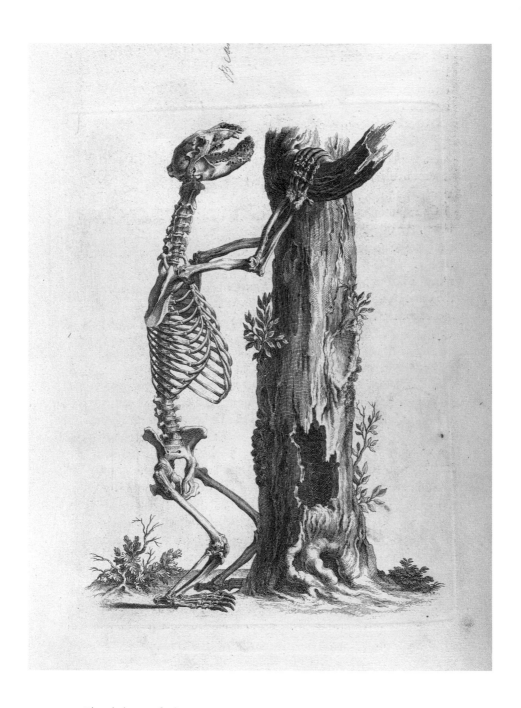

The skeleton of a bear
Opposite: The skeleton of a nine-year-old boy leaning on a horse's skull

Above and opposite: Skeletons of children, in vivo, in landscapes

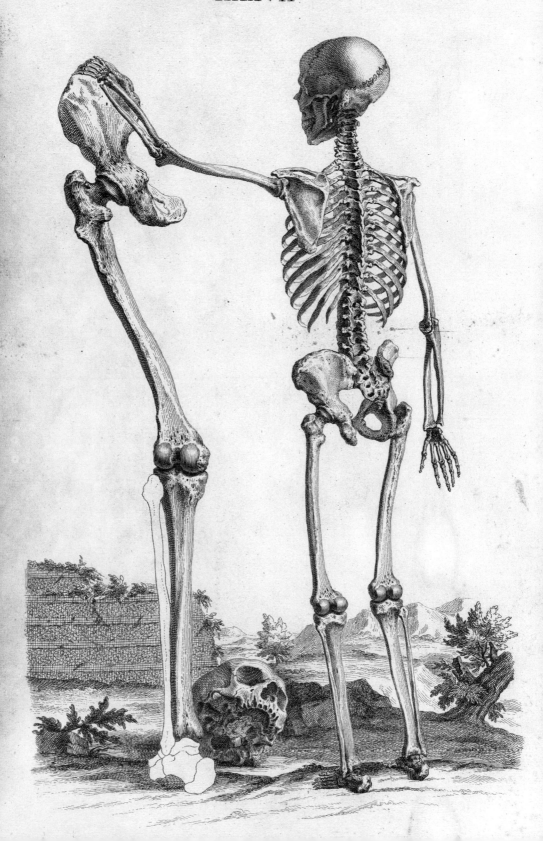

TAB. I.

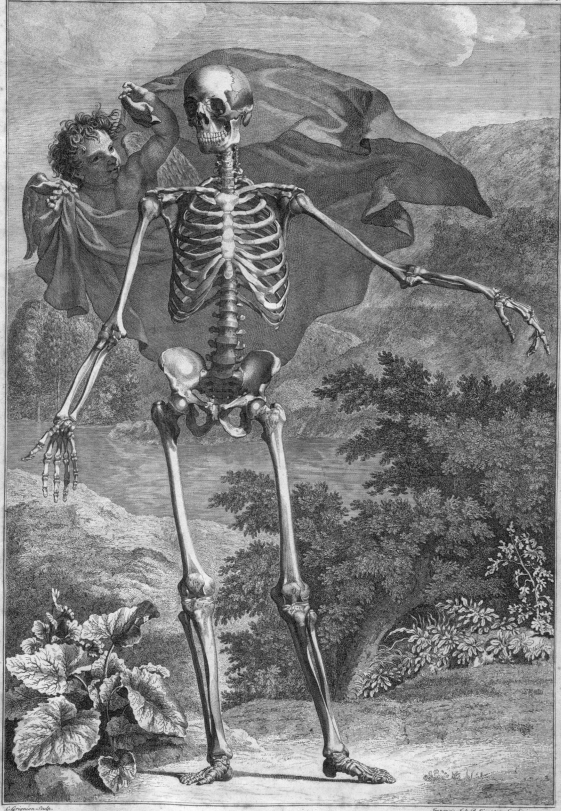

C. Grignion Sculp.

Impensis J. & P. Knapton Londini. 1747.

Bernard Siegfried Albinus (1697–1770)
Jan Wandelaar (1690–1759), artist

Tabulae sceleti et musculorum corporis humani
Leiden, 1749

IF THE UNIVERSITY OF PADUA was the world center of anatomy studies in the late sixteenth century, the University of Leiden in Holland had taken its place a century later. As we have seen, the art and science of preparing and preserving anatomical specimens was significantly advanced in seventeenth-century Holland. Once again, professional lineage is revealing: Ruysch perfected the techniques invented by Swammerdam; Bidloo was a student of Ruysch; and the Frankfurt-born Bernard Siegfried Albinus studied under Bidloo at Leiden, where he was appointed professor of anatomy and surgery in 1721 and remained until his death.

With Albinus, the study of human anatomy and its illustration entered a new phase of precision and analysis. His recognition that anatomy involved the comparative study of many subjects necessarily required a higher degree of disciplined abstraction than any anatomist had achieved previously: "It does not suffice," he wrote, "to search the body and reveal its composition like a carpenter dismantling a house with care, but just as the architect knows the structure through and though." Just so; anatomical illustration was for Albinus not a question of acute observation alone, but of observation guided by a deep knowledge of form and function, and buttressed by exact measurement.

His masterwork, published in 1747 in Leiden, was called *Tabulae sceleti et musculorum corporis humani* (*Tables of the skeleton and muscles of the human body*). Working with the artist Jan Wandelaar, he took some eight years to produce its forty large copperplates. Like Cheselden, Albinus was not content to rely on traditional draftsmanship ("not a single picture has been drawn freehand"). Instead of using a camera obscura, however, he and Wandelaar devised a technique of placing nets with square webbing at specified intervals between the artist and the subject, to help avoid distortion in rendering.

It seemed odd to Albinus's critics that this paragon of scientific method permitted Wandelaar to place his figures in cluttered naturalistic settings, in an anachronistic return to the Vesalian tradition of the anatomical figure-in-a-landscape. The anatomist was fierce in defense of his artist, however, maintaining that the environments improved the tonal balance of the figures themselves. Who today would dare argue with him?

Opposite: Skeleton, anterior view

TAB. I.

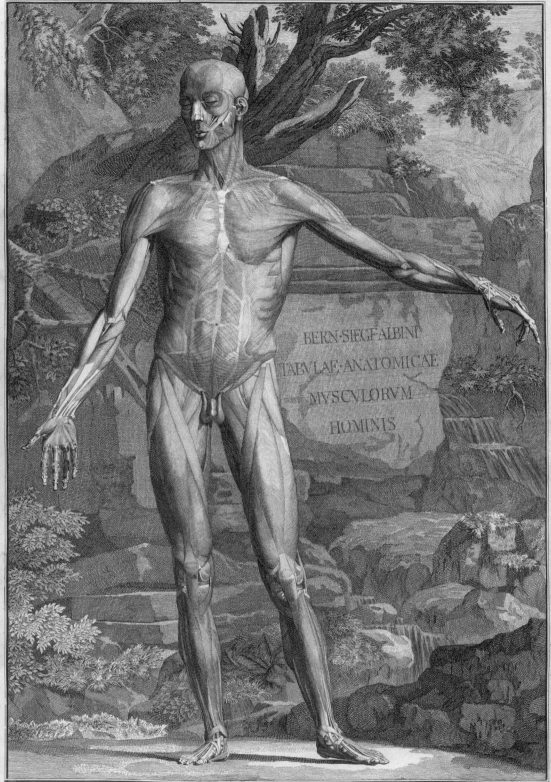

G. Scotin Sculp.

Impensis J. & P. Knapton Londini. 1747.

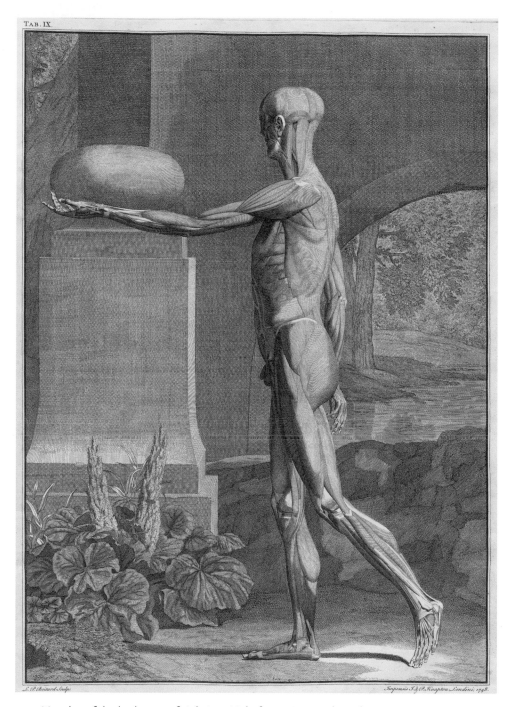

TAB. IX.

Muscles of the body, superficial view. Male figure, in vivo, lateral view
Opposite: Muscles of the body, superficial view. Male figure, in vivo, anterior
view

Tabulae sceleti et musculorum corporis humani • 179

TAB. II.

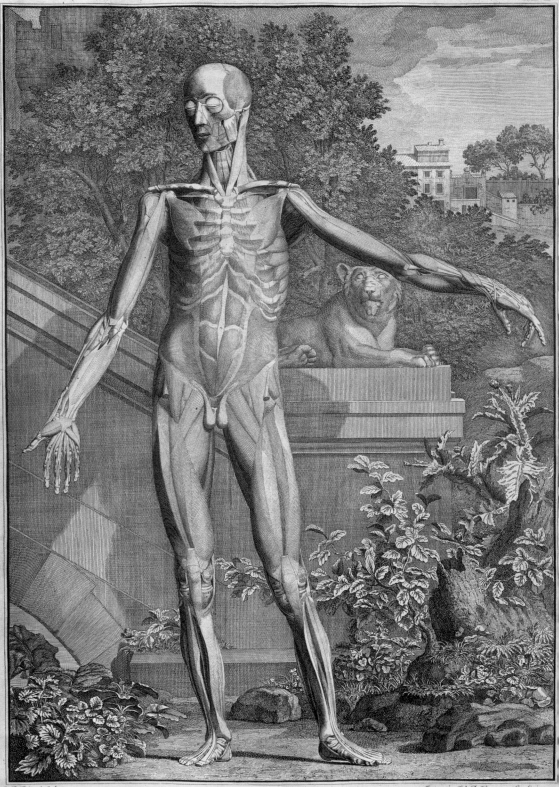

L. P. Boitard Sculp. Impensis J. & P. Knapton Londini. 1747.

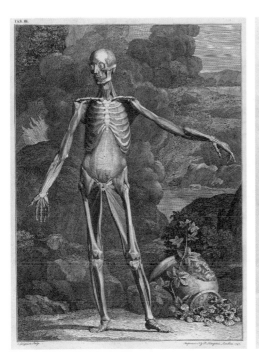
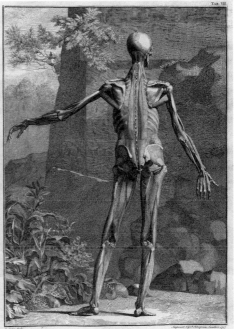

Above left: Muscles of the body, deep dissection. Ribs, intercostal muscles, femur, and tibia shown. Male figure, in vivo, anterior view

Above right: Muscles of the body, deep dissection. Skull, ribs, and intercostal muscles, scapula shown. Male figure, in vivo, posterior view

Opposite: Muscles of the body, superficial dissection. Male figure, in vivo, anterior view

Tabulae sceleti et musculorum corporis humani ● 181

TAB II.

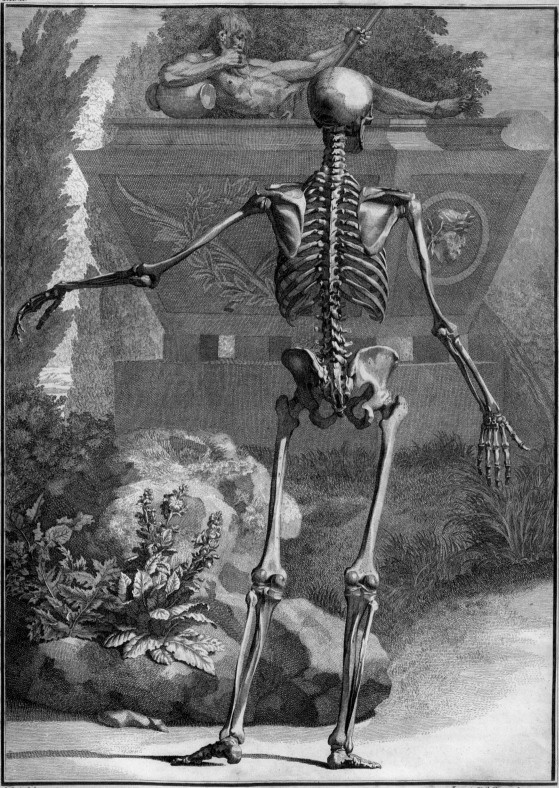

G. Scotin Sculp.

Impensis J.&P. Knapton Londini. 1747.

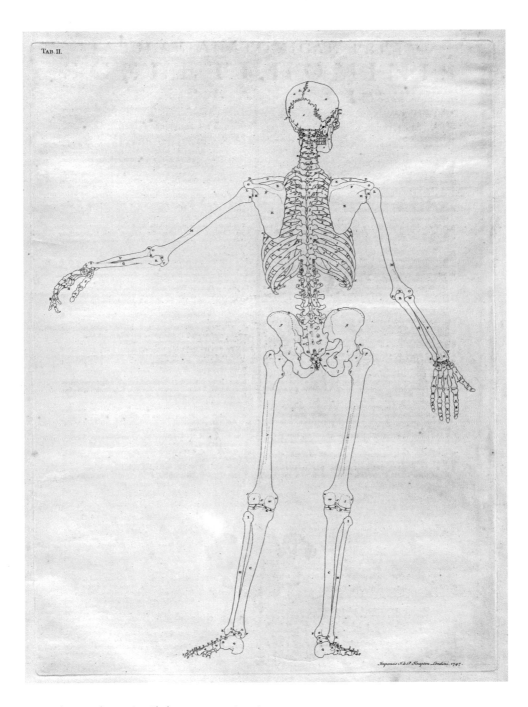

TAB. II.

Above and opposite: Skeletons, posterior views

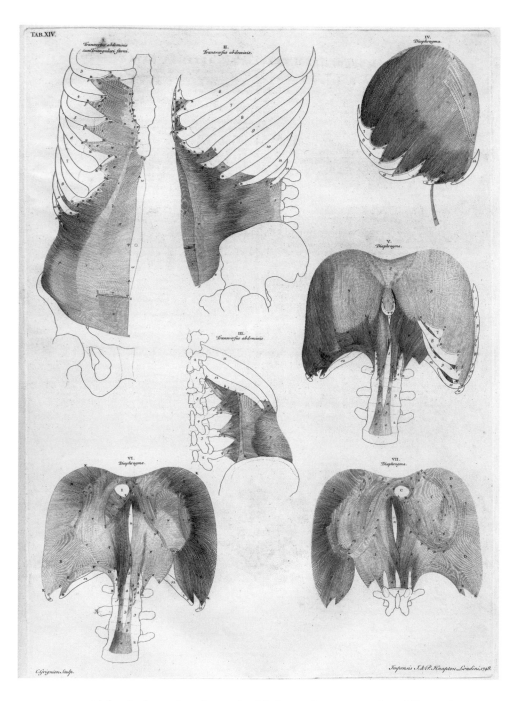

Abdominal muscles, ribs, and pelvic bones, in seven numbered illustrations. Transverse abdominus muscle, and diaphragm shown. Ribs, pelvic bones, and spine indicated

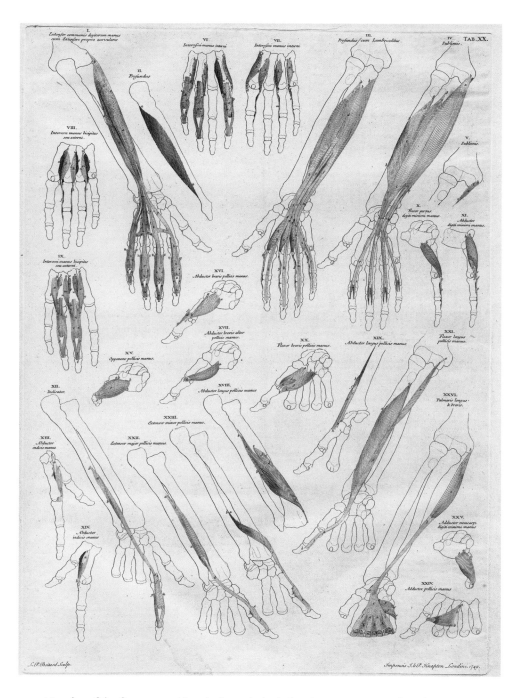

Muscles of the forearm and hand, shown in isolation, in twenty-six numbered illustrations. Radius, ulna, carpal bones, and metacarpus indicated. Hands shown pronated and supinated

Jacques Fabian Gautier d'Agoty (1717–1785)
assisted by Jacques-François-Marie Duverney (1661–1748) and Antoine Mertrud (d. 1767)

Anatomie générale des viscères en situation
Paris, 1752

COMING AFTER THE EXQUISITE and scientifically impeccable work of Albinus, the anatomical illustrations of Jacques Fabian Gautier d'Agoty appear crude. Indeed, they are included here not because they signal an advance in the anatomist's art, but because they were printed mechanically in color. Furthermore, they are among the first copperplate illustrations of any sort to have been printed in color.

Gautier d'Agoty was born in Marseille. He trained as an artist under master printmaker Jacob Christoph Le Blon, who invented colored mezzotinting, a process that used three plates – one for blue, one for yellow, and one for red ink – to form an image. Gautier d'Agoty claimed to have invented the colored mezzotint himself after Le Blon's death, but in reality he only added a fourth impression in black ink. This brought the process closer to the four-color process still widely in use for printing colored images in ink, but his own prints were not discernably better than Le Blon's.

That Gautier d'Agoty employed this process to publish large and somewhat shocking anatomical atlases reminds us that throughout the centuries, anatomists, artists, and publishers have viewed human anatomy as a potentially lucrative subject for expensive books. More often than not, they were disappointed. Gautier d'Agoty had no medical training; he found a collaborator in surgeon Jacques-François-Marie Duverney, but the illustrations they made were neither anatomically correct nor useful to physicians. After Duverney's death, Gautier d'Agoty produced his huge *Anatomie générale,* with its bold, dramatic, and very colorful illustrations. Ever the showman, he distributed many of his full figures over three plates, so that the reader could remove them from the book and assemble them into even bigger images. This suggests that he also sold them separately.

Goethe, writing about Gautier d'Agoty's color theories, called him, "an active, quick, rather impulsive man, certainly gifted, but more than befittingly aggressive and sensational."

Opposite: Skeleton and nervous system, anterior view, left; muscles in deep dissection with circulatory system, posterior view, right

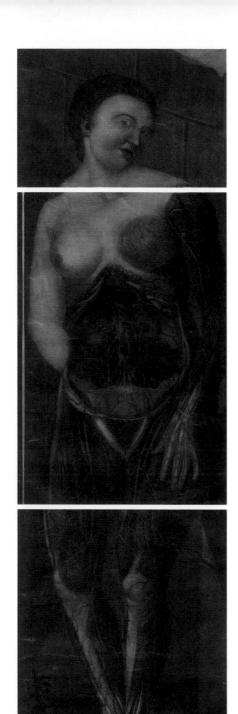

Muscles, blood vessels, and viscera. Female
figure, in vivo, anterior view
Opposite: A detail of the same illustration

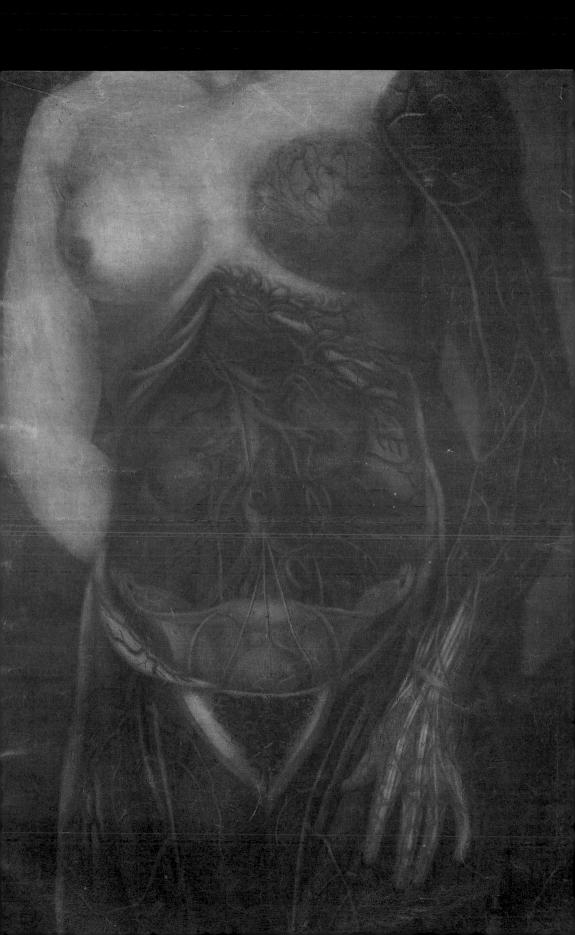

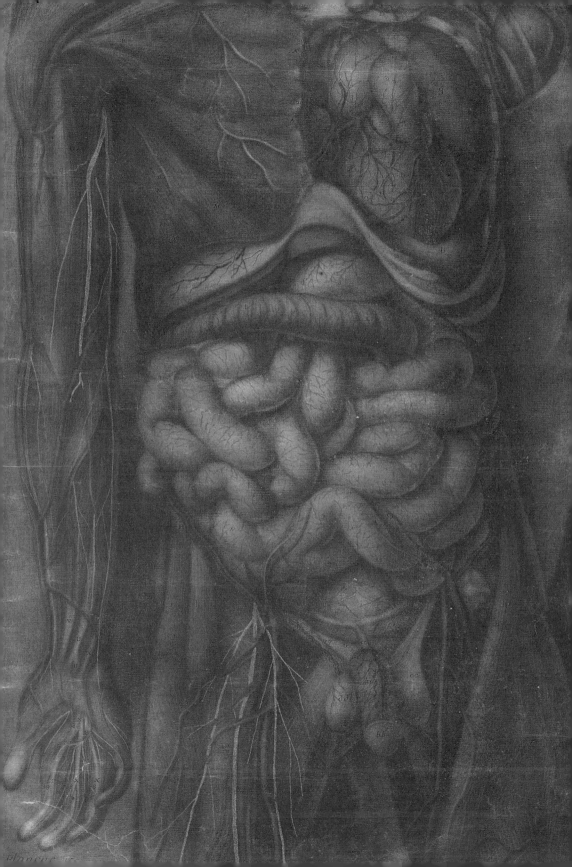

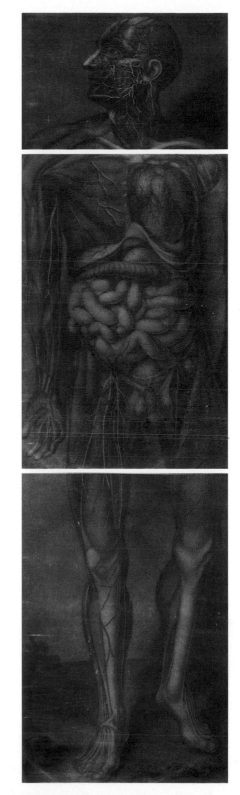

Muscles, blood vessels, and viscera. Male figure, in vivo, anterior view
Opposite: A detail of the same illustration

Male urogenital organs, shown in isolation

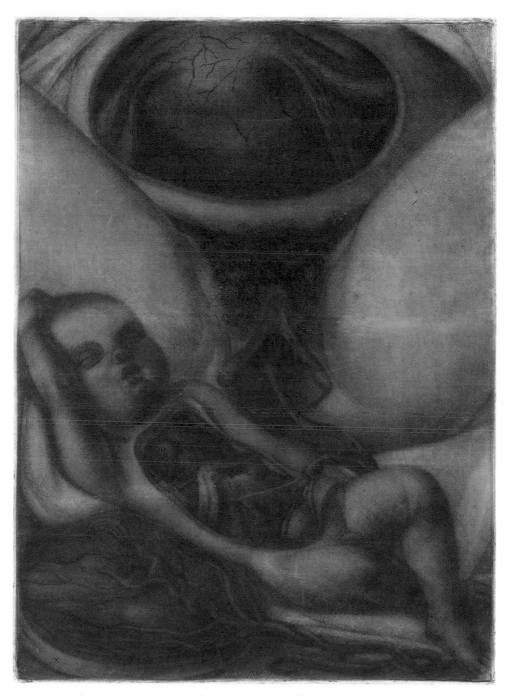

Dissection of the womb of a new mother and the torso of her new-born child.
Antero-interior view

TAB. X

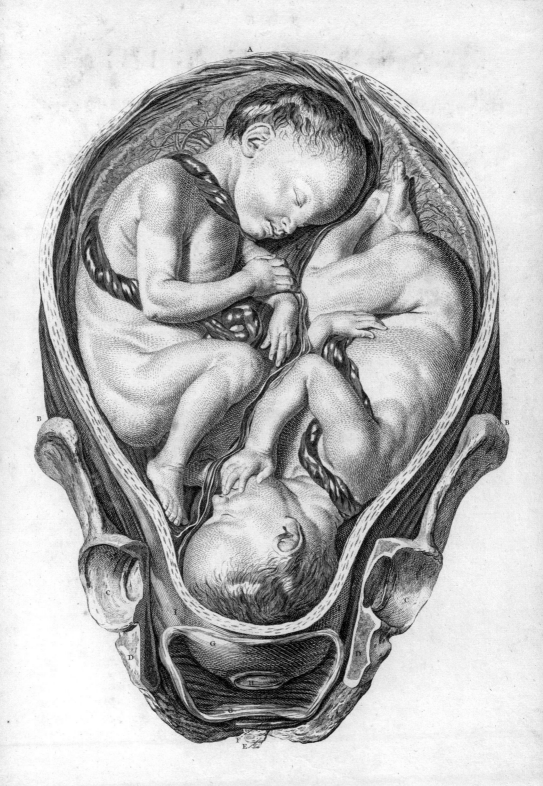

William Smellie (1697–1763)
Jan van Rymsdyk (fl. 1750–1788), Petrus Camper (1722–1789), and Smellie [?], drawings; Charles Grignion (1717–1810), engravings

A Sett of Anatomical Tables, with Explanations, and an Abridgment, of the Practice of Midwifery
London, 1754

William Hunter (1718–1783)
Jan van Rymsdyk (fl. 1750–1788) and others, artists

The Anatomy of the Human Gravid Uterus Exhibited in Figures
Birmingham, 1774

WILLIAM SMELLIE AND WILLIAM HUNTER, two Scottish pioneers of obstetrics, created marvelous atlases of pregnancy and fetal development. Their work marks a significant watershed in the history of the care of pregnant women, when the medical discipline of obstetrics began to take shape against the time-honored lore of midwifery. That they should have developed this specialized knowledge surely has much to do with the growing prestige of medicine as a profession in their day, a development to which both contributed; the explosive population growth of London in the late eighteenth century; a growing societal attitude toward infant mortality as something that could be remedied; and the existence of a class of female patients that sought out professional medical care for normal life experiences. Even today, the clinical realism of their anatomical illustrations causes discomfort in some viewers. These images convey an almost touching faith in the power of direct observation to combat popular misconceptions and lore, but there is no denying that they evoke the dissecting table more than the lying-in bed. Perhaps the best way to view them is in the spirit of one of the students of Smellie's popular London lectures for midwives and medical students, who described his attitude as "distinct, mechanical, and unreserved."

William Smellie, the older of the two, was a small-town practitioner in Lanark, Scotland, until he joined the medical school in Glasgow as a professor of midwifery. (In regard to the status of midwifery in his day, it is worth noting that Smellie joined the Glasgow

Opposite: Gravid uterus with twin fetuses during labor, shown in isolation with placentas, amnion, pelvic bones, and vagina. Pelvic bones divided to show cervix dilated approximately 2 cm. Anterior view

faculty in that discipline in 1733 and only received his medical degree there in 1745.) He moved to London, where Hunter was to become one of his students, in 1739.

Smellie made many innovations in improving childbirth. He laid down safe rules regarding the use of forceps (he himself was reluctant to use them) and invented better ones – some with locks or curved blades – and developed a technique for delivering breech babies. In his accurate decriptions of labor, he paid particular attention to how the infant's head adapts to changes in the pelvic canal during birth. He delivered poor women free of charge if medical students were allowed to attend, and to him, the mother's life was always paramount. Among his numerous books, his monumental *Sett of Anatomical Tables, with Explanations, and Abridgment, of the Practice of Midwifery* of 1754 has lasted on the strength of its unprecedented illustrations. Interestingly, in regard to modern preconceptions about New England puritanism, an American edition published in Boston in 1786 was the first illustrated medical book published in the United States.

William Hunter, Smellie's star pupil, was a fellow Scotsman – and brother to the noted anatomist John Hunter – who also studied at Glasgow. Hunter was destined to become one of the most prominent physicians of his day, and it was a symbolic moment in the history of the transition from midwifery, traditionally a female preserve, to obstetrics, for two centuries a predominantly male profession, that he was in 1762 the first male physician to attend to an English queen during her confinement, in this case Queen Charlotte, the wife of King George III.

The breadth of Hunter's accomplishments was impressive, helped no doubt by the fact that he was a much smoother character than Smellie. In midwifery, he was an early proponent of what would today be called "natural childbirth," to the extent that he put aside folk traditions relating, for example, to the placenta and the treatment of lactating breasts. He founded what is considered to be the first modern medical school in London, the Windmill School, with an amphitheater for dissections, and became a celebrated lecturer on medicine and anatomy. A tireless worker into old age, Hunter fainted from exhaustion while lecturing and died ten days later of stroke.

Hunter's monumental *Anatomia uteri humani gravidi* (*The Anatomy of the Human Gravid Uterus*) was finally published in 1774, although he had begun to prepare the drawings for it in 1751. He acknowledged his brother John's help with the project, but the two later fell out over claims to the discovery of the structure of the placenta and how it interacted with the uterus. The book contains thirty-four copper plates depicting the gravid uterus (a uterus in a state of advanced pregnancy), lifesize. It is beloved by bibliophiles as the only significant medical publication to come from John Baskerville's famous press in Birmingham, England.

External female genitalia, during delivery of the fetus, shown in situ. Head of the fetus shown crowning; vulva, clitoris, and anus also shown. Antero-inferior view

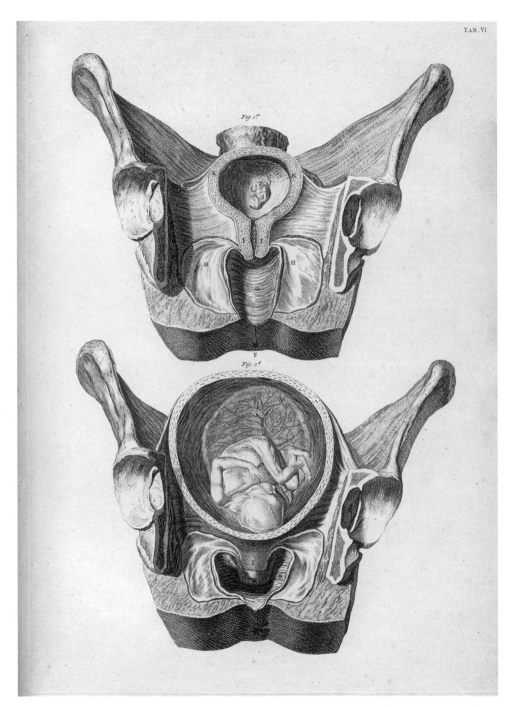

Female genitalia; gravid uterus, shown at two to three months gestation, and four to five months gestation, shown in situ, in two numbered illustrations. Pelvis shown in coronal section, uterus divided to show fetus, placenta. Anterior view

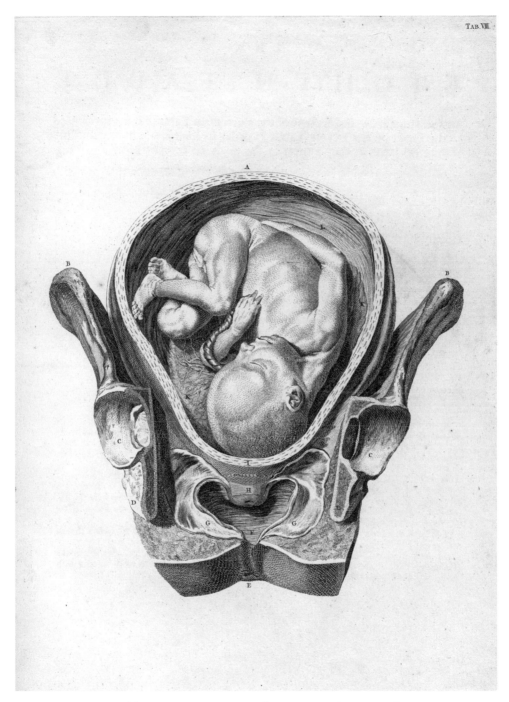

TAB. VIII.

Gravid uterus and fetus, at six to seven months gestation, shown in isolation with vagina, anus, and pelvic bones. Pelvis and uterus in coronal section to show fetus and placenta. Anterior view

A Sett of Anatomical Tables • 199

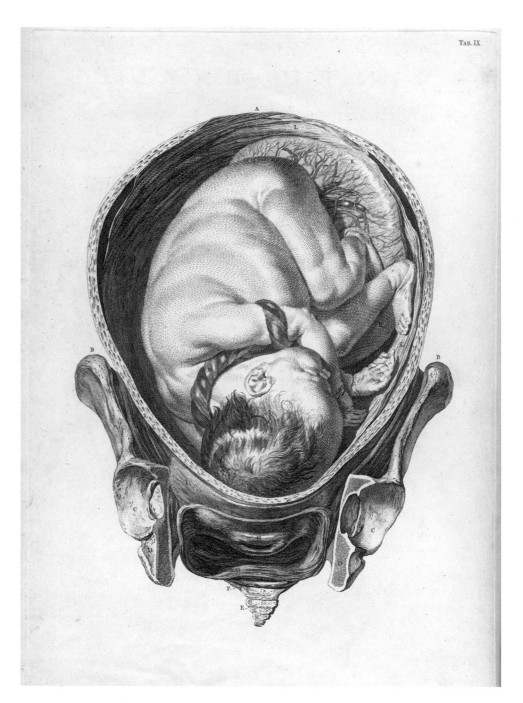

TAB. IX.

Gravid uterus and fetus, at eight to nine months gestation, shown in isolation with vagina and pelvic bones. Pelvic bones and uterus in coronal section to show fetus and placenta. Anterior view

Opposite: Gravid uterus with fetus, during labor, shown in situ. Uterus, pelvis and spine in sagittal section to show fetus. Alternate shapes and locations of uterus indicated (abnormally high and low) with resulting difficulties described. Lateral view

200 ● Smellie

TAB. XII.

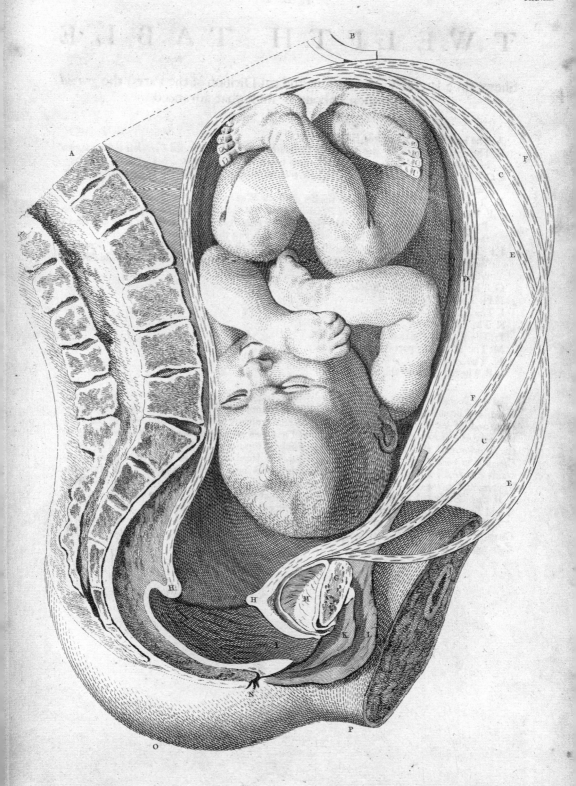

TAB. XIII.

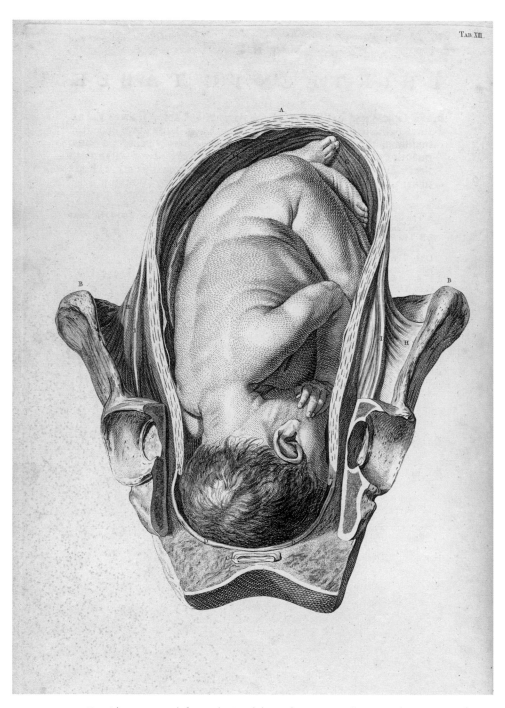

Gravid uterus and fetus during labor, shown in isolation with vagina and pelvic bones. Pelvic bones divided to show fetal head entering the vagina. Anterior view

TAB.XIV.

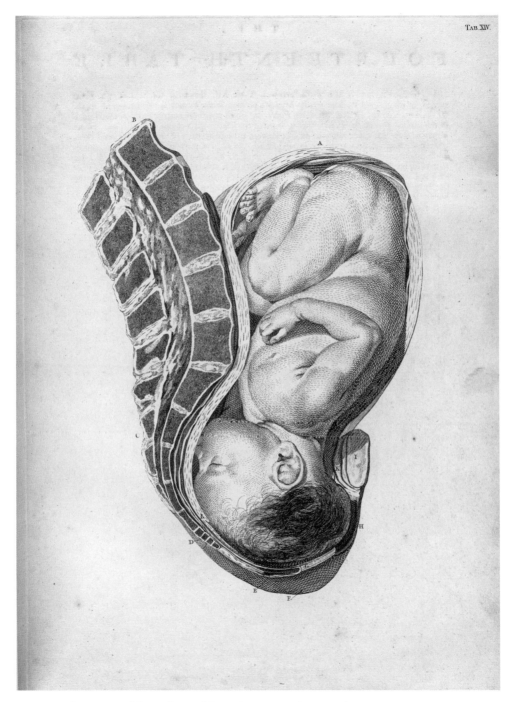

Gravid uterus and fetus during labor, shown in isolation with vagina, spine, and pelvic bones. Pelvis in sagittal section to show fetal head in the vagina, and crowning. Lateral view

TAB. XXIX.

Gravid uterus with fetus in breech position, shown in situ. Pelvis in coronal section with pelvic bones indicated; vagina and anus shown. Fetus shown facing posteriorly. Anterior view

Gravid uterus with fetus in breech position, shown in situ. Pelvis in coronal section with pelvic bones indicated; vagina and anus shown. Fetus shown facing anteriorly. Anterior view

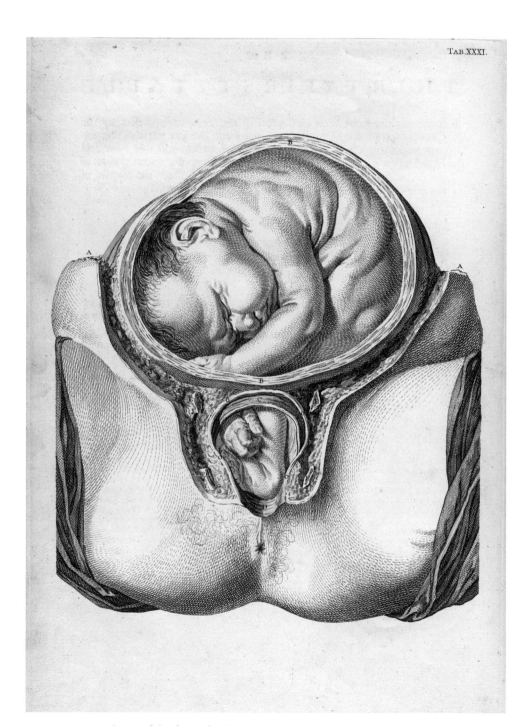

Delivery of the fetus, footling breech presentation, shown in situ. Dissection of the pelvis and perineum to show uterus, fetus, and cervix. Antero-inferior view

206 ● Smellie

TAB XXXII

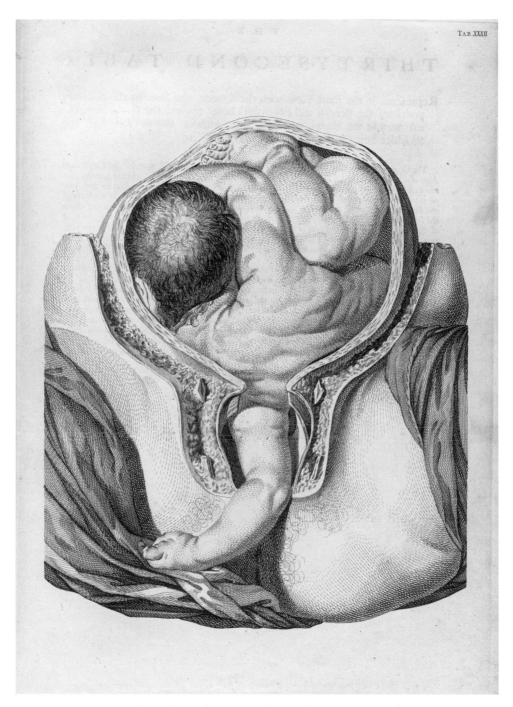

Fetus in transverse lie. Pelvis and perineum dissected to show uterus, fetus, cervix, and vagina. Arm of the fetus has been delivered. Antero-inferior view

TAB. XXXIII

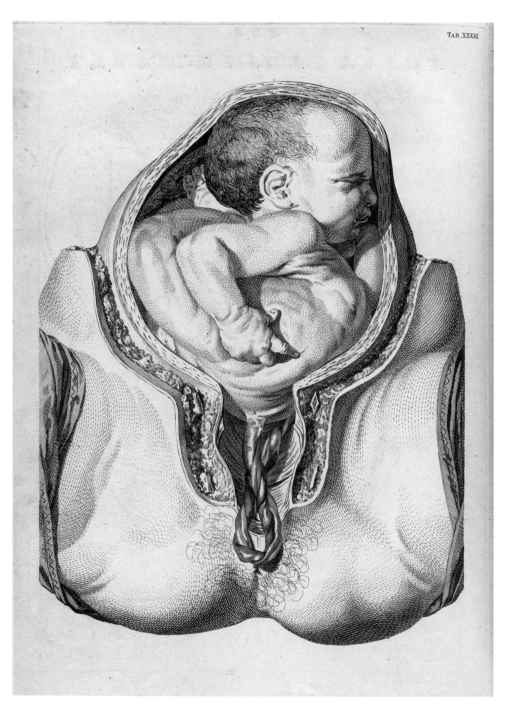

Fetus in transverse lie with umbilical cord prolapse, shown in situ. Pelvis, uterus dissected to show fetus, cervix, and vagina. Inferior view
Opposite: Delivery of the fetus using forceps, shown in situ. Fetus in breech presentation, body delivered, but head remaining above the pelvic bones. Pelvis shown in sagittal section, spine, pubic bone, and intestines shown. Lateral view

TAB. XXXV

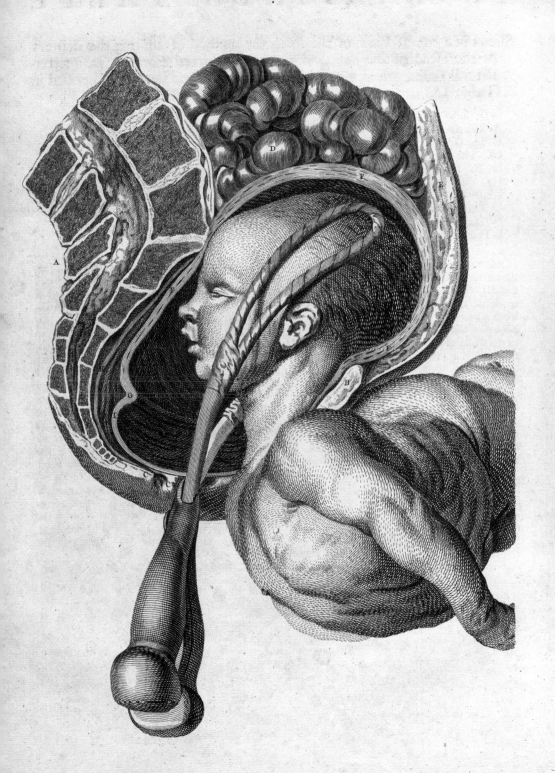

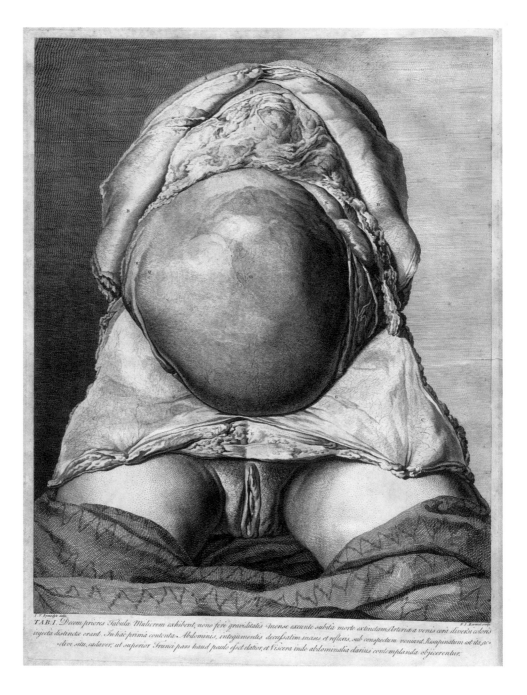



TAB. I. *Decem priores Tabula Mulierem exhibent, nono ferè graviditatis mense exeunte subita morte extinctam. Arteriæ a venis cerâ diversâ coloris injecta distinctæ erant. In hâc primâ contenta Abdominis, integumentis decussatim incisis et reflexis, sub conspectum veniunt. Resupinatum est ita, ac clivi situ, cadaver, ut superior trunci pars haud paulo esset elatior, et Viscera inde abdominalia clarius contemplanda objicerentur.*

Gravid uterus, shown in situ. Intestines and omentum partly visible. Antero-inferior view

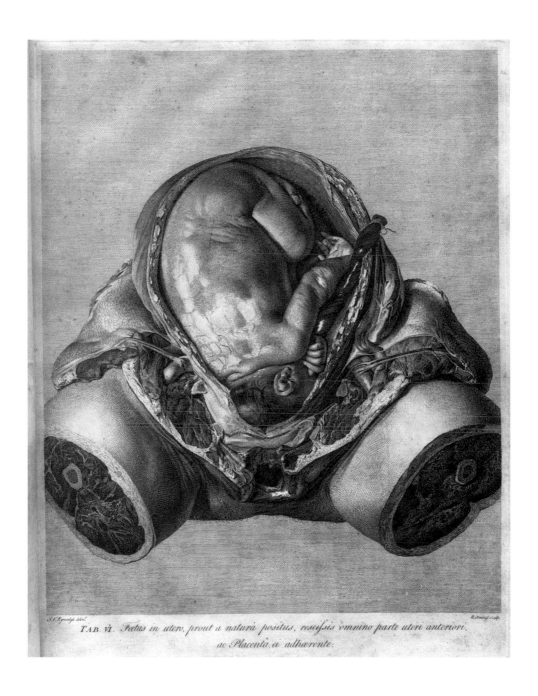

T.A.B. VI. *Fetus in utero, prout a natura positus, rescissis omnino parte uteri anteriori, ac Placenta ei adhærente.*

Fetus in utero with umbilical cord, shown in situ. Abdomen and amputated legs shown only. Antero-inferior views

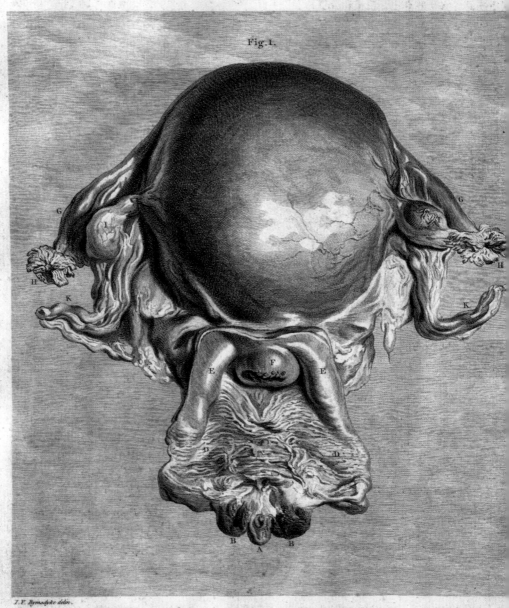

Fig. I.

TAB. XXVII. *Undecimum Cadaver, mense quinto ineunte.* Fig. I. *Uterus cum appendici*
status apparet. Fig. II. *Utero omnino aperto, membrana Decidua Reflexa, Chorion in*

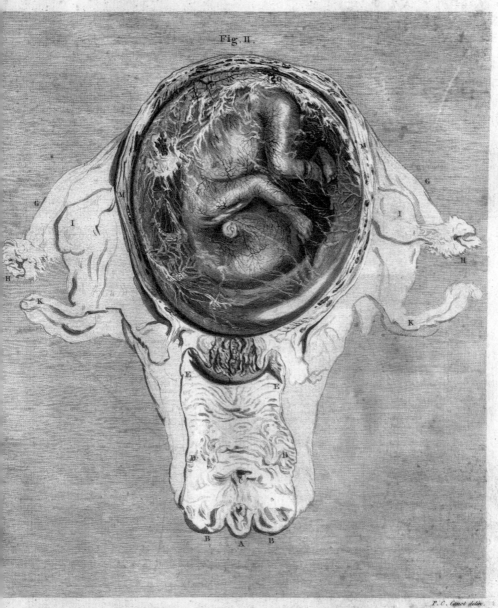

Fig. II.

P. C. Canot delin.

suis a tergo visus; Vagina secundum longitudinem incisa, Cervicis et Oris uterini
riens, cernitur, cum Fœtu translucente, et Cervicis Orisque uterini facies interna.

Fetus in utero, at five months gestation, with chorion, cervix, vagina, vulva, clitoris, Fallopian tubes, and ovaries, shown in isolation, in two numbered illustrations. Uterus shown intact with vagina divided to show cervix. Uterus in coronal section to show fetus contained in intact chorion. Fallopian tubes and ovaries also shown

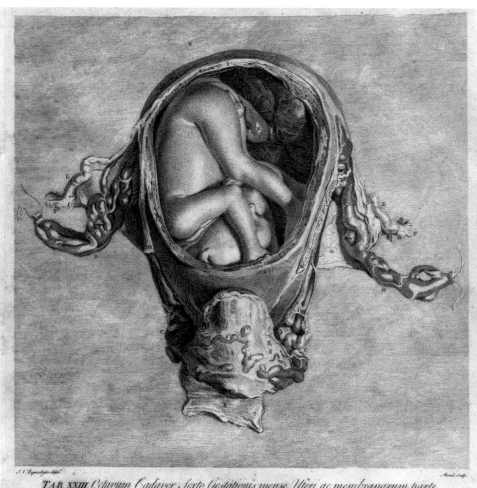

TAB. XXIII. *Octavum Cadaver, Sexto Gestationis mense. Uteri ac membranarum parte anteriori sublata, exhibetur Fœtus cum parte Placentæ et Funiculi umbilicalis. Uteri Vasa cerâ impleta erant.*

Fetus in utero, at seven months gestation, shown in isolation. Uterus in coronal section to show fetus, umbilical cord, and placenta. Fallopian tubes, round ligament, vagina, and bladder shown. Anterior views
Opposite: Gravid uterus at eight months gestation, Fallopian tube, and round ligament, shown in isolation. Blood vessels supplying the uterus shown. Lateral view (artist, Edward Edwards, 1738–1806)

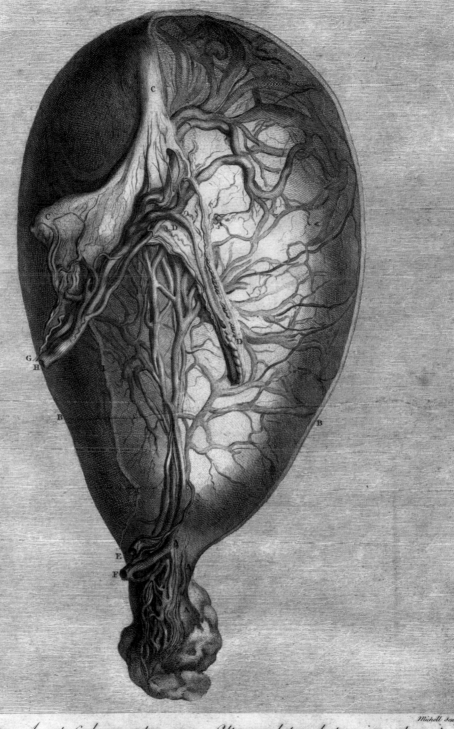

E.Edwards delin.

Michell Sculp.

TAB. XVI. *A sexto Cadavere, octavo mense. Uterus a latere dextro visus, atque ita injecta cera praeparatus, et scalpello anatomico denudatus, ut vasorum ad eum accessus, eorumque primae ramificationes quàm clarissimè appareant.*

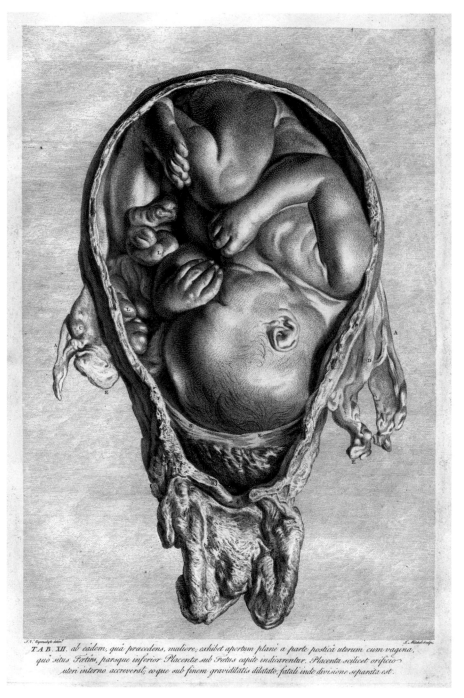

TAB. XII. ab eâdem, quâ præcedens, muliere, exhibet apertum planè a parte posticâ uterum cum vaginâ, quò situs Fœtus, parsque inferior Placentæ sub Fœtus capite indicarentur. Placenta scilicet orificio uteri interno accreverit, eoque sub finem graviditatis dilatato, fatali inde divisione separata est.

Fetus in utero, at nine months gestation, shown in isolation, with Fallopian tubes and vagina shown. Uterus and vagina in coronal section to show fetus and interior wall. Anterior view

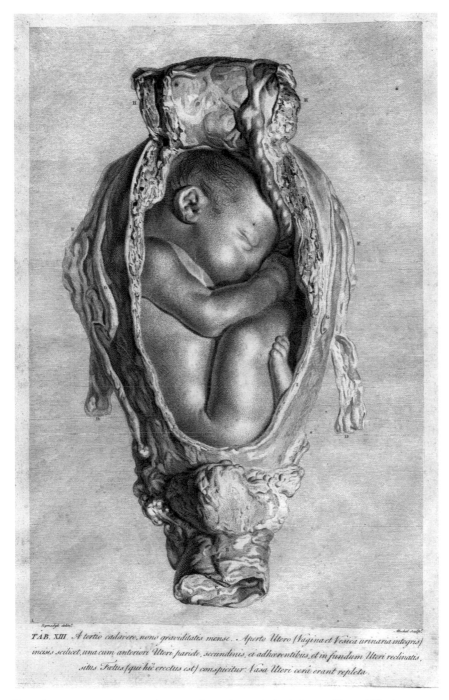

TAB. XIII. A tertio cadavere, nono graviditatis mense. Aperto Utero (Vagina et Vesica urinaria integris) incisis scilicet, una cum anteriori Uteri pariete, secundinis, ei adhærentibus, et in fundum Uteri reclinatis, situs Fœtus (qui hic erectus est) conspicitur. Vasa Uteri cera erant repleta.

Fetus in utero, at nine months gestation, shown in isolation, with umbilical cord; placenta divided and reflected, Fallopian tubes and vagina shown. Uterus and vagina in coronal section to show fetus and interior wall. Fetus in breech presentation. Anterior view

Orate ne intretis in tentationem

Jacques Gamelin (1738–1803)
Lavalée (fl. 1779), engravings

Nouveau recueil d'ostéologie et de myologie
Toulouse, 1779

WITH THE WORK OF JACQUES GAMELIN, we interrupt a series of works created by physicians to take a brief detour into the artist's studio. We have reached that moment in history, the cusp of the nineteenth century, when the artist and the anatomist came to a fork in the road and each took a different path. From this point forward, we will accompany the scientist, leaving Gamelin to represent the many artists who even up to the present day illustrate anatomical primers for artists. Their books, designed to teach the art of drawing the human figure, focus on musculature and the skeleton beneath it, for together these structures determine how the body looks in different positions. Their quintessential subjects are the human skeleton and the écorché (flayed) figure, portrayed with the skin removed to show the musculature beneath.

Jacques Gamelin was neither a physician nor an anatomist, but a painter, draftsman, and engraver. Born in France, the son of a successful merchant, he was educated by Jesuits and then employed as a bookkeeper by the Baron de Puymaurin, a wealthy Toulouse businessman. Gamelin had little interest in business and a keen interest in art, and when his father refused to pay for his art education, the baron stepped in and paid his tuition at the Académie royale de Toulouse. Gamelin later went on to pursue his art studies in Paris and Rome, where he may have studied with Goya, under the patronage of Puymaurin. Eventually, he gained a reputation as a battle painter.

The death of his father left Gamelin with a sizeable fortune, which he probably used to fund his great anatomical work, *Nouveau recueil d'ostéologie et de myologie* (*A New Book on the Bones and Muscles*), published in 1779. One of the most imaginative anatomy primers for artists in a genre that more often tends toward disciplined but stolid representation, it shows skeletons at play, and impressive scenes from the Resurrection and the Crucifixion portrayed by écorché figures.

Opposite: A skeleton reading a book, with the inscription: *Orate ne intretis in tentationem* ("Pray that you do not enter into temptation")

permis d'imprimer
Lartigue Jugemano.

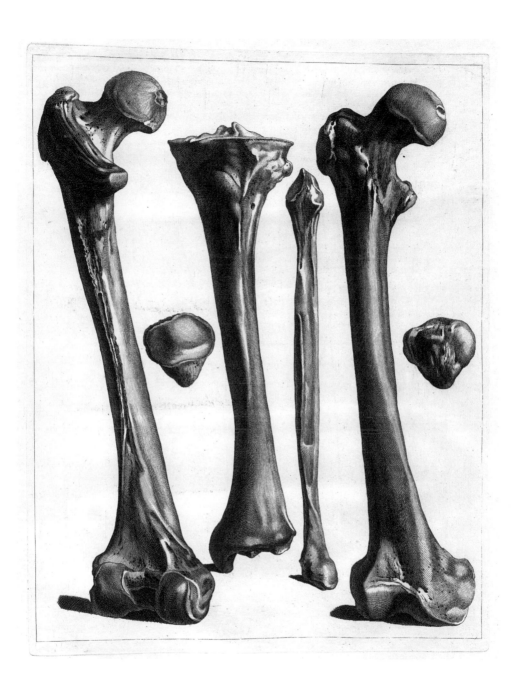

Bones of the leg
Opposite: A skeletal figure of Time, with the remains of dissections

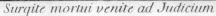
Surgite mortui venite ad Judicium

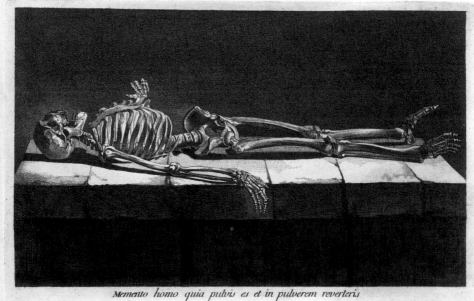
Memento homo quia pulvis es et in pulverem reverteris

Above: A skeleton hearing the last trumpet, inscribed *Surgite mortui venite ad Judicium* ("Arise, dead one, and come to Judgment")
Below: A skeleton on a slab, with the inscription *Memento homo quia pulvis es in pulverem reverteris* ("Remember, man, you are dust and to dust shall return")

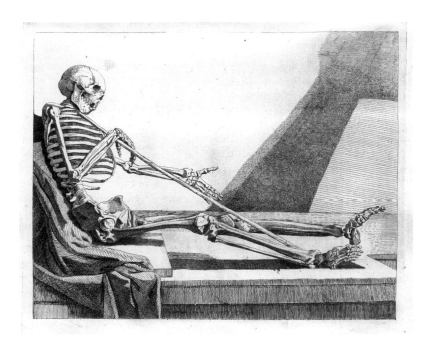

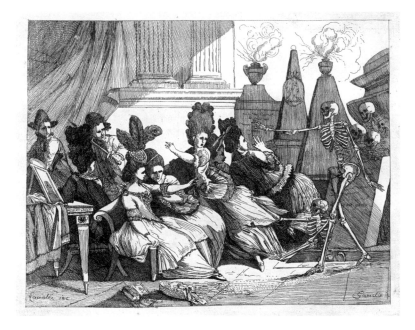

Above: A skeleton on a slab, with a dissection prop
Below: Skeletons interrupting a gathering

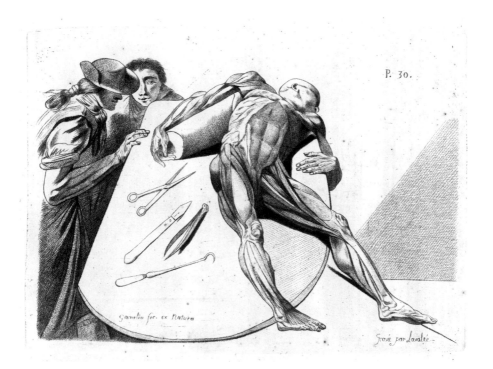

Gamelin fec. ex Natura

Gravé par Lavalée

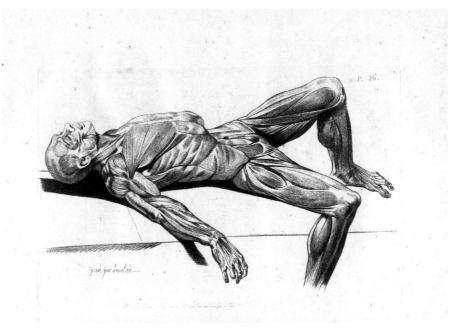

Gravé par Lavalée

Above: Two gentlemen contemplating a cadaver
Below: A flayed cadaver

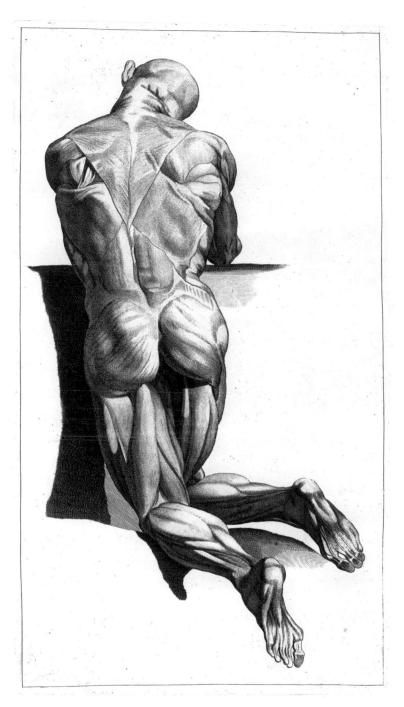

A flayed cadaver in prayer

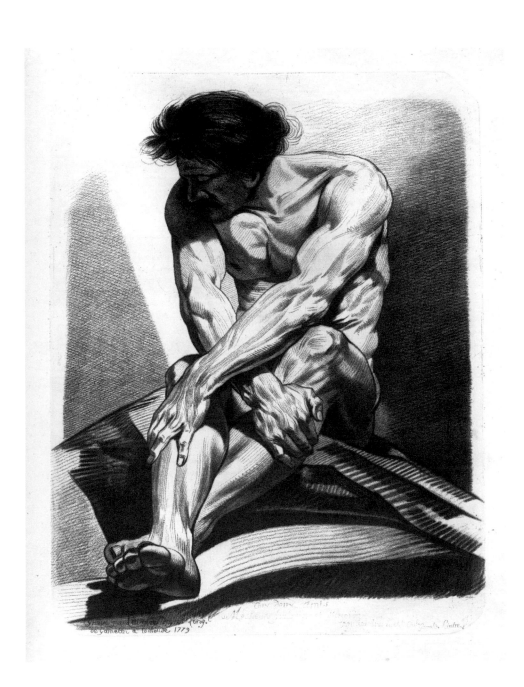

Above and opposite: Two male nudes

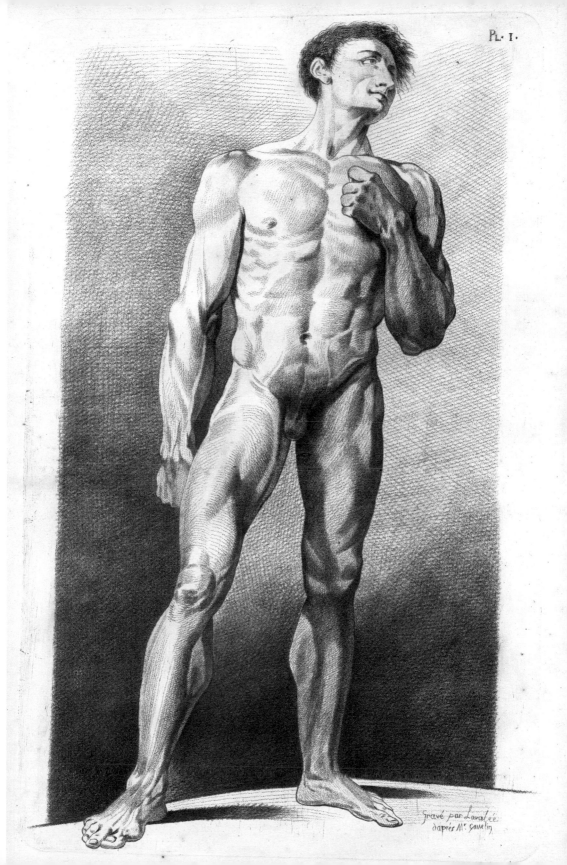

PL. I.

Gravé par Lavalée
d'après M. Gamelin

I

II

Published for the author I. Bell october 1794

Engraved by J Bell

John Bell (1763–1820)

Engravings, explaining the anatomy of the bones, muscles, and joints
Edinburgh, 1794

John and Charles Bell (1774–1842), artists
John Bell and others, engravers

The principles of surgery
Edinburgh, 1801–1808

IN JOHN BELL, SURGEON AND ANATOMIST, we find a sympathetic man who would not seem out of place, or unwelcome, in a modern hospital. Bell was a product of his native Edinburgh, the son of a clergyman there, and trained in its schools. It was there that he founded his own academy, with an anatomy theater where he lectured over his dissections, and later became a prominent private surgeon. His anatomical works were intended for surgeons. A compassionate man of strongly held convictions, he entered into medical disputes with powerful professors at the university that caused his career to languish. In the words of one biographer, "he was one of those men who, without apparently achieving great success . . . stamp their character in the institutions and thought of the age in which they live."

Bell was both a writer and an artist (he drew most of the illustrations seen here), and he was astute in evaluating other anatomists' work. Of Albinus he wrote, "each drawing of his is but a mere plan, resembling no individual body . . . ; it is such a view as never is to be seen in a dissection." He admired the realism of Bidloo's illustrations – "we have the very subject before us! The tables, the knives, the apparatus, down even to the flies that haunt the places of dissection" – but observed that, "in respect to anatomy, they are all disorder and confusion," remarking perceptively that "one must be both anatomist and painter to guess . . . what parts are seen."

Bell set for himself the very modern goal of steering between a systematic and a realist approach to anatomical illustration, and the reader can decide on the evidence of these plates from *Engravings, explaining the anatomy of the bones, muscles, and joints* (1794) and *The Principles of Surgery* (1801–08), how successful he was. In spirit, some find his work evocative of the surgeon's immediate experience; others would simply call it gruesome.

Opposite: Skull, shown in isolation, in two numbered illustrations. One skull shown intact with mandible, antero-lateral view. The second skull with mandible, divided sagittally, medial view

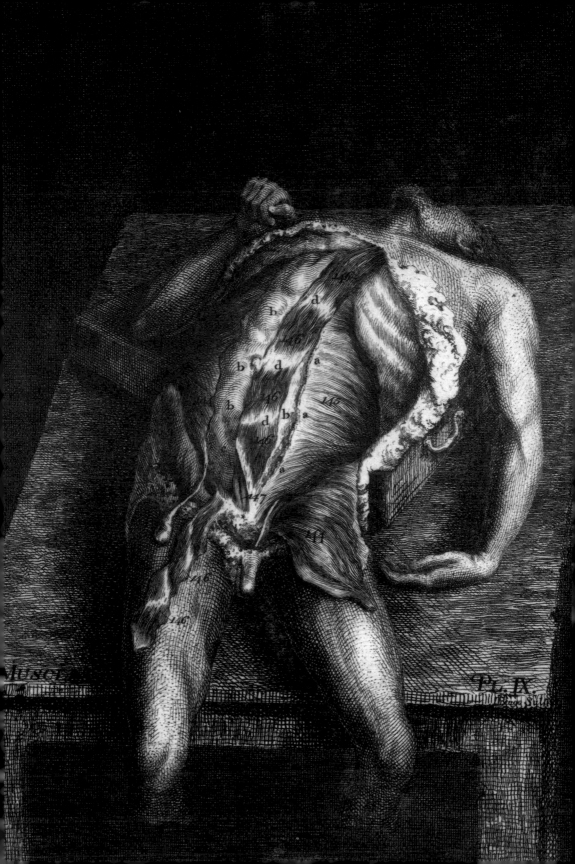

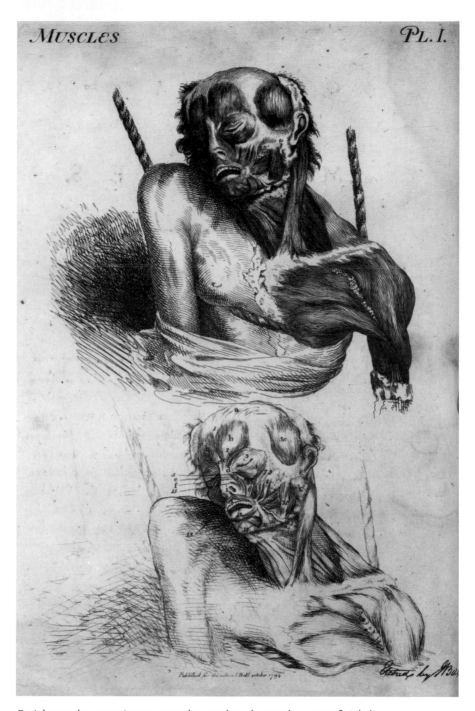

Facial muscles, masticatory muscles, and neck muscles, superficial dissec-
tion, in two numbered illustrations. Male figure, anterior view
Opposite: Abdominal muscles, testis, superficial dissection, in situ. Male
cadaver dissected to show rectus abdominis, testis dissected free from the
scrotum. Anterior view

Engravings, explaining the anatomy of the bones, muscles, and joints ● 231

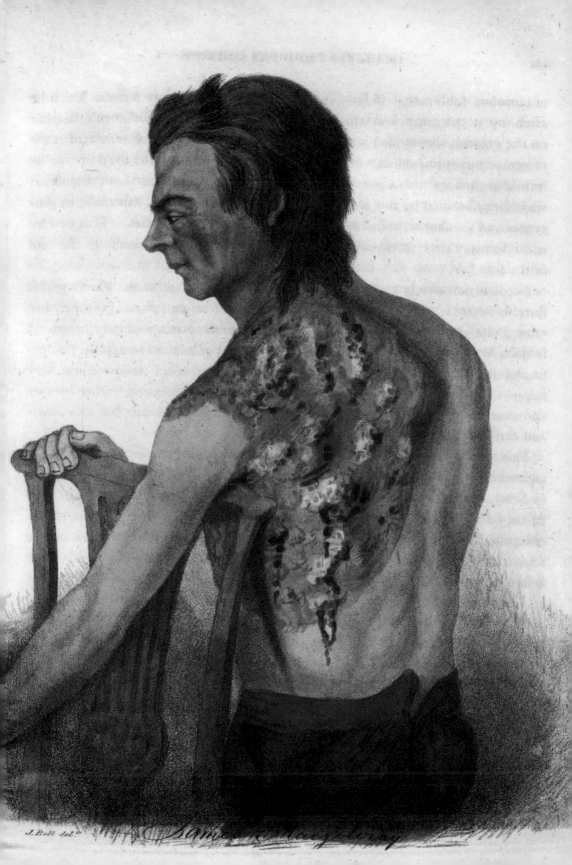

J. Bell del. Samuel Macgillivray

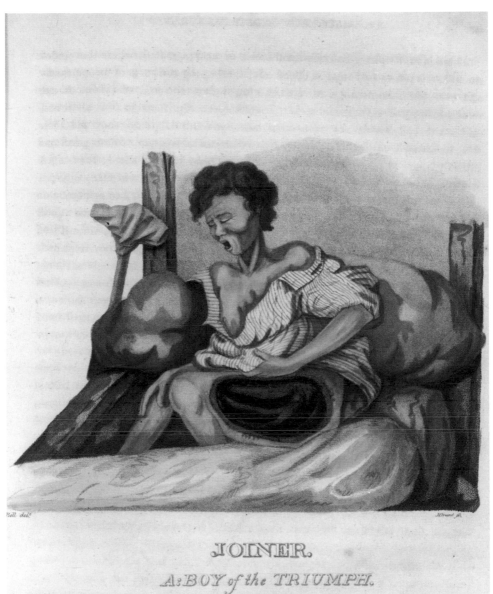

JOINER.

A: BOY of the TRIUMPH.

Gangrene; large lesion involving the entire lateral thigh. Lateral view
Opposite: Abscess from a gunshot wound, inflammation and abscesses covering the shoulder and back. Postero-lateral view

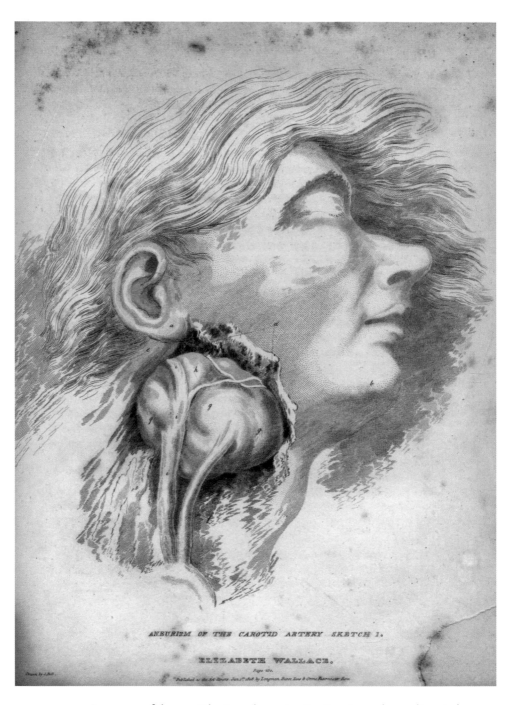

Aneurysm of the carotid artery, shown in situ. Specimen shown dissected post-mortem. Female patient, lateral view

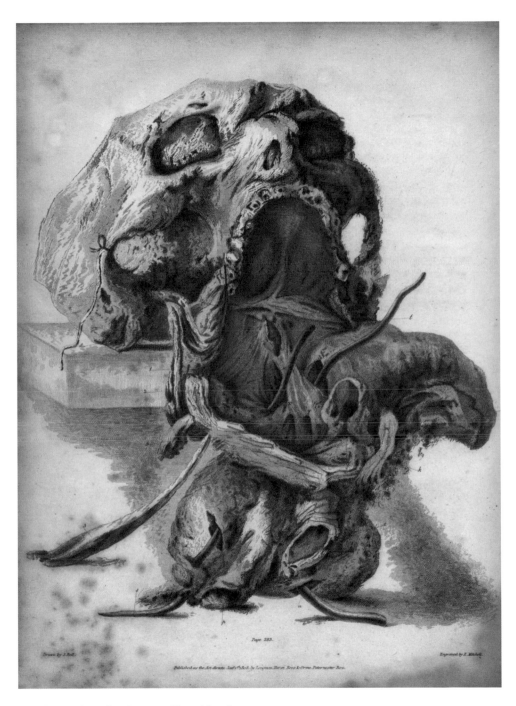

Dissection of a pharynx affected by abscess

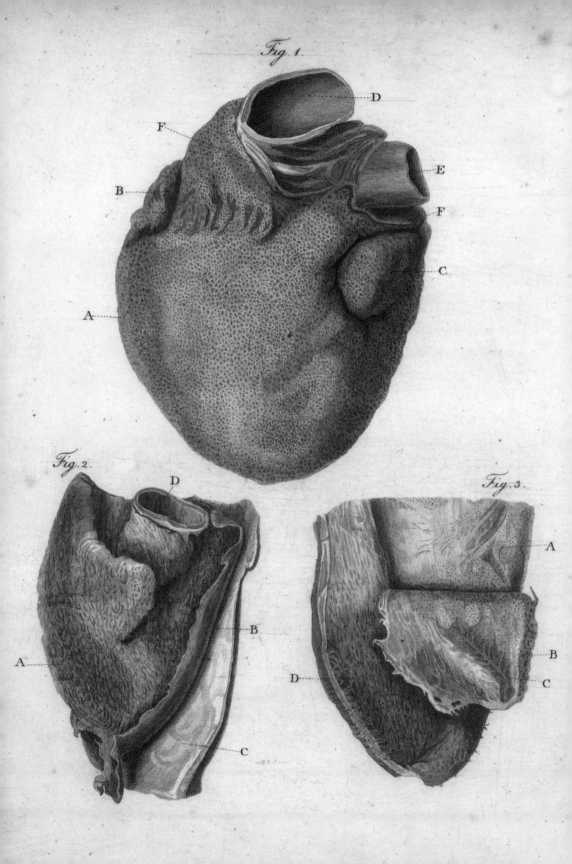

Fig. 1.

Fig. 2.

Fig. 3.

Matthew Baillie (1761–1823)
William Clift (1775–1849), drawings
William Skelton, James Basire, and James Heath, engravings

A series of engravings, accompanied with explanations,
which are intended to illustrate The morbid anatomy of
some of the most important parts of the human body
London, 1799–[1803]

Robert Willan (1757–1812)

On cutaneous diseases
London, 1808

Jean Cruveilhier (1791–1874)
Antoine Toussaint de Chazal (1793–1854), lithographer

Anatomie pathologique du corps humain
Paris, 1829–1835

Robert Carswell (1793–1857)

Pathological anatomy.
Illustrations of the elementary forms of disease
London, 1838

THE LATE EIGHTEENTH AND EARLY NINETEENTH CENTURIES saw the beginning of the scientific study of disease and pathology. Just as demographers began to collect and analyze information chronicling life and death in large populations, physicians began to scrutinize more precisely the impact of diseases on the human body, seeking correlations between the case histories of particular patients and the

Opposite: Heart, shown in isolation, in three numbered illustrations. Heart shown intact and dissected, showing signs of pericarditis

appearance of each organ at autopsy. It is perhaps difficult to look at these precise and gaudy illustrations of diseased organs, mostly the preserved remains of autopsies. Upon reflection, however, they begin to acquire a nobility of character, for they convey the urgent pressure felt by doctors to understand and ameliorate the great diseases and maladies of the modern world, which poisoned the lungs, broke the hearts, and ruined the stomachs of the urban masses, both rich and poor.

The first treatise on pathology in English was Matthew Baillie's *The morbid anatomy of some of the most important parts of the human body* (1793), to which he appended seventy-three plates drawn from specimens in the John Hunter Museum during the next decade. Baillie was the nephew and pupil of William Hunter, whose obstetrical atlas is seen earlier in this book, and he ultimately assumed the directorship of Hunter's London school. A pathologist before the word (or the profession) existed, Baillie developed a classification system for lesions and gave the first known description of a number of diseases, including cirrhosis, emphysema, and dermoid cysts of the ovaries. He also gave an excellent clinical description of stomach ulcers. He counted it among his honors that he performed the autopsy on Samuel Johnson.

The skin is, of course, an organ of the body, and one of the pioneers of its pathology was Robert Willan, a private practioner in London whose *On cutaneous diseases* (1808) was a landmark in the history of dermatology. Like Baillie, Willan developed a classification system to make sense of his observations, sorting skin ailments according to their appearance. He was the first physician to describe impetigo, lupus, psoriasis (also known as "Willan's syndrome"), sceloderma, ichthyosis, sycosis, and pemphigus, and was an early advocate of compulsory vaccination against smallpox.

Jean Cruveilhier, who was the first occupant of a newly established chair of pathology at the University of Paris in 1825, wrote the groundbreaking *Anatomie pathologique du corps humain* (1829–35) with the first illustrations of multiple sclerosis, auditory neurinoma, intracranial edpidermoid tumors, and intracranial and spinal meningiomas. He is credited with the earliest accurate descriptions of disseminated sclerosis and progressive muscular atrophy, also known as "Cruveilhier's palsy."

Three years after Cruveilhier assumed his post in Paris, Robert Carswell, a skilful artist as well as an indefatigable physician, was made Professor of Morbid Anatomy at University College, London. Previously, he had made more than two thousand watercolor drawings of diseased tissues while living in Paris and Lyon, and these formed the foundation for his highly regarded *Pathological anatomy* (1833–38). The quintessential eminent Victorian, Carswell added diplomacy to his achievements in art and science: he was knighted for looking after the health of Louis-Philippe when the French king was exiled to Britain after the Revolution of 1848.

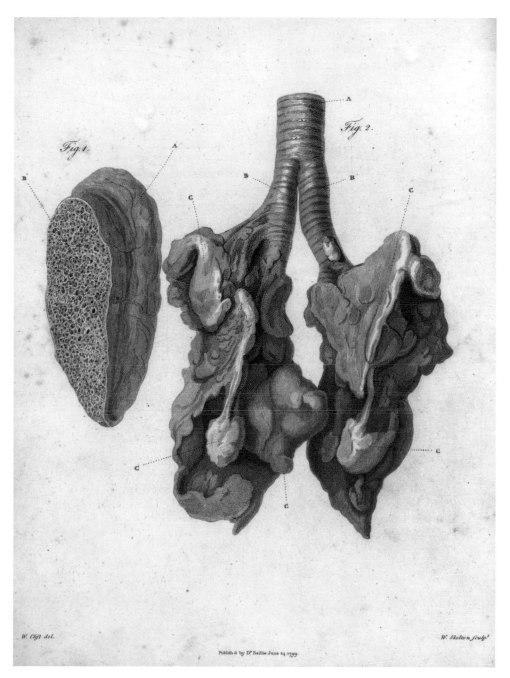

Lungs, showing signs of calcification and pulmonary emphysema, in two numbered illustrations. Cross section of lung tissue shown with enlarged air-spaces, and both lungs shown with trachea and bronchi, with hardened areas of tissue described in the text as ossifications

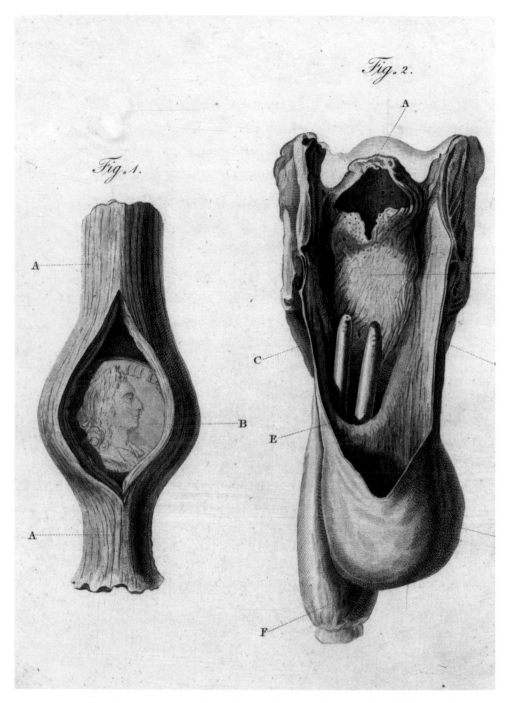

Esophagus; a coin caught in the esophagus, and an esophageal diverticulum, in two numbered illustrations. Posterior view of the diverticulum
Opposite: Skull with neoplasms, shown in isolation, in two numbered illustrations. Skull shown intact, without mandible, and divided to shown neoplasm projecting into the orbits. Lateral and anterior views

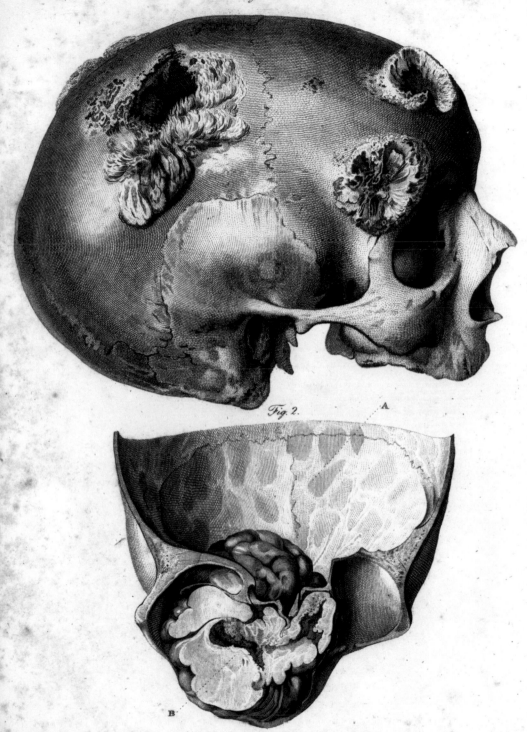

Fig. 1.

Plate 1.

Fig. 2.

A

B

W.^m Clift del.

Published by D.^r Baillie. Oct.^r 30. 1802.

Heath sc.

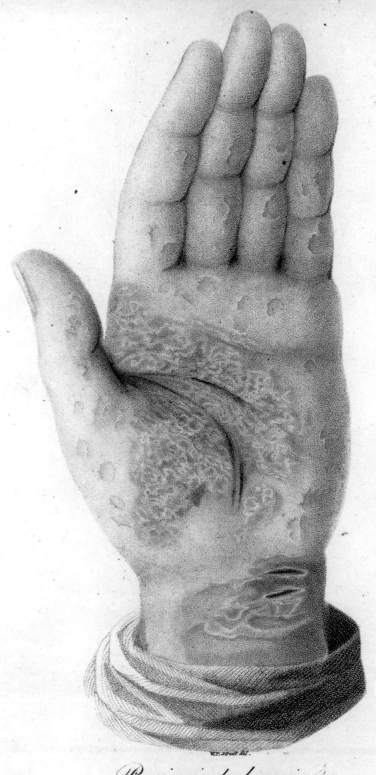

Psoriasis palmaria

London. Published Aug.ᵗ 1-1798. by J.Johnson. Sᵗ Pauls Church Yard.

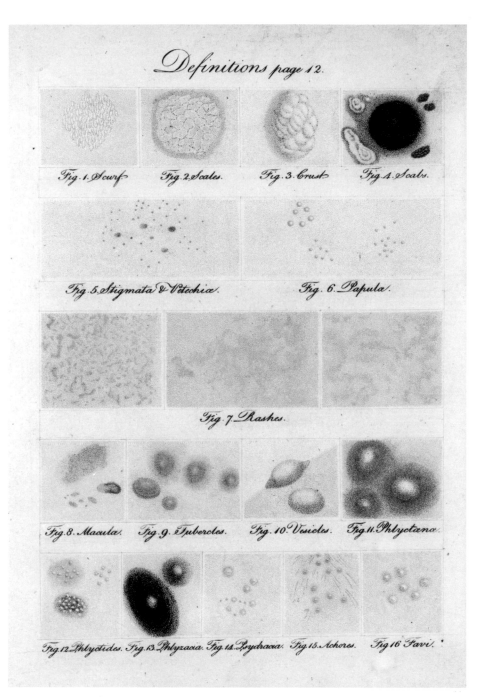

Examples of skin lesions, defined and illustrated in sixteen numbered illustrations. Examples of scurf, scale, scab, stigma, papula, rash, macula, tubercle, vesicle or bulla, and pustules defined as phlyzacum, psydracium, achorceria, favi, and phlyctis

Opposite: Scaly lesions on the palm of the hand, with dark scaly eruptions and cracks shown on the hand and wrist. Condition described as Psoriasis palmaria

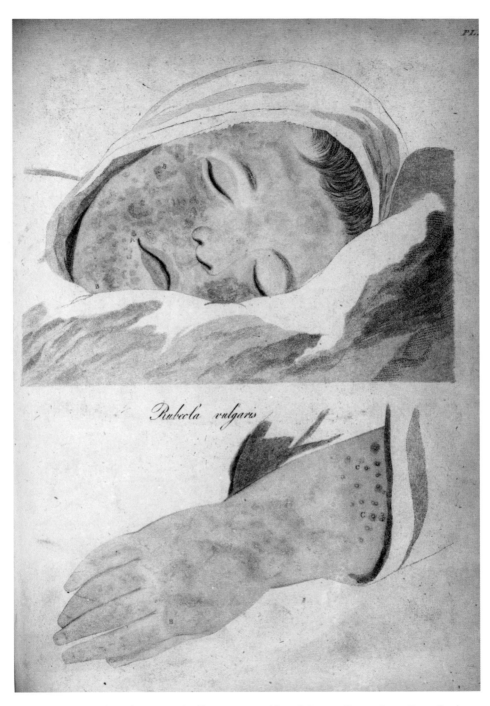

Rubeola vulgaris

Measles, shown on the face, arm, and hand, in two illustrations. Described as Rubeola vulgaris

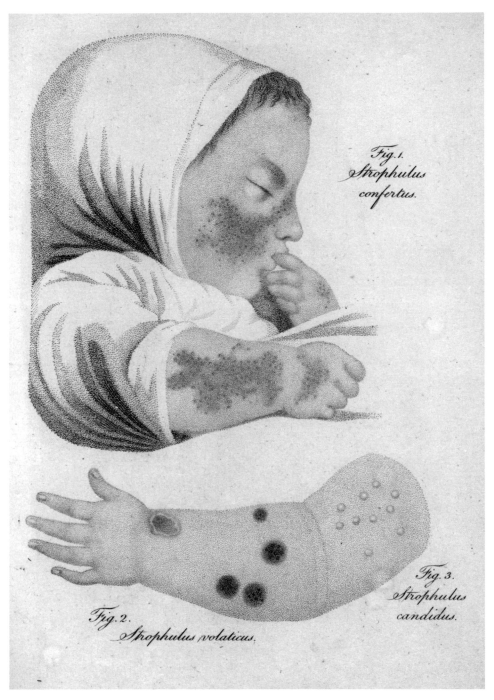

Fig. 1.
Strophulus
confertus.

Fig. 3.
Strophulus
candidus.

Fig. 2.
Strophulus volaticus.

Infant with rash and pustules of the face and arm, in three numbered illustrations. Eruptions covering the cheek and nose shown, lateral view. Arm shown with red and white pustules, lateral view

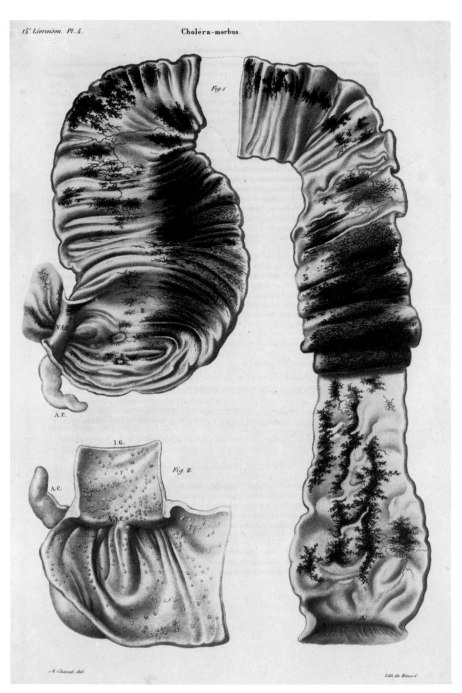

Intestines affected by cholera, shown in isolation, in three numbered illustrations. Sections of intestines dissected to show interior inflammation
Opposite: Diseased spinal cord and cerebellum, shown in isolation, in six numbered illustrations. Degeneration of white matter shown with scattered margins not related to anatomical boundaries, possibly from multiple sclerosis. Text states that patient was paraplegic and suffered from chronic "Danse de Saint-Guy" (i.e., St. Vitus's Dance.)

MALADIES DE LA MOËLLE ÉPINIÈRE.

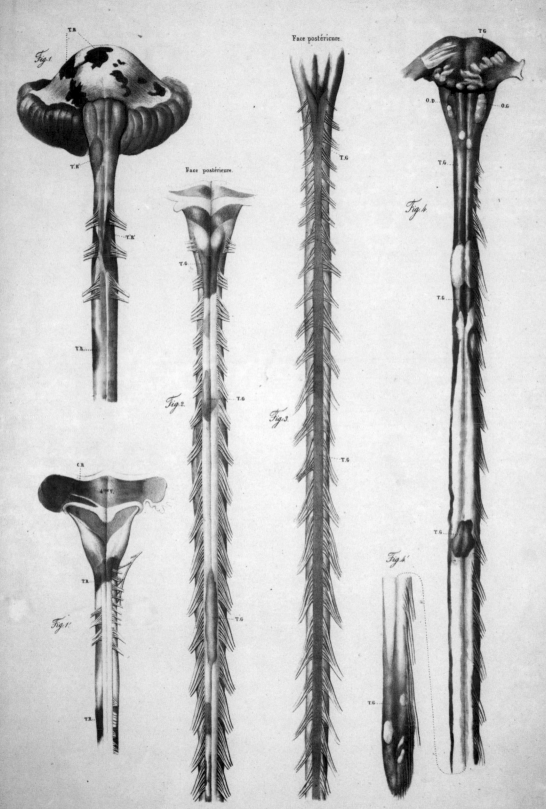

Face postérieure.

Face postérieure.

Fig.1.

Fig.2.

Fig.3.

Fig.4.

Fig.1'.

Fig.4'.

A. Cazal del.

Imp. de Lemercier, Benard et Cⁱᵉ

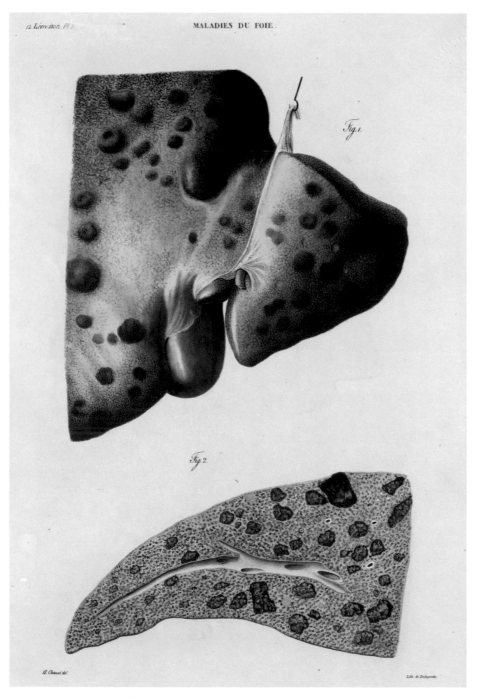

Fig.1.

Fig.2.

Diseased liver, shown in isolation, in two numbered illustrations. Cirrhotic liver shown intact, and in cross section. Gallbladder partly visible

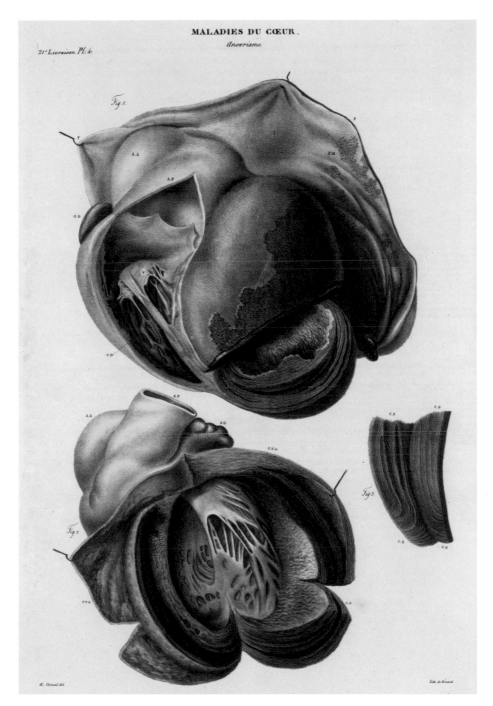

Aneurysm, shown with heart, in three numbered illustrations. Heart dissected to show aortic aneurysm. One illustration of myocardia, shown in cross section

Neoplasms of the peritoneum, the stomach, the kidney, portal vein, peritoneum, and lung, shown in isolation, in six numbered illustrations
Opposite: Liver cirrhosis, shown in isolation, in five numbered illustrations. Sections of liver shown with clotting in the portal vein

Plate II.

Fig.2.

Fig b.

Fig.1.

Fig3.

Fig 4.

R. Carswell ad. nat. del.

Day & Haghe, Lith.rs to the King.

LONDON MEDICAL SOCIETY

Plate II.

Fig.5. Fig.4.

Fig.2

Fig.1

Gangrene of the toes and foot, caused by heart disease, shown in isolation, in four numbered illustrations. Three illustrations of the toes and foot showing progression of the disease. One illustration of tissue necrosis caused by venous insufficiency caused by heart disease

Pulmonary tuberculosis, shown in isolation, in five numbered illustrations.
Sections of tissue shown in isolation with tuberculosis and caseation

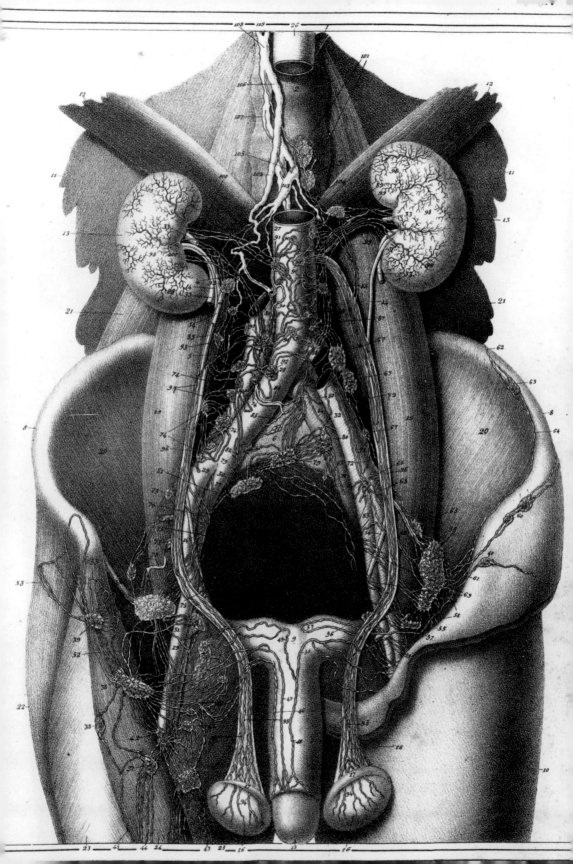

Jules Cloquet (1790–1883)

Manuel d'anatomie descriptive du corps humain, représentée en planches lithographiées
Paris, 1825

Jean-Baptiste Sarlandière (1787–1838)
Louis Courtin (fl. 1809–1841), drawings
Courtin and Delaporte, lithographs

Anatomie méthodique,
ou Organographie humaine en tableaux synoptiques, avec figures
Paris, 1829

LITHOGRAPHY, A PRINTING TECHNIQUE INVENTED IN GERMANY in the late eighteenth century, began to be exploited intensely for anatomical illustration in Paris in the 1820s. The process, which allowed for a seemingly infinite number of impressions, promised to reduce the cost of printing illustrations dramatically. These books by Cloquet and Sarlandière exemplify the impact of the new printing technology on medical illustration.

Fittingly, one was the son of an artist; the other of a doctor; each entered the family business at an early age. Jules Germain Cloquet apprenticed in his father's art studio in Paris before moving on to a school of anatomy in Rouen, where he studied under Achille Flaubert. (Flaubert's son Gustave was to be a lifelong friend of Cloquet.) Returning to the capital, he worked as an anatomical waxmodeler before entering medical school. His thesis was on the hernia, and like any modern surgeon, he mastered his chosen specialty by repeating the operation over and over. He is said to have performed more than three hundred.

Opposite: Lymphatic drainage of the pelvis and abdomen, shown in situ. Pelvis shown with kidney, aorta, inferior vena cava, penis, and testes with lymphatic vessels, inguinal, iliac, and celiac lymph nodes, thoracic duct. Anterior view

With a colleague who soon dropped out of the project, Cloquet conceived of a massive visual anatomy atlas. Over ten years (1821–31), he produced five volumes containing more than three thousand figures, divided between original illustrations (many by Cloquet or his sister and many hand colored) and plates copied from other books. Undoubtedly, the presence in Paris of several printers capable of lithography helped make this effort possible, as did a large subculture of artists and anatomists, which could only have been found in that city. Cloquet realized that none but the wealthy would be able to afford his *Anatomie du corps de l'homme, ou Description et figures lithographiées de toutes les parties du corps humain*. In 1825 he published an abridged version in smaller format called *Manuel d'anatomie descriptive du corps humain,* with more than three hundred illustrations, which was to be one of the earliest examples of the popular encyclopedic medical reference book that since then can be found in virtually every home.

Sarlandière's book, a comparatively minor publishing venture, was also a prototype. Born into a family of physicians in Aix-la-Chapelle, the neurologist Jean-Baptiste Sarlandière began training as a doctor at sixteen. He interrupted his education to spend eleven years in Napoleon's armies, finally settling in Paris in 1814 after the Allies defeated the Emperor. In the capital, he resumed his medical education and accepted a post in a military hospital. It was there that he developed an interest in acupuncture and the electro-stimulation of muscles, probably as a therapy to alleviate his patients' pain. He is chiefly known to the history of medicine for a paper that he wrote in 1825, describing a treatment for gout and rheumatism with needles wired to Leyden jars, a device to generate an electrical current. Sarlandière was encouraged in his wide-ranging interests by the legendary François Magendie, a remarkable anatomist, physiologist, and pharmacologist who makes an appearance in a novel of Balzac's.

Sarlandière's *Anatomie méthodique,* a short work of thirty-two pages with fifteen lithographs drawn from dissections by the author, is an example of a particular kind of anatomical book that became popular in the nineteenth century: a compendium to educate or edify a general audience. It speaks of musty school rooms from long ago and the equally musty flea markets of today, where there is always someone selling loose prints torn from old books.

Opposite: Brain, spinal cord, and cauda equina, with skull and vertebrae, shown in isolation. Skull with mandible, and vertebrae divided in sagittal section, brain shown intact, dura mater removed. Lateral view

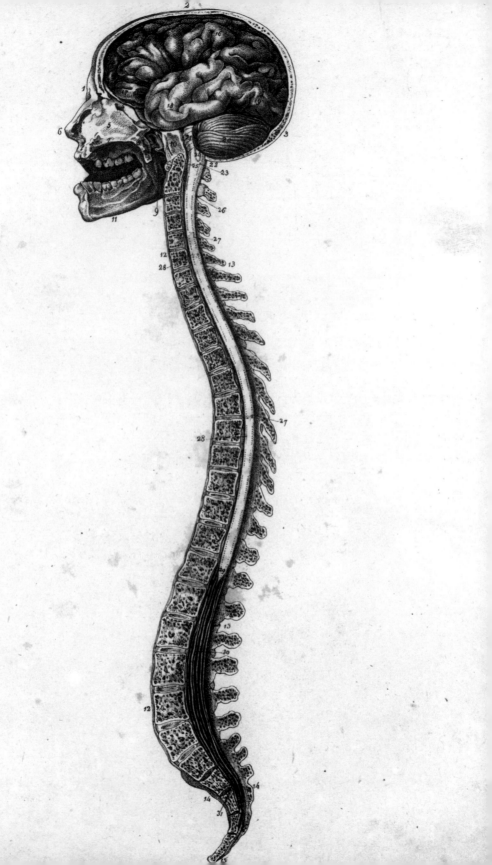

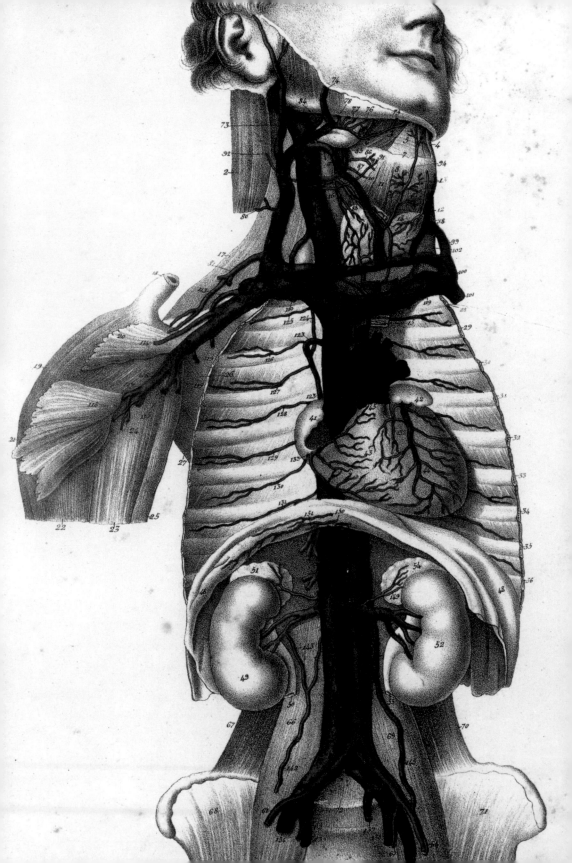

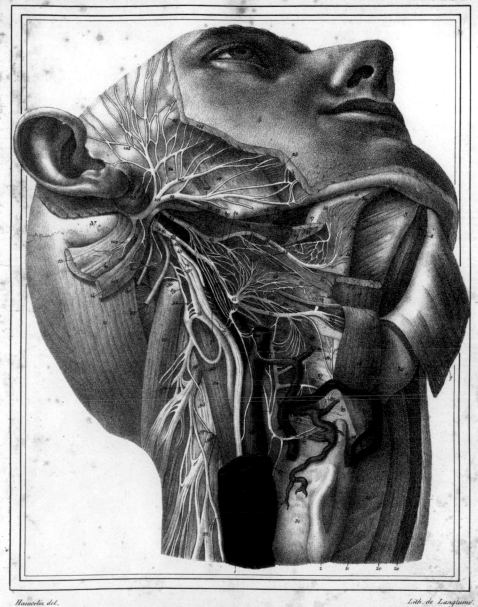

Haincelin del.

Lith. de Langlumé.

Dissection of the neck, deep dissection, showing facial nerve (cranial nerve VII), glossopharyngeal nerve (cranial nerve IX), vagus nerve (cranial nerve X), and carotid arteries. Neck muscles divided and reflected to show cranial nerves, superior and cervical ganglion, carotid arteries, and cervical spinal nerves. Anterio-lateral view

Opposite: Veins of the neck, thorax, and abdomen, shown in situ. Anterior thoracic and abdominal wall removed with most viscera, showing superior and inferior vena cava, brachiocephalic veins, subclavian vein, jugular vein, renal veins, and iliac veins. Heart with coronary veins, kidneys, and thyroid gland also shown. Anterior view

Manuel d'anatomie descriptive du corps humain • 259

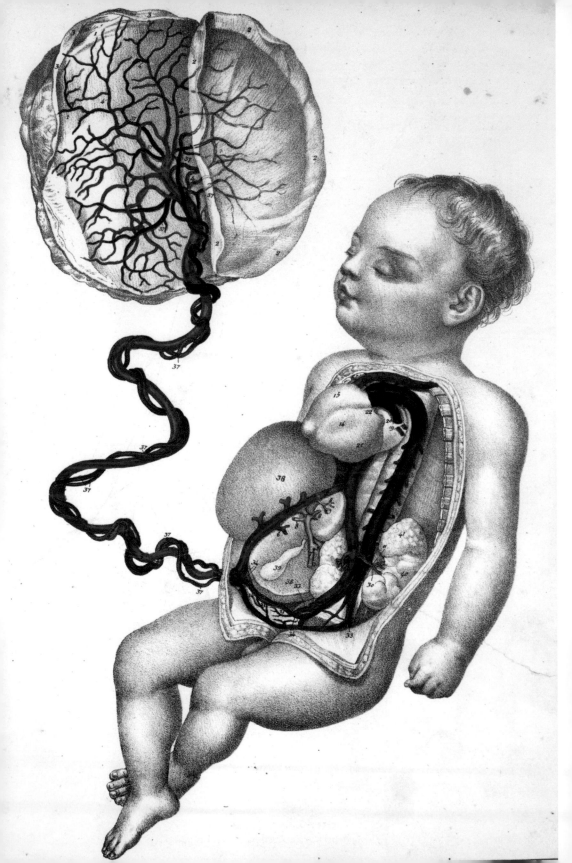

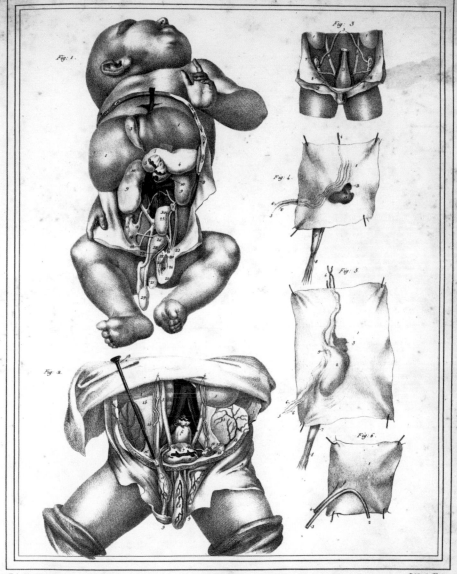

Abdominal organs of a male fetus, testis and inguinal canal, shown in situ
and in isolation, in six numbered illustrations. Three illustrations of dissec-
tion of the abdomen, anterior abdominal wall removed, intestines removed
to show liver, gallbladder, stomach, penis, scrotum, and testis. Testis shown
undescended, and within the scrotum. Inguinal canal indicated. Two illustra-
tions of perineum, showing descent of the testis in the inguinal canal. One
illustration of perineum showing canal of Nuck

Opposite: Fetus, umbilical cord, and placenta; fetal circulation, shown in iso-
lation. Abdomen and thorax of fetus dissected to show fetal circulation with
heart, liver, and umbilical veins. Placenta dissected to show umbilical arteries
and veins

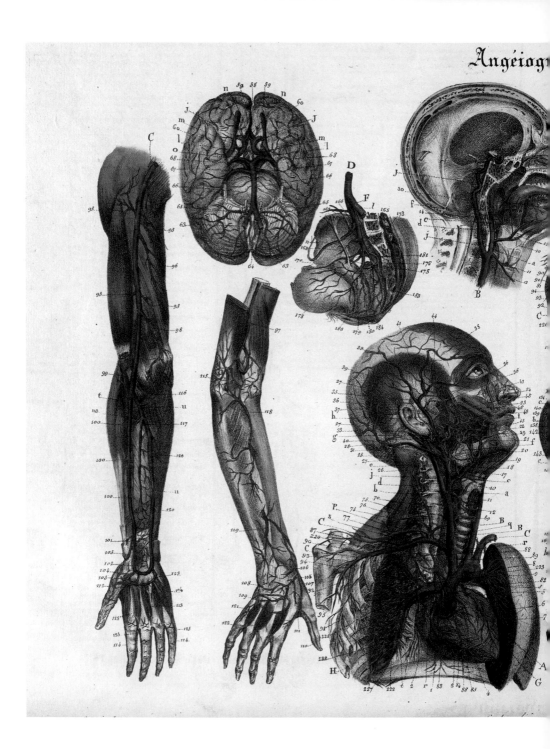

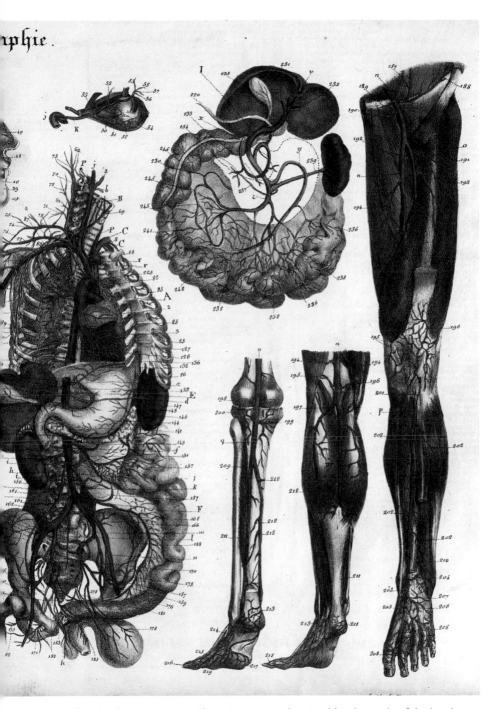

The circulatory system, with various views showing blood vessels of the head and brain, arms and legs, upper body, torso, and digestive system

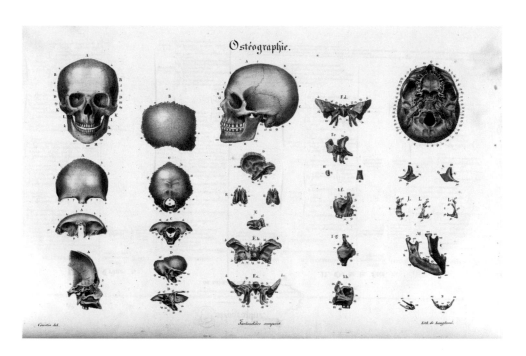

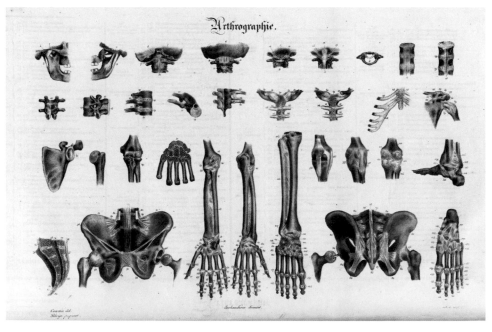

Above: Bones of the skull
Below: Bones and joints, including the jaw, vertebrae, arms, legs, hands, feet, and pelvis

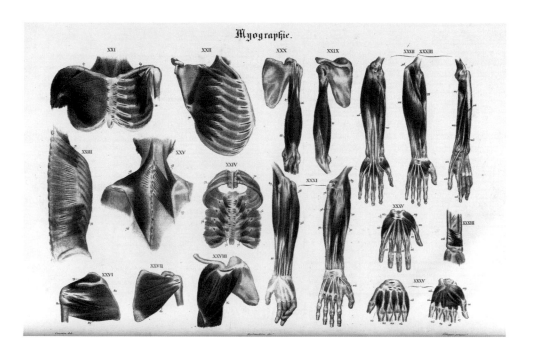

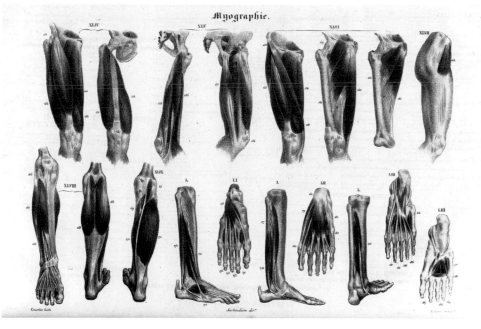

Above: Muscles of the arms, hands, chest, back, and shoulder
Below: Muscles of the legs and feet

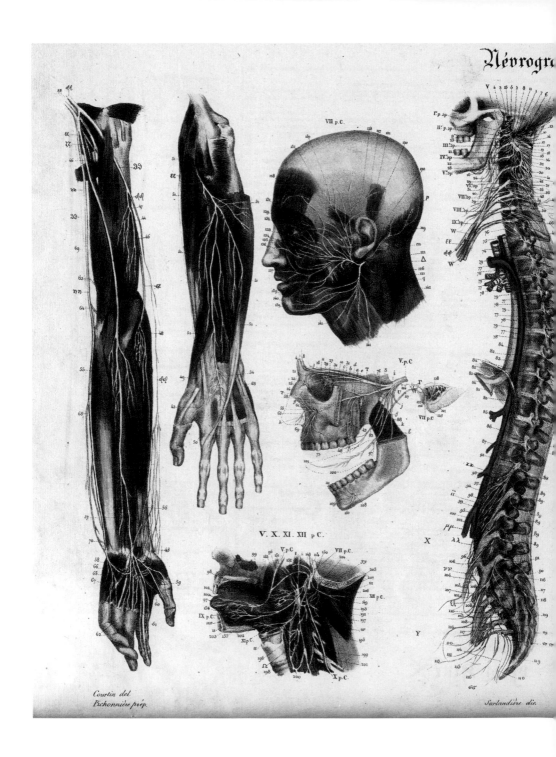

Courtin del
Pichonnière prép.

Sarlandière dir.

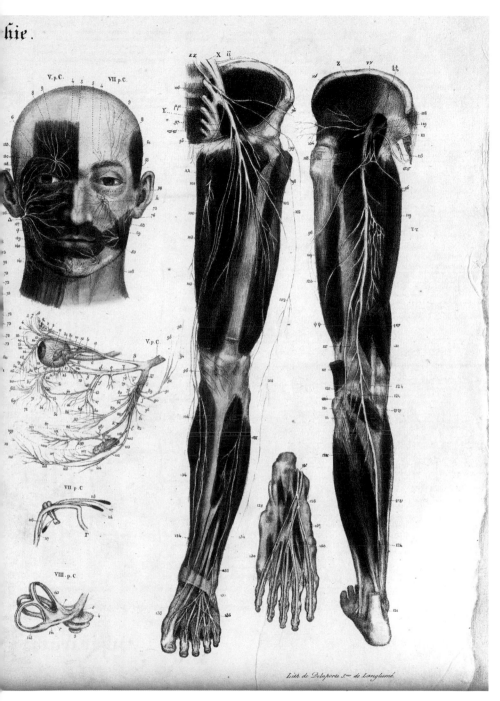

The nervous system, with various views showing nerves of the head, spine, arms, and legs

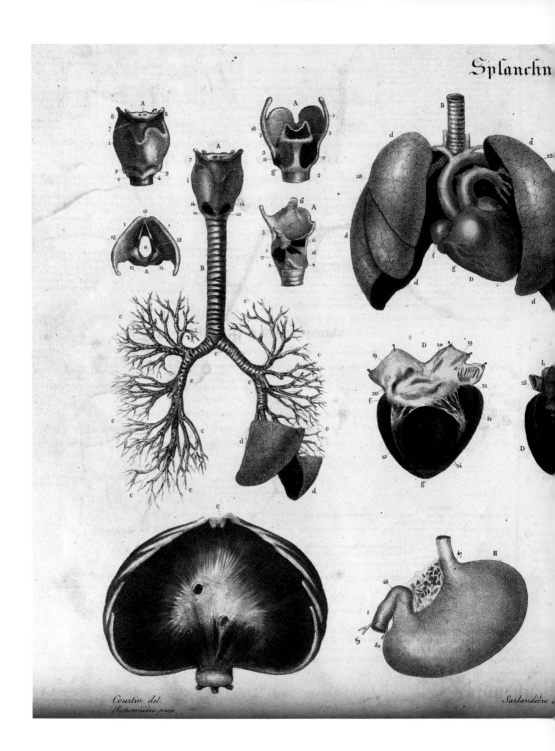

Courtin del.
Pichonnière prep.

Sarlandière

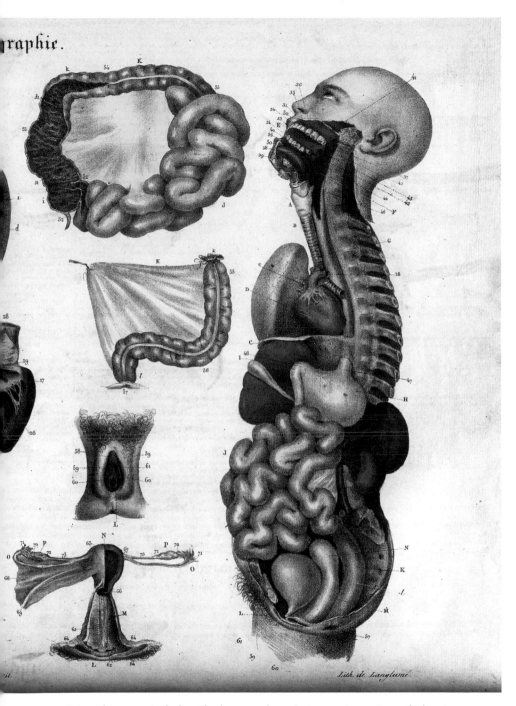

Internal organs, including the lungs and respiratory system, stomach, heart, digestive system, and reproductive system. Female

Pl. 68.

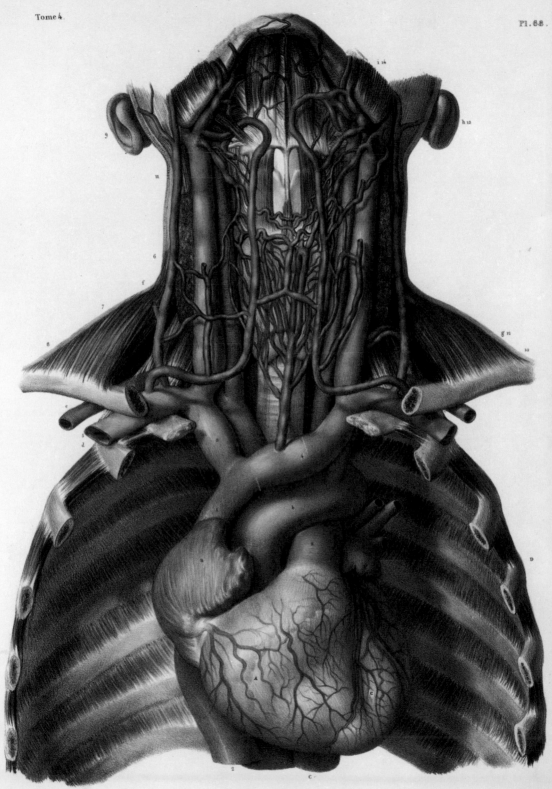

Jean-Baptiste Marc Bourgery (1797–1849)
Nicolas-Henri Jacob (1782–1871), drawings

Traité complet de l'anatomie de l'homme comprenant la médecine opératoire
Paris, 1831–1854

CLOQUET'S MULTIVOLUME ANATOMICAL ATLAS was one of three pub-
lished in Paris during the first half of the nineteenth century. By the
time the last volume of the last one was published in 1866, these
totaled seventeen large volumes: five from Cloquet; eight from Jean-
Baptiste Marc Bourgery; and four from Constantin Louis Bonamy.
The infrastructure of anatomists, artists, lithographers, printers, and
publishers – and sufficient cadavers for dissection – required to cre-
ate the thousands of plates in these and the many other less com-
prehensive anatomical works published simultaneously could not
have been found in any other city. The cadavers came from the pub-
lic hospitals, as the bureaucracy mandated that any corpse could be
examined by the same ever-expanding medical establishment that
produced the anatomists. The artists and printmakers were turned
out in great numbers by the city's unrivaled art academies and print-
ers. But who supported this effort by purchasing the books that
resulted from it? We don't know. Presumably they were too expen-
sive for students, but they certainly found their way into the homes
of that growing class whose name – the bourgeoisie – the French
contributed to the world's languages at around this same time. One
imagines an unopened set of them in the study of Dr. Charles
Bovary, the dull, plodding husband of Emma Bovary. And unopened
many of them undoubtedly were, if the evidence of their present-day
condition is any indication.

Unlike Cloquet, Bourgery's one achievement was his anatomy
atlas. The story is often told that when, as a young anatomist just out
of school, he confessed to the scientist Georges Cuvier his dream
project, the great man told him that it would consume a lifetime.
Cuvier was proven right in this; Bourgery, with a squadron of helpers
and the collaboration of the very talented Nicolas-Henri Jacob, pub-
lished his first volume in 1831 and had been in his grave for twenty-
two years when the last volume of a revised edition came off the
press in 1871. Cuvier approved the results, which he attributed in
part to advances in lithography: "One must say that without the art
of the printer, natural history and anatomy, as they exist today, would
not be possible."

Opposite: Dissection of the neck and thorax, heart, and veins of the neck,
shown in situ. Anterior thoracic wall divided and removed, lungs removed to
show heart, superior vena cava, brachiocephalic vein, and jugular veins. Aorta
and carotid arteries also shown. Anterior view

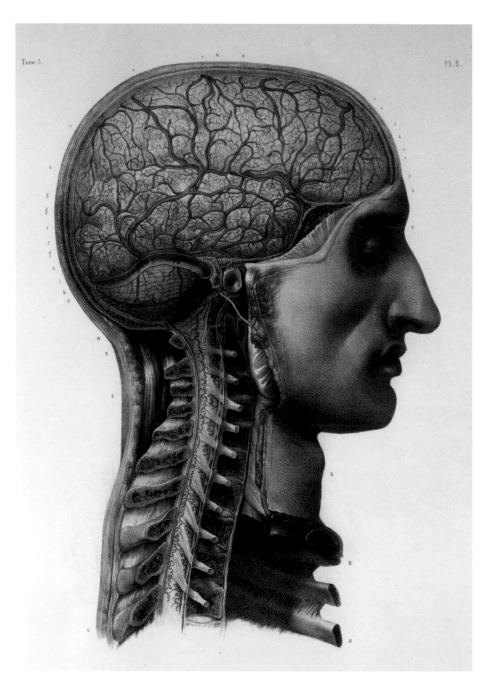

Pl. 8.

Brain and cervical spinal cord, shown in situ. Cranium divided in sagittal section to show intact brain, face also shown intact. Dura mater removed. Cervical spine divided to show spinal cord and cauda equina. Cranial sinuses and spinal nerves shown. Lateral view

Opposite: Brain, cerebellum, brainstem, and spinal cord, shown in situ. Head and skull dissected, brain divided in sagittal section to show corpus callosum, pituitary gland. Falx cerebri and cranial sinuses partly shown. Medial view of brain, face shown intact. Male cadaver, lateral view

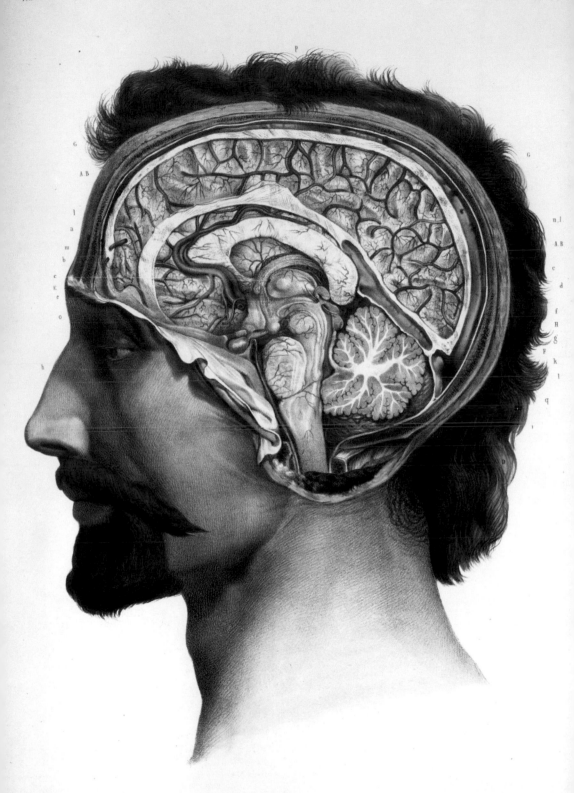

d'apres nature par N.H. Jacob

Lith par A Leroux.

Imp. Lemercier, Benard et C.ie

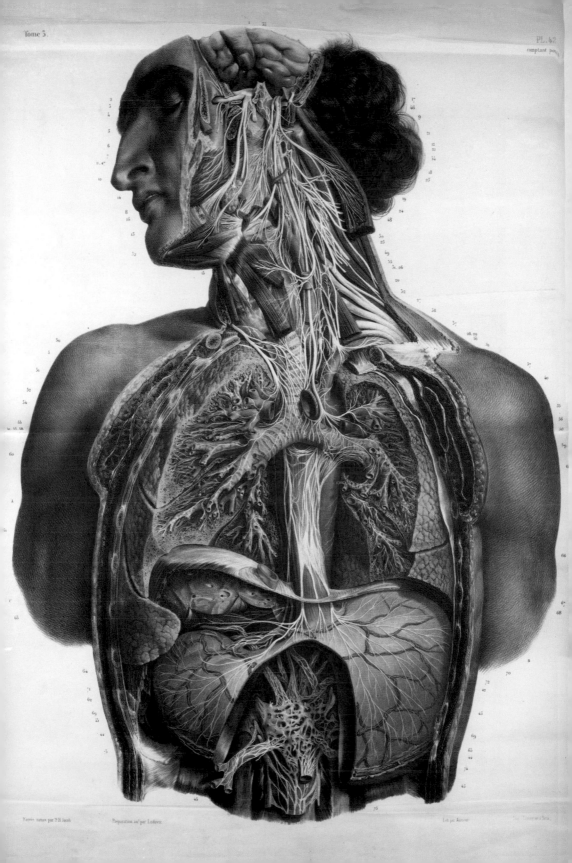

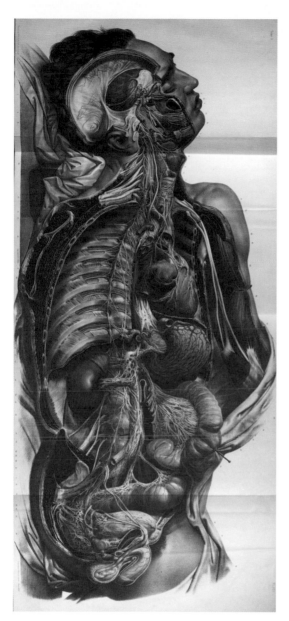

Autonomic nerves of the body, shown in situ. Thorax and abdomen divided in sagittal section, with deep dissection of the head and neck to show autonomic pathways. Brain, lungs, liver, and small intestines removed to show cranial nerves, autonomic plexus in the thorax, abdomen, and pelvis. Heart, stomach, kidneys, adrenal glands, and mesenteries shown. Sympathetic chain and ganglia, brachial plexus. Male cadaver, lateral view

Opposite: Autonomic nerves of the face, neck, thorax, and abdomen, shown in situ. Dissection to show branches of the trigeminal nerve (cranial nerve V), glossopharyngeal nerve (cranial nerve IX), and hypoglossal nerve (cranial nerve XII). Spinal nerves and brachial plexus, vagus nerve (cranial nerve X), and laryngeal nerves, esophageal plexus, and celiac plexus also shown. Lungs and stomach shown divided. Male cadaver, anterior view

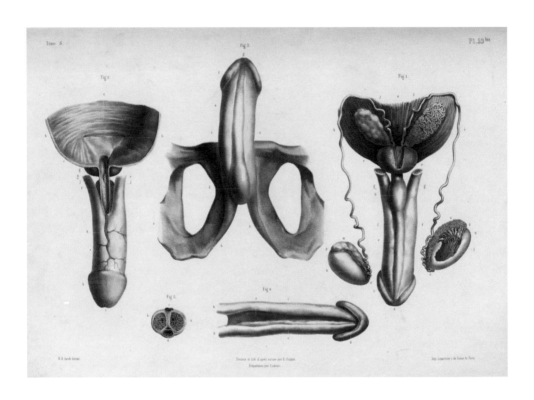

Dissection of the male urogenital system, shown in isolation, in five numbered illustrations. One illustration of penis, skin removed, shown with bladder in cross section, anterior view. One illustration of penis, skin removed, shown with pelvic bones. One illustration of penis with bladder, prostate, seminal vesicles, testes, and vas deferens. Testis dissected to show seminiferous tubules and epididymis, posterior view. One illustration of penis in isolation, dissected to show glans and corpora cavernosum. One illustration of penis divided in transverse section

Opposite, top: Dissection of the pelvis, female urogenital system, shown in situ. Anterior pelvic wall divided and removed, to show uterus, Fallopian tubes, ovaries, and round ligament. Bladder partly shown. Rectum and iliac arteries also shown. Anterior view

Opposite, center and bottom: Dissection of the pelvis, female urogenital system, shown in situ. Female pelvis divided in transverse section at the level of L4 (4th lumbar vertebra). Uterus, Fallopian tubes, ovaries, and bladder shown. Rectum, aorta, inferior vena cava, and iliac arteries also shown. Superior view

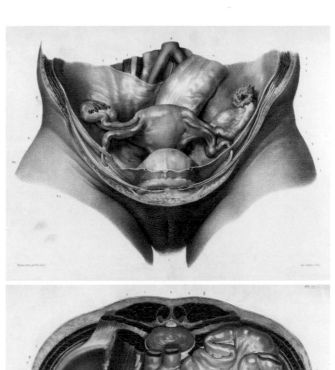

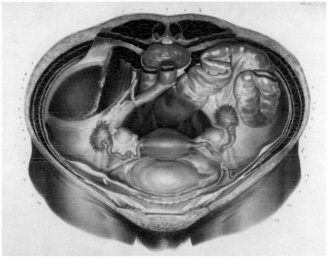

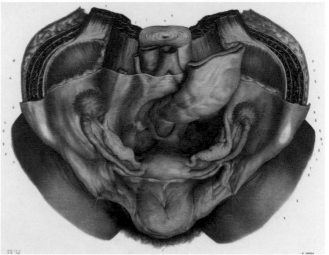

Pl. 86.

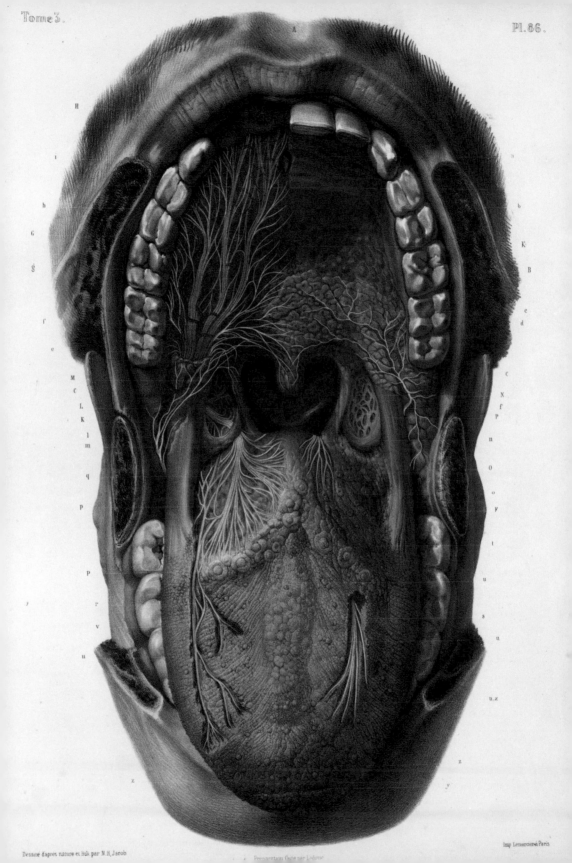

Dessiné d'après nature et lith. par N.H. Jacob

Préparation faite par Ledoux

Imp. Lemercier à Paris

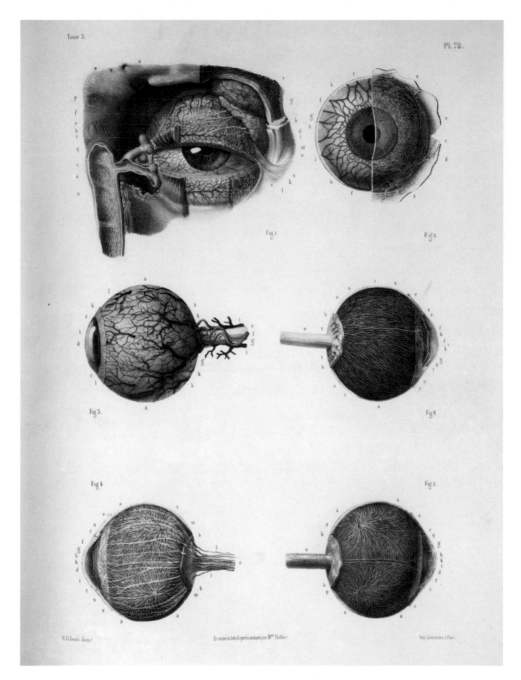

N.H.Jacob direx.t

Dessiné et lith.d'après nature par M.me Hublier.

Imp Lemercier à Paris.

Eye, shown in situ and in isolation, in six numbered illustrations. Dissection of the orbit to show eye, lacrimal apparatus, anterior view. Five illustrations of the eye and optic nerve (cranial nerve II), shown under the microscope, anterior and lateral views

Opposite: Mouth, oropharynx, nerves of the oropharynx. Dissection of the tongue and palate to show branches of the trigeminal nerve (cranial nerve V) and glossopharyngeal nerve (cranial nerve IX). Papillae, permanent dentition, tonsils, and uvula shown. Anterior view

Traité complet de l'anatomie • 279

Plate 1.

W.I.E. Wilson direxit.　　　　Drawn from Nature by T. Bagg.　　　　Will.m Fairland lith.
London, Taylor & Walton Upper Gower Street
Printed by Fairland.

Jones Quain (1796–1865) and Erasmus Wilson (1809–1884)

J. Walsh, William Fairland, J. W. Giles, and George Childs, drawings

The viscera of the human body: including the organs of digestion, respiration, secretion, and excretion

London, 1840

Joseph Maclise (ca. 1815–ca. 1880)

Joseph Maclise and Daniel Maclise (1806–1870), drawings

Surgical Anatomy

London, 1856 (2nd ed.)

George Viner Ellis (1812–1900)

George Henry Ford (1809–1876), drawings

Illustrations of Dissections: in a series of original coloured plates the size of life

London, 1867

IN LONDON AS IN PARIS, there was a flowering of anatomical book publishing in the first half of the nineteenth century. With the founding of the University of London in 1828 – Charles Bell, the brother of John, gave the inaugural lecture – the capital finally had a medical school to compete with those of Edinburgh, Paris, and Leiden. Meanwhile, the private schools that the earlier generation of anatomists had founded either closed their doors or were incorporated into larger teaching hospitals, with state-of-the-art dissecting rooms. The Anatomy Act of 1832, which permitted physicians to take unclaimed corpses from workhouses and hospitals, while less permissive than the law in Paris, ensured these schools an adequate supply of cadavers for dissection. The study of anatomy was firmly integrated into an increasingly professionalized educational establishment, to provide practitioners – especially surgeons – with accurate anatomical information.

These developments set the stage for Henry Gray's great book. The most important of his precursors was Jones Quain, who took over the anatomy curriculum at University of London, now called University College, in 1831. (Jones's brother Richard joined him there as professor of descriptive anatomy a year later.) Quain, who

Opposite: Salivary glands, shown in situ with neck muscles. Deep dissection of face and neck, mandible divided and removed to show parotid gland, submandibular gland, and sublingual gland. Male cadaver, lateral view

received a medical degree from Trinity College, Dublin, and advanced training in Paris, published *Elements of descriptive and practical anatomy* in 1828. This book, illustrated with small wood engravings, was to be the principal competitor of Gray's *Anatomy* for the rest of the century. Between 1836 and 1842, Quain published a five-volume lithographic atlas of anatomy to rival books like Cloquet's: *The muscles of the human body* was followed by volumes on the vessels (1837), the nerves (1839), the viscera (1840), and the bones and ligaments (1842). His coauthor for the last four volumes was the colorful Erasmus Wilson, who later spent part of his fortune earned as a dermatologist on the commonweal, including the campaign to abolish flogging in the British navy and the erection of an Egyptian obelisk on the Thames embankment.

Before turning to Gray, however, we will take a brief look at the work of two anatomists associated with University College that exemplifies the pragmatic approach to anatomical illustration pioneered by John Bell for the use of surgeons (we have already looked at the work of another University College man, Robert Carswell, in an earlier chapter on the illustration of pathology). In mid-century, University College Hospital was a center for innovative surgical techniques, including one of the first operations under anesthesia in England in 1846.

The first of these, Joseph Maclise, produced his rather startling *Surgical Anatomy* in 1851. Like the Quains, Joseph Maclise and his brother Daniel – who was to develop into an important British Romantic painter – came from County Cork in Ireland; Joseph studied anatomy with Richard Quain in London. The book the Maclise brothers produced was intended strictly for surgeons: Joseph's aim was "truthful demonstrations well planned in aid of practice We dissect the dead body in order to furnish the memory with as clear an account of the structures of its living representative as if this latter, which we are not allowed to analyse, were perfectly translucent." What they produced was far from the undisguised dissections of John Bell, but rather a portrait gallery of extremely buff Victorians, somehow transfigured from the cadavers of the recently deceased urban poor that presumably comprised their actual subjects.

George Viner Ellis was a demonstrator for Richard Quain and subsequently joined him on the faculty at University College. His *Illustrations of Dissections,* with drawings by G. H. Ford that were clearly influenced by Maclise, is a pioneering example of color lithography.

Opposite: Lungs, shown in situ. Anterior thoracic wall divided and removed, heart removed to show lungs. Brachiocephalic veins, carotid arteries, trachea, and thyroid gland partly visible. Anterior view

Plate 14.

W. J. E. Wilson, Direxit.

Drawn from Nature by W. Bagg.
London, Taylor & Walton, Upper Gower Street.
Printed by Hullmandel.

Wall. Richard, Lithog.

Abdominal regions, shown on intact torso. Abdomen shown with twelve regions indicated: left and right hypochondriac regions, epigastric region, left and right lumbar region, umbilical region, left and right iliac regions, and the hypogastric region. Male subject, anterior view

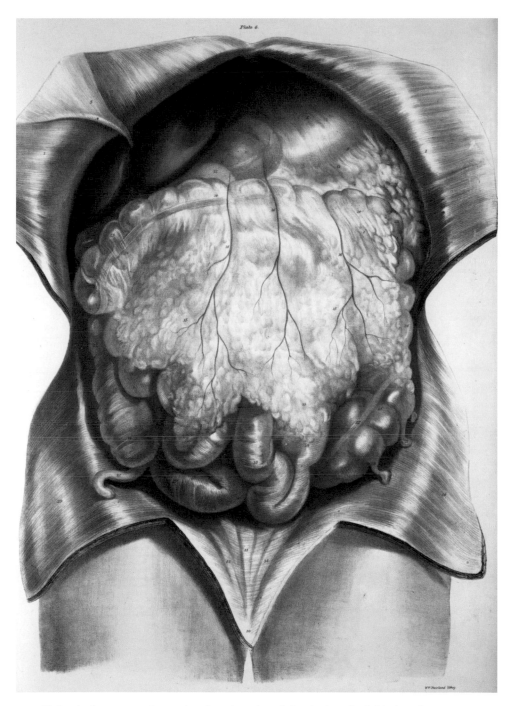

Abdominal organs, shown in situ. Anterior abdominal wall divided and reflected to show omentum and intestines, liver partly visible

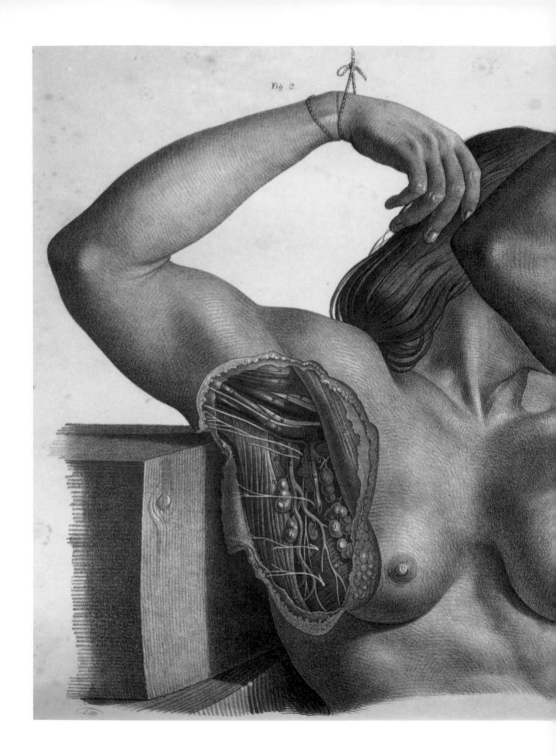

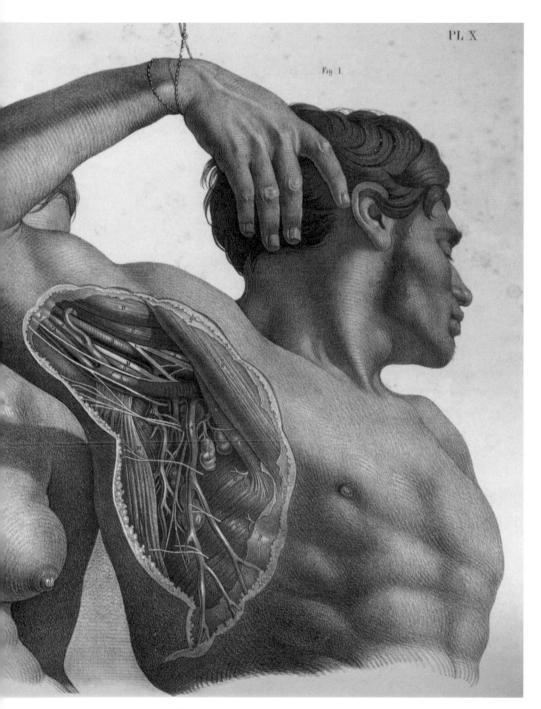

Fig. 1

Dissection of the axilla, deep dissection, in two numbered illustrations. Brachial vein and axillary artery and their branches, brachial plexus, and axillary lymph nodes shown. Male and female cadavers, anterior view

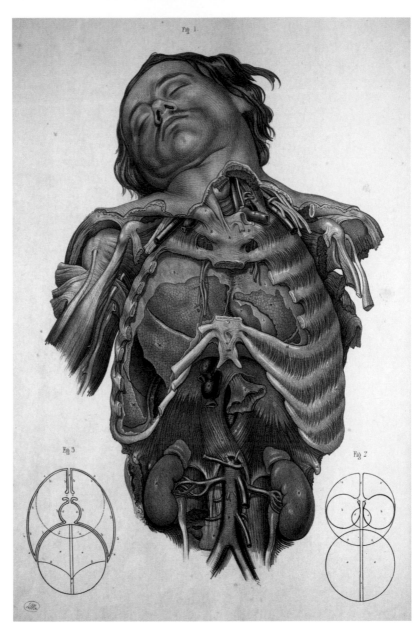

Dissection of the thorax and abdomen, shown in situ, in three numbered illustrations. One illustration of head and torso, rib cage partially divided and removed (leaving manubrium and xiphoid bone) to show lungs, intercostal muscles. Heart partly visible. Anterior abdominal wall, stomach, and intestines removed to show diaphragm, aorta, kidneys, adrenal glands, and ureter. Partial dissection of the shoulder to show axillary artery, brachial plexus. Male cadaver, anterior view. Two inset diagrams showing the relative position of the thorax and pleura to the abdomen and peritoneum. Male figure, superior views. *Opposite*: Location of viscera in vivo, shown as a diagram superimposed on the torso. Lungs, heart chambers, diaphragm, stomach, and intestines indicated. Male figure, anterior view

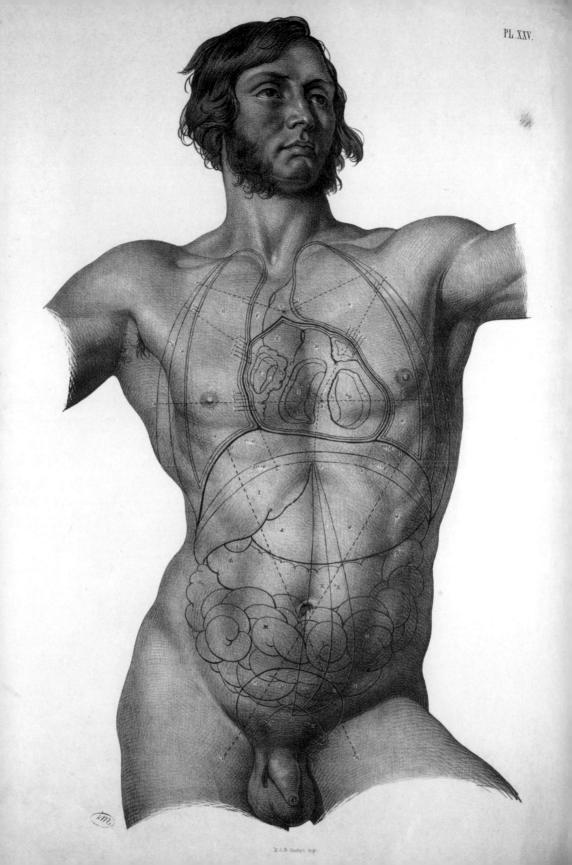

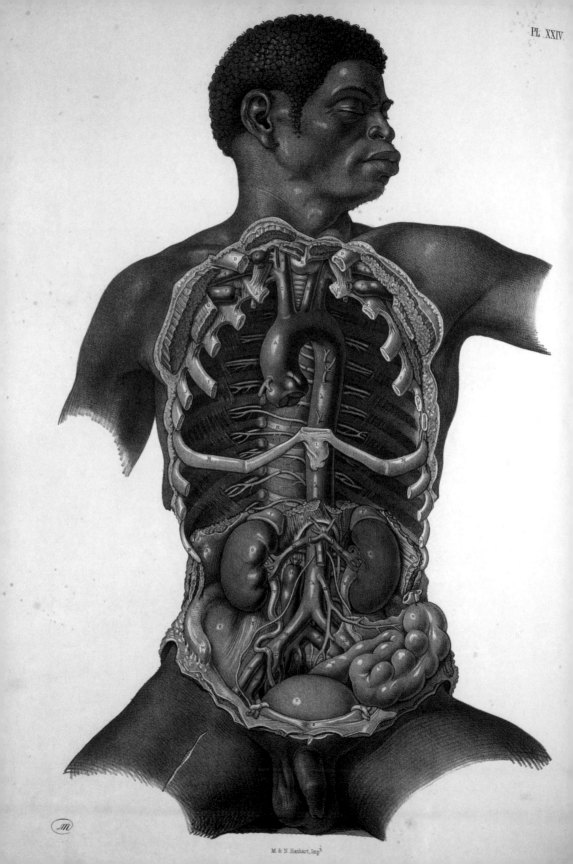

M & N Hanhart, Imp.

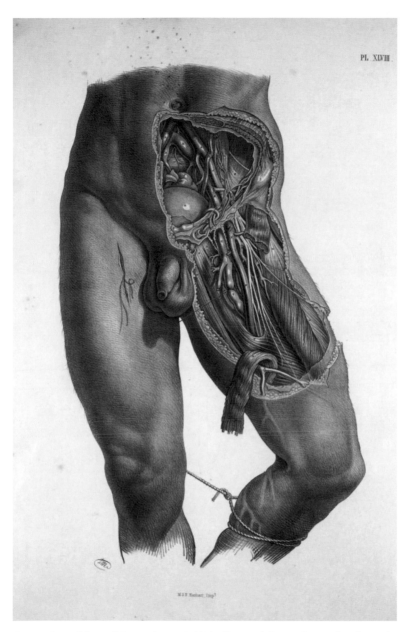

M.J.N Rasbart. lith.?

Dissection of the pelvis, groin, and thigh; iliac and femoral vessels, shown in situ. Anterior pelvic wall divided and removed, intestines removed, deep dissection of the groin and thigh. Iliac artery and vein, bladder, ureter, femoral artery, vein, and nerve shown. Male cadaver, anterior view

Opposite: Dissection of the thorax and abdomen; male urogenital system, shown in situ. Anterior thoracic and abdominal walls divided and removed; most viscera removed to show aorta, brachial and carotid arteries, renal, mesenteric, and iliac arteries, kidneys, and adrenal glands, ureters, bladder, and sigmoid colon. Ribs of posterior thoracic wall, intercostal arteries and nerves also shown. Tenth rib and xiphoid bone also shown in situ. Male cadaver, anterior view

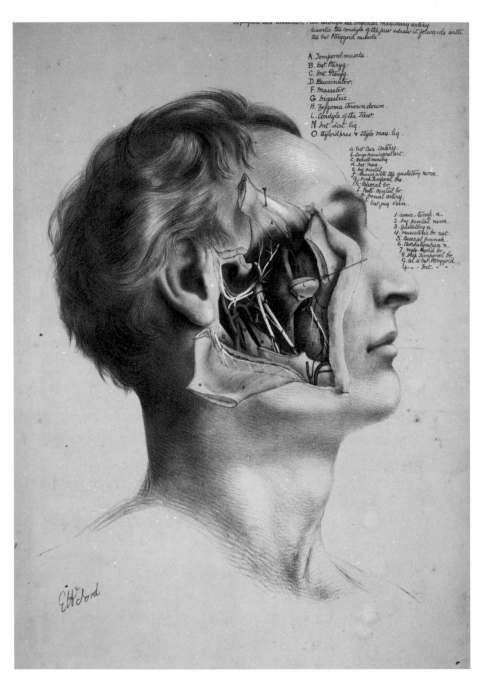

A. Temporal muscle.
B. Ext. Pteryg.
C. Int. Pteryg.
D. Buccinator.
F. Masseter.
G. Digastric.
H. Zygoma thrown down.
L. Condyle of the Jaw.
N. Int. lat. lig.
O. Styloid pres. + stylo max. lig.

a. Ext. Car. artery.
b. Large meningeal art.
c. Small meningy.
d. Int. max.
e. Inf. Dental.
f. Branch with the gustatory nerve.
g. Deep Temporal brs.
h. Buccal br.
i. Post. dental br.
*. Facial artery.
*. Ext. Jug. Vein.

1. auric. temp. n.
2. Inf. Dental nerve.
3. Gustatory n.
4. Masseteric br. cut.
5. Buccal branch.
6. Chordatympan. n.
7. mylo-hyoid br.
8. deep Temporal br.
9. Bt. to Ext. Pterygoid.
4. - - Int. - - -

to - - - - - - - through the internal maxillary artery
disartic. the condyle of the jaw + draw it forwards with
the Ext. Pterygoid muscle.

Dissection of the face, deep dissection, shown in situ. Skin and muscles
divided and reflected, mandible divided and removed to show jugular vein,
carotid artery and its branches, and branches of the trigeminal (cranial
nerve V). Male cadavar, lateral view
Opposite: Cranial fossa, cranial nerves, eyes, and oculomotor muscles, shown
in situ. Skull divided in transverse section, brain removed to show base of
skull, cranial fossa, cranial nerves in situ. Trigeminal ganglion shown. Orbits
divided to show eyes and oculomotor muscles in situ. Superior view

ὀφλὸς long ΚΕΦΑΛΗ = head ・ ・ προ: before γναθος = jaw
βραχίων arm ・ ・ μέσος = middle ・ ・ pertaining to premaxillary bone. gnathic index 98 to 103.
μεσάτης medium ・ ・ ὀρθός = straight - gnathic index less than 98.

The middle cranial fossa & fossa for sigmoid sinus are nearer the Ext. Audit. Canal & the Tympanic cavity & the mastoid antrum in brachycephalic skulls than in dolichocephalic heads.

Fig. 5.—Typical Crania seen from the Vertex : a, Negro, index 70, Dolichocephalic ; b, European, index 80, Mesaticephalic ; c, Samoyed, index 85, Brachycephalic. (After Tylor.)

Fig. 6.—Lateral View of three typical Skulls: a, Australian, prognathous ; b, African, mesognathous ; c, European, orthognathous. (After Tylor.)

2. Optic nerve
3. 3rd n.
4. 4th n.
5. 5th n.
6. 6th n.
13. Gasserian ganglion
20. nasal n. at its origin
21. upper br. of 3rd
22. Lower br. "
23. nasal n. leaving orbit
24. Infratrochlear n.
25. Lenticular gang.
26. Long root of lentic. g. to nasal n.

4 parts of Optic nerve.
1. The intracranial . 1 cm. long.
2. The intra canalicular { (a) bony 4 m.m.
{ (b) fibrous extending into cranial cavity. = 2 m.m.
3. Intra orbital 3 c.m. lax & S shaped, to permit of rotation.
4. Intra-ocular piercing sclera & choroid = 1·25 m.m. long.

The Central artery & Vein of the Retina enter the Optic n. 10 m.m. behind the globe.

4th & last stage. 3rd stage of dissection.

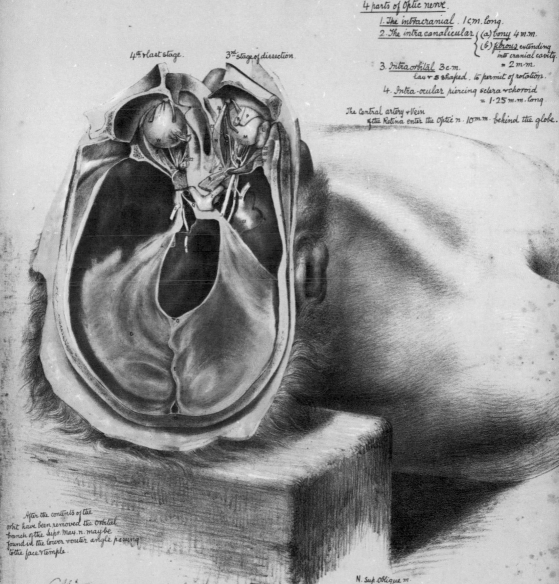

After the contents of the orbit have been removed the orbital branch of the Supr. Max. n. may be found in the lower outer angle passing to the face & temple.

G.M. Ford. Q. The Cavernous Sinus (for structures in the outer boundary see Pl. XII)

N. Supr. Oblique m.
O. Supr. long. Sinus.
P. Lev. Palp. Supr.
Q. Cav. Sinus.
R. Supr. Rectus.
S. Ext. Rectus (note the nerves passing between its heads) 3rd, nasal of 5th, 6th.
V. Infr. Rectus.
W. Infr. Oblique.
X. Int. Rectus.

The dura at base, the Cavernous Sinus, the dissection of orbit in its two deeper stages.

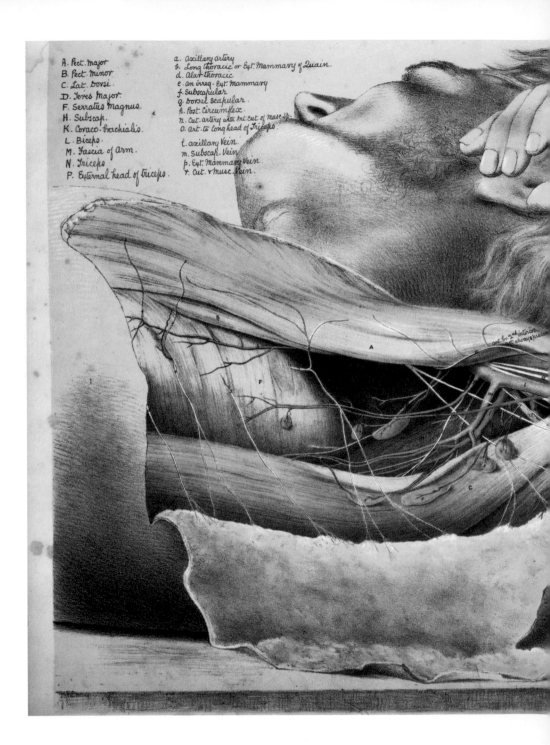

A. Pect. Major
B. Pect. minor
C. Lat. dorsi.
D. Teres Major.
F. Serratus Magnus.
H. Subscap.
K. Coraco-brachialis.
L. Biceps.
M. Fascia of arm.
N. Triceps
P. External head of triceps.

a. axillary artery
b. Long thoracic or Ext. Mammary of Quain.
d. Alar thoracic
e. an irreg. Ext. Mammary
f. Subscapular
g. Dorsal Scapular.
h. Post. Circumflex
n. Cut. artery with int. cut. of musc.sp.
O. art. to long head of Triceps

l. axillary Vein.
m. Subscap. Vein.
p. Ext. Mammary Vein
r. Cut. & musc. Vein.

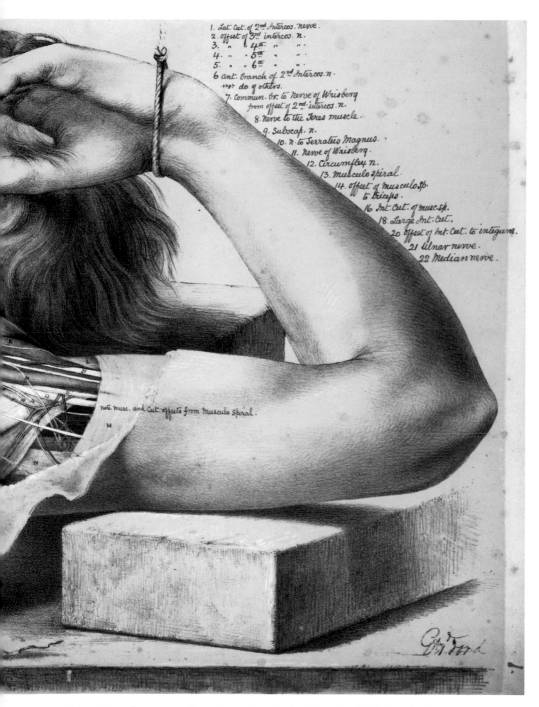

1. Lat. Cut. of 2nd Intercos. nerve.
2. offset of 3rd intercos. n.
3. " " 4th " "
4. " " 5th " "
5. " " 6th " "
6 ant. branch of 2nd Intercos. n.
+++ do of others.
7. Commun. br. to Nerve of Wrisberg
from offset of 2nd intercos. n.
8. Nerve to the Teres muscle.
9. Subscap. n.
10. n. to Serratus Magnus.
11. Nerve of Wrisberg.
12. Circumflex n.
13. Musculo Spiral.
14. offset of Musculo Sp.
to Biceps.
16. Int. Cut. of musc. Sp.
18. Large Int. Cut.
20 offset of Int. Cut. to integums.
21 Ulnar nerve.
22 Median nerve.

note musc. and Cut offsets from Musculo Spiral.

Dissection of the axilla, deep dissection, in situ. Muscles divided and reflect-
ed to show axillary artery and vein, subscapular artery and vein, ulnar and
median nerve, and axillary lymph nodes. Lateral view

Female Organs of Generation.

THE External Organs of Generation in the female are the mons Veneris, the labia majora and minora, the clitoris, the meatus urinarius, and the orifice of the vagina. The term "vulva" or "pudendum," as generally applied, includes all these parts.

The *mons veneris* is the rounded eminence in front of the pubes, formed by a collection of fatty tissue beneath the integument. It surmounts the vulva, and is covered with hair at the time of puberty.

Fig. 374.—The Vulva. External Female Organs of Generation.

The *labia majora* are two prominent longitudinal cutaneous folds, extending downwards from the mons Veneris to the anterior boundary of the perineum, and inclosing an elliptical fissure, the common urino-sexual opening. Each labium is formed externally of integument, covered with hair; internally, of mucous membrane, which is continuous with the genito-urinary mucous tract; and between the two, of a considerable quantity of areolar tissue, fat, and a tissue resembling

Henry Gray (1827–1861)
Henry Vandyke Carter (1831–1897), drawings

Anatomy, Descriptive and Surgical
London, 1858

HENRY GRAY, who was likely born in Windsor Castle (his father was private messenger to George IV at the time), entered St. George's Hospital, London, as a student at eighteen; by the time he was twenty-five, he had been made a Fellow of the Royal Society for contributions to medical knowledge. Ironically, the man who has became synonymous with the grimly unimaginative presentation of a vast body of knowledge was himself of broad scientific and intellectual interests.

Gray approached his colleague Henry Vandyke Carter, the hospital's Demonstrator of Anatomy, with his idea of jointly writing an anatomy textbook in 1855, in the midst of a national initiative to create a board that would regulate professional medical education. Carter, who went on to a distinguished medical career capped by his appointment as Honorary Surgeon to Queen Victoria in 1890, was an excellent choice. Their goal was to produce an affordable, accurate book that would help surgical students study anatomy, pass their exams, and solve problems that might arise in their practice.

The two spent eighteen months jointly performing dissections, while Gray wrote the text and Carter produced the illustrations. *Anatomy, Descriptive and Surgical* was an immediate success upon publication in August of 1858 (shown here are plates from the second American edition of 1862). While Gray's lucid text was widely appreciated, it was almost certainly Carter's limpid labeled diagrams that distinguished the book from all competition. It was a tour de force of reference-book publishing: well organized; handsomely designed; neither too large for portability nor too small for legibility. Part of its visual power came from the decision to use wood engraving rather than lithography for the illustrations: with their incisive lines, they appear authoritative but utterly devoid of opinion or personality. By rights, it ought to be called Gray and Carter's *Anatomy* – they were equally credited on the title page – but the latter joined the East India Company's medical service before the book was published and played no role in its subsequent history.

There is no space for that history here. Henry Gray died in June of 1861, at the age of thirty-four, from confluent smallpox contracted while caring for his nephew. His book acquired a life of its own.

Opposite: The vulva, with labiae, clitoris, and vaginal opening

Fig. 114.—Bones of the Right Foot.　Plantar Surface.

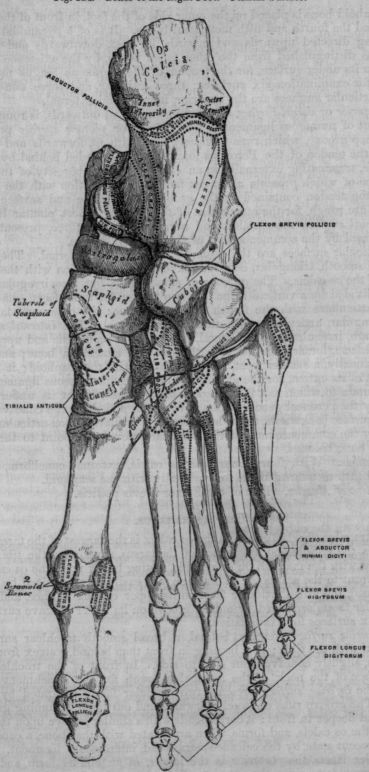

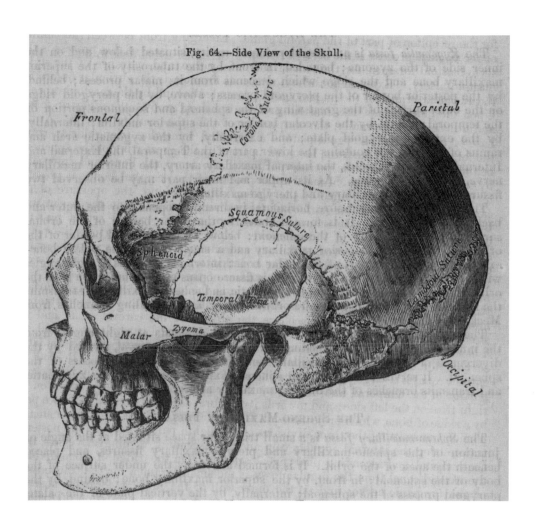

Fig. 64.—Side View of the Skull.

Frontal

Parietal

Coronal Suture

Squamous Suture

Sphenoid

Lambdoid Suture

Temporal Fossa

Malar

Zygoma

Occipital

Bones of the skull, lateral view
Opposite: Bones of the foot, superior view

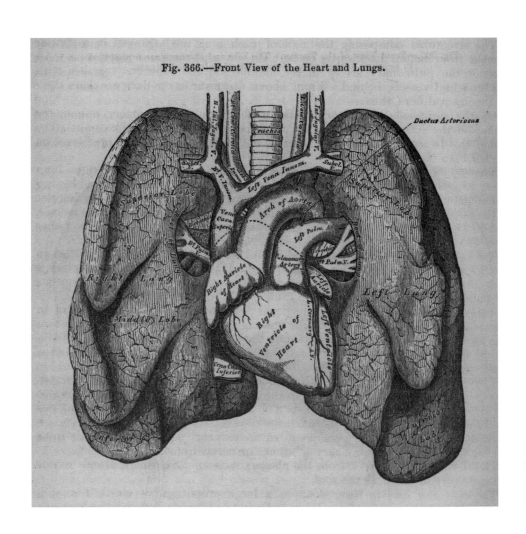

The heart and lungs, anterior view
Opposite: The brain, showing the arteries of the brain base. Inferior view

passes to the nasal duct, ramifying, in its mucous membrane, as far as the inferior meatus.

Fig. 214.—The Arteries of the Base of the Brain. The Right Half of the Cerebellum and Pons have been removed.

The *frontal artery*, one of the terminal branches of the ophthalmic, passes from the orbit at its inner angle, and, ascending on the forehead, supplies the muscles, integument, and pericranium, anastomosing with the supra-orbital artery.

The *nasal artery*, the other terminal branch of the ophthalmic, emerges from the orbit above the tendo oculi, and, after giving a branch to the lachrymal sac,

Fig. 275.—Nerves of the Orbit. Seen from above.

Nerves of the orbit and the optic nerve, superior view

Fig. 303.—A Vertical Section of the Eyeball. (Enlarged.)

Sclerotic
Choroid
Retina
Hyaloid Membrane
Optic Nerve
Cavity occupied
by Vitreous Humour
Ciliary Processes
Tendon of RECTUS
Ciliary Muscle & Ligament
Lens in its Capsule
Iris
Cornea
Circular Sinus
Canal of Petit

A vertical section of the eye

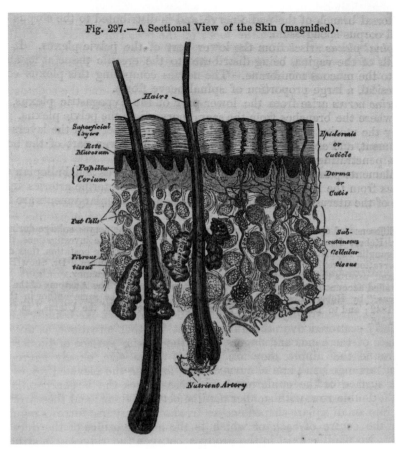

Fig. 297.—A Sectional View of the Skin (magnified).

Hairs

Superficial layers

Rete Mucosum

Papillæ
Corium

Fat Cells

Fibrous tissue

Epidermis or Cuticle

Derma or Cutis

Sub- cutaneous Cellular tissue

Nutrient Artery

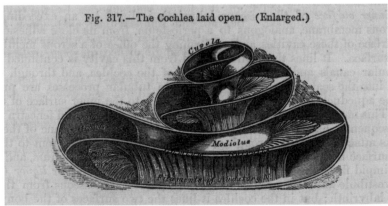

Fig. 317.—The Cochlea laid open. (Enlarged.)

Cupola

Modiolus

Top: A sectional view of the skin
Above: Cross section of the cochlea
Opposite: Views of the interior of the spleen

size even at their origin, commence on the surface of each vesicle throughout the whole of its circumference, forming a dense mesh of veins, in which each of these

Fig. 349.—One of the Splenic Corpuscles, showing its Relations with the Bloodvessels.

bodies is inclosed. It is probable, that from the blood contained in the capillary network, the material is separated which is occasionally stored up in their cavity; the veins being so placed as to carry off, under certain conditions, those contents

Fig. 350.—Transverse Section of the Human Spleen, showing the Distribution of the Splenic Artery and its Branches.

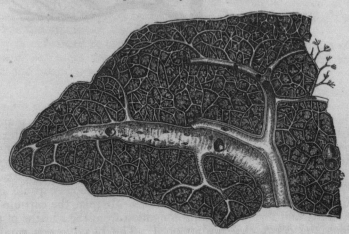

that are again to be discharged into the circulation. Each capsule contains a soft, white, semi-fluid substance, consisting of granular matter, nuclei similar to those found in the pulp, and a few nucleated cells, the composition of which is apparently

Braune gezeg.

Druck Veit & Comp. Leipzig.

J.G. Fritzsche imp. Leipzig.

Christian Wilhelm Braune (1831–1892)
C. Schmiedel, artist

Topographisch-anatomischer Atlas, nach Durchschnitten an gefrornen Cadavern
Leipzig, 1867–1872

Supplement: Die Lage des Uterus und Foetus am Ende der Schwangerschaft
Leipzig, 1872

AFTER ABOUT 1880, anatomy book publishing entered a period of stagnation, as poor-quality offset printing began to replace lithography in book illustration. The 1905 edition of Gray's *Anatomy* even reverted to wood engraving after years of awful offset experiments. New books continued to be published, but on the whole they were not particularly distinguished.

One notable project of the second half of the nineteenth century that was oddly prescient of developments at the end of the twentieth century was initiated by Christian Wilhelm Braune of the University of Leipzig. Braune and his colleagues developed superb techniques for cross-sectional anatomy. To create his *Topographisch-anatomischer Atlas* (*Atlas of Topographical Anatomy*), he obtained the cadaver of a healthy man who had committed suicide by hanging. The body was frozen and then sectioned, and tracings on thin paper were made of the sections. These tracings, along with direct observation, were used by the artist to produce more than thirty drawings, which were reproduced in the book via lithography. A similar technique was employed for the plates of female anatomy, as well as a supplement dealing with pregnant women.

We may wonder about the value of cross-sectional anatomical illustrations (which turn up in Vesalius and Estienne) for physicians and surgeons who never saw real anatomy in cross-section – at least until the development of CT scans and MRI. Braune, in his introduction, has an answer: "By means of the sections found in this atlas, the exact position and relations of the structures which must be divided or avoided in the course of an operation are indicated."

Twenty years after publishing his atlas, Braune, working with Otto Fischer, published *Der Gang des Menschen* (The Human Gait), a classic of biomechanics that also used data from frozen cadavers, this time using them to measure the body's center of gravity.

Opposite: A full-term fetus, posterior view

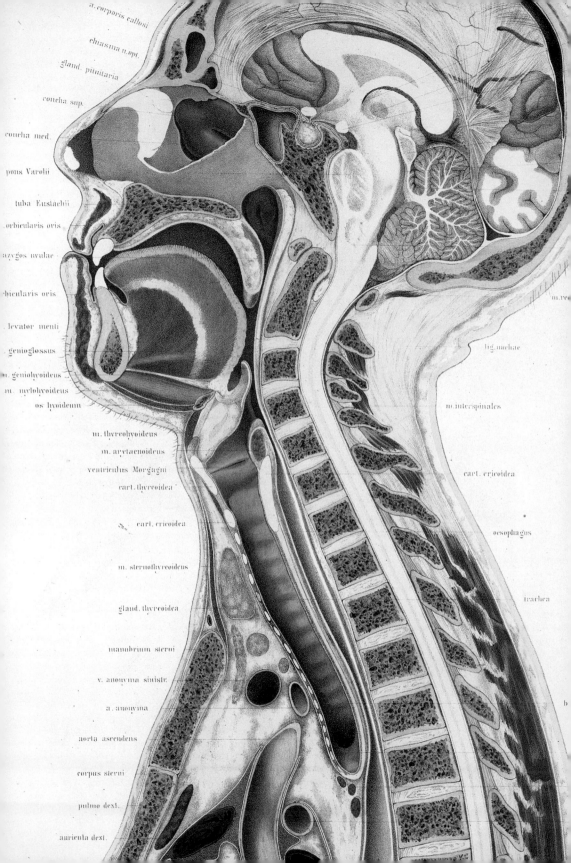

a. corporis callosi

chiasma n. opt.

gland. pituitaria

concha sup.

concha med.

pons Varolii

tuba Eustachii

orbicularis oris

azygos uvulae

rbicularis oris

levator menti

genioglossus

m. geniohyoideus

m. mylohyoideus

os hyoideum

m. thyreohyoideus

m. arytaenoideus

ventriculus Morgagni

cart. thyreoidea

cart. cricoidea

m. sternothyreoideus

gland. thyreoidea

manubrium sterni

v. anonyma sinistr.

a. anonyma

aorta ascendens

corpus sterni

pulmo dext.

auricula dext.

m. rre

lig. nuchae

m. interspinales

cart. cricoidea

oesophagus

trachea

b

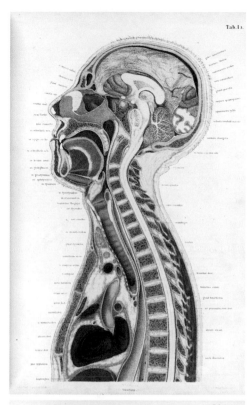

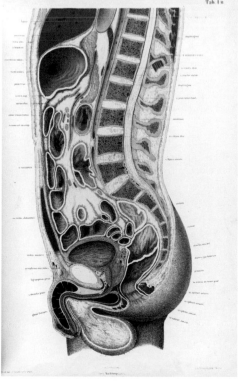

Sagittal section, male
Opposite: A detail of the same illustration

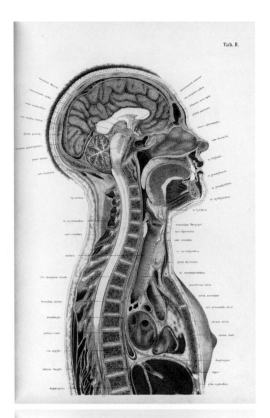

Tab. II.

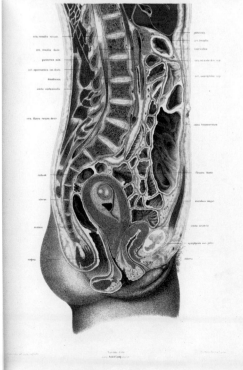

Sagittal section, female
Opposite: A detail of the same illustration

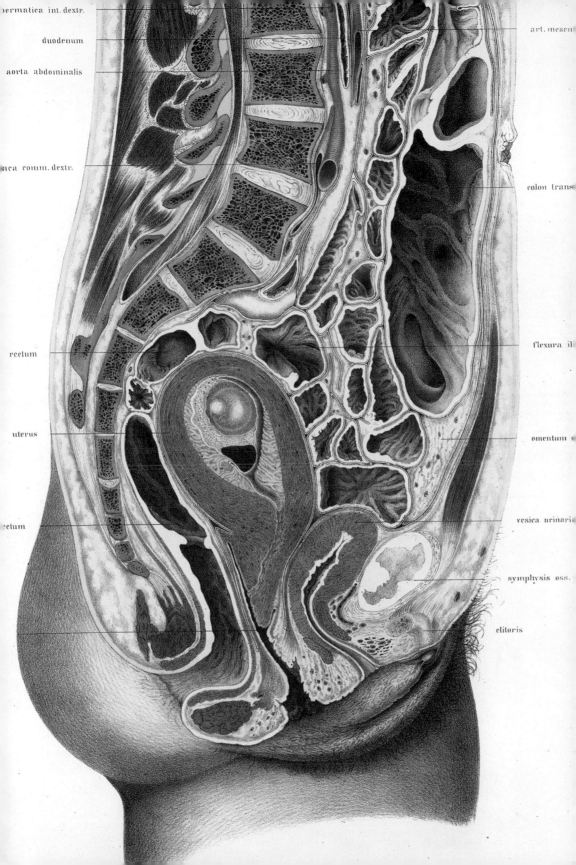

ermatica int. dextr.

duodenum

aorta abdominalis

aca comm. dextr.

rectum

uterus

ectum

art. mesen

colon trans

flexura il

omentum

vesica urinaria

symphysis oss.

clitoris

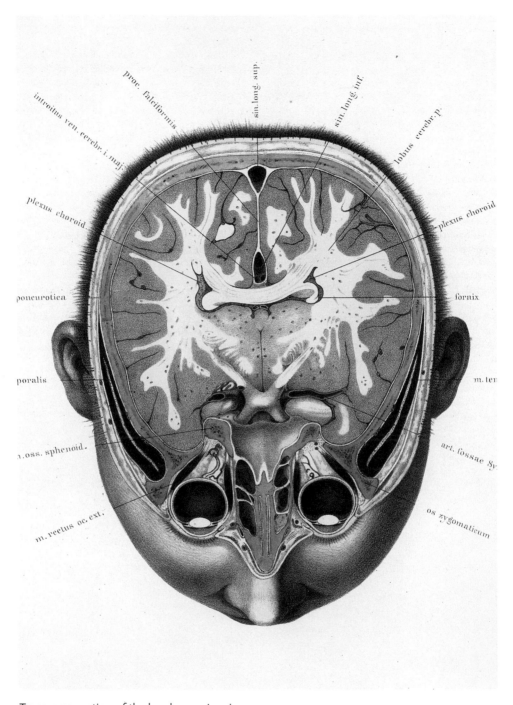

proc. falciformis

sin. long. sup.

sin. long. inf.

introitus ven. cerebr. i. maj.

lobus cerebr. P.

plexus choroid.

plexus choroid

poneurotica

fornix

poralis

m. ten

...oss. sphenoid.

art. fossae Sy...

m. rectus oc. ext.

os zygomaticum

Transverse section of the head, superior view

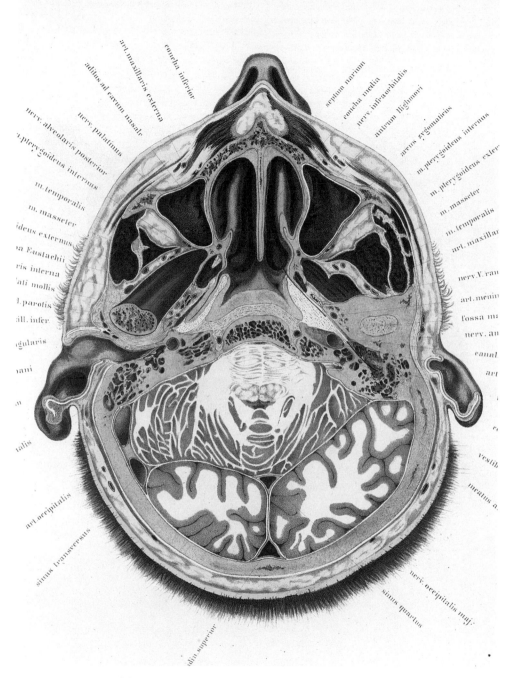

concha inferior

art. maxillaris externa

aditus ad cavum nasale

nerv. palatinus

nerv. alveolaris posterior

a. pterygoideus internus

m. temporalis

m. masseter

ideus externus

a Eustachii

ris interna

ati mollis

l. parotis

ill. infer.

gularis

ani

n

alis

art. occipitalis

sinus transversus

din. superior

septum narium

concha media

nerv. infraorbitalis

antrum Highmori

arcus zygomaticus

m. pterygoideus internus

m. pterygoideus exter

m. masseter

m. temporalis

art. maxillar

nerv. V. ram

art. menin

fossa m

nerv. au

canal

art

r

vestib

meatus a.

nerv. occipitalis maj.

sinus quartus

Transverse section of the head, inferior view

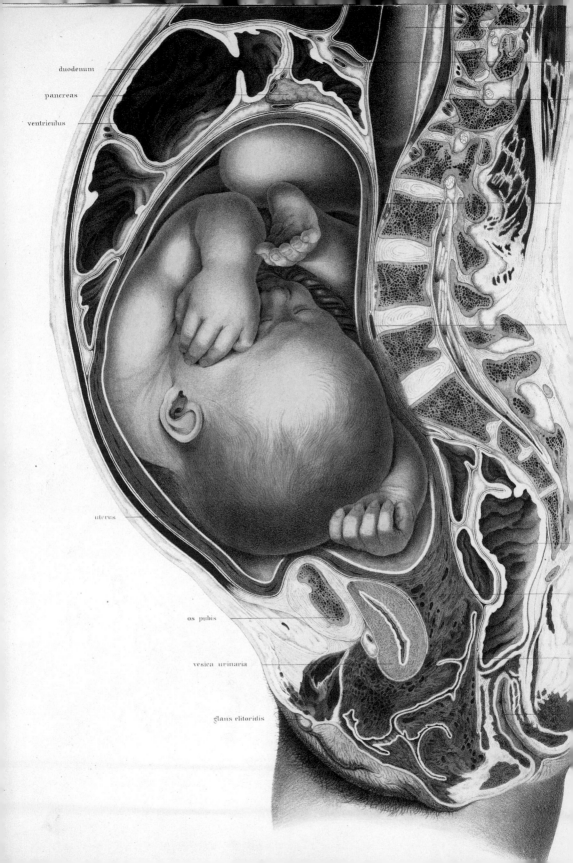

duodenum

pancreas

ventriculus

uterus

os pubis

vesica urinaria

glans clitoridis

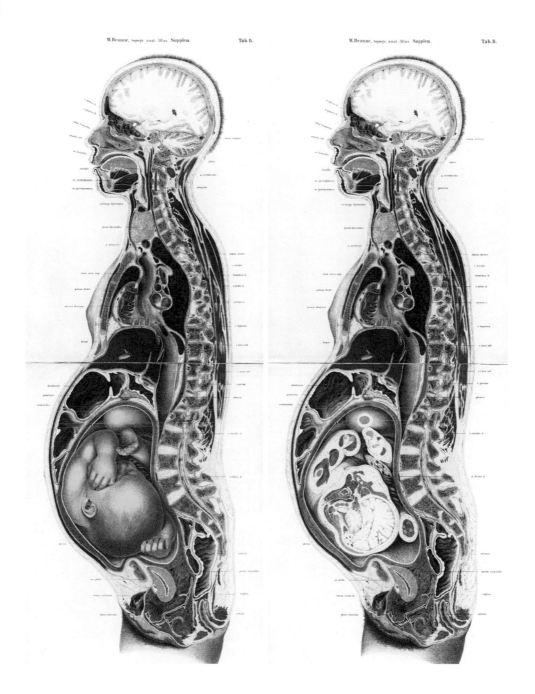

W.Braune, topogr. anat. Atlas. Supplem. Tab. B.

Sagittal section of a pregnant female, one view with fetus in the round, the other
in section
Opposite: A detail of the illustration above left

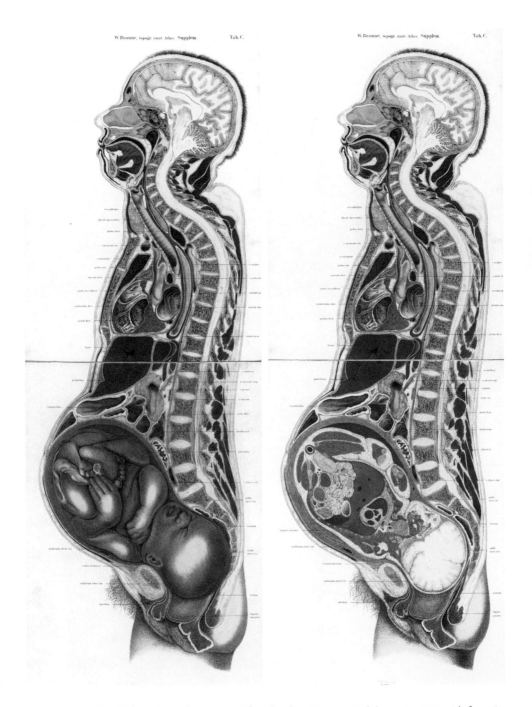

Sagittal section of a pregnant female about to go into labor, one view with fetus in the round, the other in section
Opposite: a detail of the illustration above left

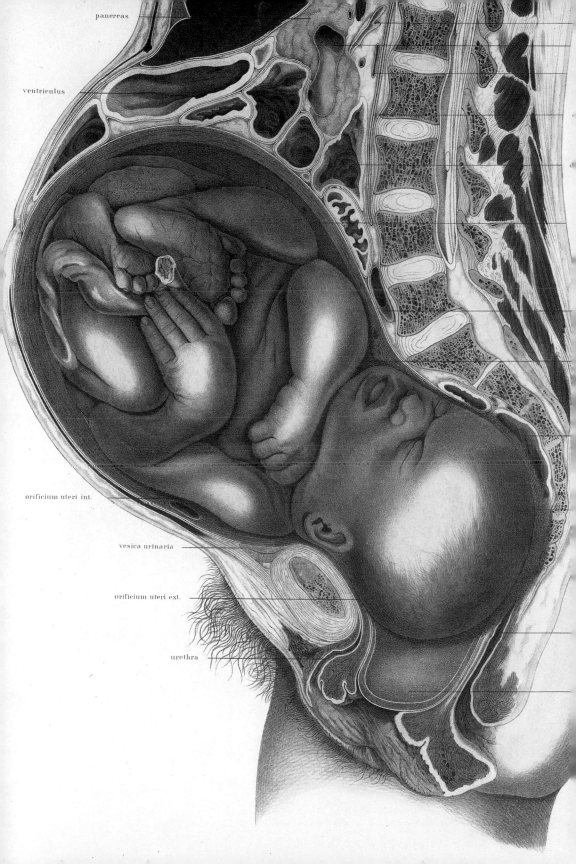

pancreas

ventriculus

orificium uteri int.

vesica urinaria

orificium uteri ext.

urethra

Anatomy in the Digital Age

Michael J. Ackerman

The hand of Mrs. Wilhelm Roentgen: the first X-ray image, 1895, from Otto Glasser, *Wilhelm Conrad Röntgen and the Early History of the Roentgen Rays*, London, 1933

THE CHALLENGE FACED BY ANATOMICAL ILLUSTRATORS has shifted dramatically since the rise of modern medicine. The reader of this book can see immediately that the great anatomical illustrators from the Renaissance to the eighteenth century by and large thought of themselves as image makers as much or more than faithful recorders of what they saw. From Vesalius's skeleton pondering a human skull to Albinus's skeleton contemplating a rhinoceros is two hundred years of imagery full of visual elements that would be not only useless but positively distracting to a medical student or practicing doctor. To be taken seriously as educational or diagnostic tools, that is, to meet the needs of the growing medical establishment of modern times, anatomical illustrations would need to attain a higher degree of accuracy, a quality that can be measured in different ways. Certainly, scientific accuracy calls for greater precision in rendering and the sacrifice of such artistic values as composition and proportion; clarity, not expressiveness; and a sharp focus on the parts that needed to be mastered by the student, with distracting elements omitted. These factors explain the widespread popularity in the second half of the nineteenth century of anatomical atlases like Gray's, which an artist might see as being plain and uninspiring.

In a deeper sense, accuracy demanded a better mode of 3D visualization than had been attained by anatomists working with artists since the Renaissance. From the beginning of anatomical art, two-dimensional atlases of anatomy have been the mainstay for visualizing and identifying features of the human body and for understanding the relationships among these features. There is no question that enormous progress was made, from the primitive paper flaps used in the late Middle Ages to show that the organs were under the skin, to the remarkable axonometric perspectives of organs, systems, and body cavities mastered by nineteenth-century artists after demanding technical training. It was partly because each ensuing century brought more innovative rendering techniques that the understanding of human anatomy advanced as it did. Virtually every strategy that would later be used in the twentieth-first century world of digital imaging to portray a 3D image on a flat surface was developed by artists working before the twentieth century. (It is interesting to note in this regard that even the cross section view of the human body familiar now from CT scans and MRIs was anticipated by certain anatomical atlases that consisted of drawings of frozen cross sections of human cadavers. Serial sectioning of a specimen and viewing it with a microscope was the classic way of studying pathology.) Very few of the images reproduced thus far in this book, however, would be adequate for modern medical education, and, by definition, none

would be a reliable guide to a doctor or surgeon caring for a specific patient.

The solution to this problem required that anatomical illustration, like so much else in the modern world, come under the control of machines rather than the subjective human hand and eye. In the nineteenth century, as a first step in this evolution, atlases based on photographs taken during cadaver dissection were introduced. The complex nature of the reality depicted in these photographs led to an interesting result—the photographs were often too cluttered with detail for students to be able to see their important features. Each photograph was often traced or accompanied by hand-drawn rendering of the same scene, in order to enhance or even to allow for understanding. The mid-twentieth-century anatomist J. C. Boileau Grant (opposite) described a common method in the preface to his *Atlas of Anatomy* (1943): "[E]ach specimen was posed and photographed; from the negative film so obtained an enlarged positive film was made; with the aid of a viewing box the outlines of the structures on the enlarged film were traced on tracing paper; and these outlines were scrutinized against the original specimen, in order to ensure that the shapes, positions and relative proportions of the various structures were correct. The outline tracing was then presented to the artist who transferred it to suitable paper and, having the original dissection beside her, proceeded to work up a plastic drawing in which the important features were brought out. Thus, little, if any, liberty has been taken with the anatomy; that is to say, the illustrations profess a considerable accuracy of detail."

For the purpose of teaching a student to identify an anatomical structure, a simplified tracing of the salient features in a photograph was probably preferable to an artist's freehand drawing of the same scene, even if a layman might find it duller to look at; but the necessary third dimension was still missing. This breakthrough would require the invention of mechanical visualization techniques that would render reality in 3D rather than 2D. The refinement of these was one of the many triumphs of medicine in the twentieth century.

X-RAYS A thorough grasp of the relationships between biological structure and function has been central to health care throughout recorded history, and providing a precise understanding of three-dimensional biological structure and its implications for therapy remains the gold standard for training in medical specialties such as surgery, neurology, and radiology today. To provide care, specialists in these areas require an intimate knowledge of the three-dimensional anatomy of the specific patient being treated, since the exact arrangement and

Fascia enveloping submandib- / ular gland

Facio-lingual artery

Stylo-hyoid

Ext. carotid artery

Occipital artery

Hypoglossal nerve
Accessory nerve

Desc. hypoglossi n.
Sternomastoid
artery

Int. carotid artery
Ext. carotid artery

Ansa hypoglossi
Common carotid
artery
Int. jugular vein
Sternomastoid
branch

Sternomastoid

"Fascial carpet"
of posterior triangle

Trans. cervical vein
(Trans. colli vein)

"Omohyoid fascia"

Sterno-(cleido)-
mastoid

Facial (Ext. maxill.)
artery
Submental artery
Mylohyoid nerve

Hyoid bone
Mylohyoid

Int. laryngeal nerve
Inf. Constrictor

Thyrohyoid

Ext. laryngeal nerve
Sup. thyroid artery

Sterno-thyroid
Sterno-hyoid

Ant. jugular vein

Clavicle

Clavicular head

Sternal head

Omohyoid

388. The Anterior Triangle of the Neck.

"The Anterior Triangle of the Neck," from J. C. Boileau Grant, *An Atlas of Anatomy* (Baltimore, 1943)

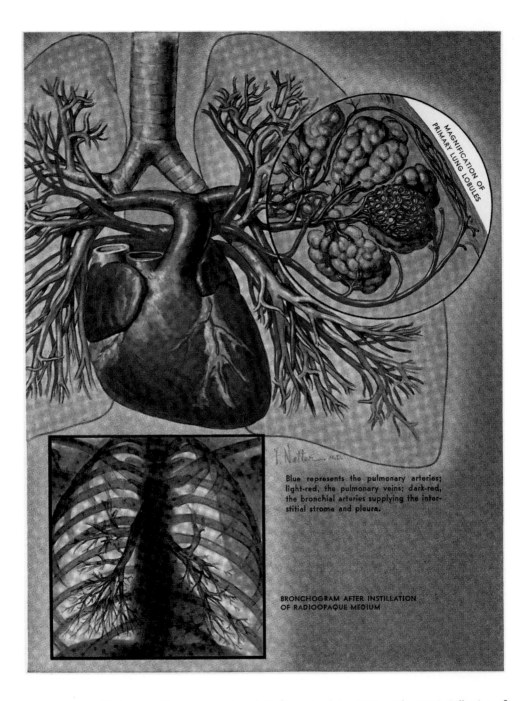

Blue represents the pulmonary arteries; light-red, the pulmonary veins; dark-red, the bronchial arteries supplying the interstitial stroma and pleura.

MAGNIFICATION OF PRIMARY LUNG LOBULES

BRONCHOGRAM AFTER INSTILLATION OF RADIOOPAQUE MEDIUM

"Pulmonary Vessels and Bronchi," from Frank H. Netter, *The CIBA Collection of Medical Illustrations* (Summit, New Jersey, 1948)

size of organs varies from individual to individual, and the exact form pathology may take is unique to each one of us. Enormous progress was made over the centuries, using cadavers, to map the interior of the average human body, but until the end of the nineteenth century, a doctor who wanted to know what was going on inside a specific patient's body would have to cut him open, often exposing him to more danger than he was in as a result of the condition that brought him to that doctor in the first place. It is probably not an exaggeration to say that the average doctor in the 1890s would have considered a noninvasive means of seeing under living human skin as unattainable as the ability to read someone else's thoughts.

That was about to change. In 1896, the German-born physicist Wilhelm Roentgen discovered the X-ray and invented X-ray photography, for which he was awarded the first Nobel Prize in Physics, in 1901. Now, for the first time, not without hazards to human health from radiation that it would take decades to understand and prevent, physicians could look inside the body noninvasively from the outside. But interpreting real anatomy from an X-ray is not as easy as it sounds.

The scene depicted in an X-ray is flat. There is no perspective. Everything appears to be located on the same plane. Look at an X-ray of the chest: the ribs, lungs, heart, and backbone appear as if they were all one structure. Furthermore, because the brightness of an object in an X-ray is determined by its physical density, not its relationship to a light source, X-rays don't even present the spatial relationships of objects as we are accustomed to seeing them. A dense object that is actually in the background of a scene may appear so bright in an X-ray that it obliterates objects that are actually in front of it. The correct interpretation of an X-ray image as a view of internal anatomical structure therefore requires a general knowledge of the anatomy in the region of interest, which was most likely obtained from cadaver dissection, the help of an anatomical atlas, and a little bit of imagination. In some of his well-known illustrations of anatomy and pathology, for example, doctor and artist Frank H. Netter juxtaposed X-rays and drawings to help practitioners better relate the one to the other (opposite).

Thus it came about that the availability of the X-ray as a diagnostic tool demanded the mastery of a new skill on the part of the physician: that of reading the X-ray, or rather, of reading a series of X-rays taken from different perspectives. Inevitably, some physicians were better at it than others. The attempt to convey three-dimensional content through a series of related two-dimensional images

man who had donated his body to science before being executed by lethal injection in Texas. The cross sections of the body were obtained in the following manner. The body was frozen, cross-sectioned into four parts, and embedded in a gelatin-ice mix. Beginning with the feet, the exposed surface of each cross section was sprayed with alcohol and then photographed with a digital camera. Then, a one-millimeter section was planed from each cross section, with a cutting device called a cryomacrotome, and the newly exposed surface was photographed. In this manner, 1,878 high-resolution digital images were obtained. A similar body of data was obtained from the body of an anonymous fifty-nine-year-old woman.

Thus, the Visible Human datasets are made up of consecutive digital images taken from real anatomical cross sections of a male and a female cadaver. Because the data is digital and the images are consecutive, 3D-modeling computer software can be used to reconstruct any aspect of anatomy in three dimensions. While the data does not change, enormous progress continues to be made in both the software and hardware used to convert it into 3D images. The data is presented in a way that corresponds to MRI and CT data, so that the correspondence between CT, MRI, and anatomic data can be learned and the three-dimensional nature of anatomy can be appreciated. The art of the past is combined with the technology of the present to provide a way to study and understand the full complexity of human anatomy in the future.

The Visible Human data has been used for a wide range of educational, diagnostic, and treatment purposes by researchers all over the world. For example, surgeons have used the data to "practice" surgery on the computer before operating on the real patient. Software has been developed that allows medical students to dissect virtual cadavers without destroying them: instead of cutting through muscle to view bone, the user can remove muscles one at a time by moving the cursor, revealing the skeleton with a series of mouse clicks. Environmental health experts are using the Visible Human data to devise computer models that predict the health risk of radiation exposure.

One consequence of the way the Visible Human datasets are

Opposite: These are five pictures using different imaging technologies of a cross section of the head of the male cadaver used for the Visible Human Project. The pictures across the top—a CT scan and three different modalities of MRI—are useful to diagnosticians who are experienced at reading them. They may reveal abnormalities in the density of tissues, for example, or the presence of fluids. The picture at the bottom is a digital photograph of the same cross section, showing the anatomy as it appears in visible light. In this picture, the very dark blue-green area indicates either a cavity or a place where material was lost when the body was sectioned.

CT

MRI
Proton Density

MRI
T1

MRI
T2

Visible Human cryosection

used is that the native format of the Visible Human images is in 3D, and when we look at them printed on the page, we are not seeing them to their best advantage. Because they are modeled in 3D in the virtual space of a computer, they are best viewed with a device like a computer, where they can be rotated in space and seen from different angles. There is a long history of anatomical teaching aids modeled in 3D in materials ranging from wax to plastic, but they always formed a minor tributary to the vast river of 2D imagery. Today, when every medical student has a computer and classrooms are equipped with multimedia equipment, we are probably reaching a turning point in the five-hundred-year history of anatomical illustration, when important new work for the medical community will have only a shadow presence on the page.

During the birth of the Visible Human project, some people predicted that the use of the Visible Human datasets on modern graphical computers would eliminate the need for artists in the field of anatomy. But just as happened in the past, students and teachers of anatomy quickly recognized that the images that resulted from an unedited stream of real-world data were too complex and too detailed for most purposes. Artists of the twenty-first century are now able to base their anatomical images on models generated in the computer from the Visible Human datasets, instead of real cadaver dissections. But it is still their interpretive and innovative renderings that help to make the human anatomy comprehensible.

Opposite: We can do a thought experiment to show how cross sections of a human cadaver might be used to create an accurate 3D model of human anatomy. Assume a stack of pages as high as a standing man. On each page is a drawing of the features you would see if you cross-sectioned the man at that precise spot. Now, let us say that you could cut away the paper on every page up to the edge of the particular anatomical structure that you wanted to reveal. You would end up with a 3D rendering of that structure, to a degree of accuracy controlled by the thickness of the paper. If you used cardboard, for example, your rendering would be much cruder than if you used tracing paper. This is similar to the process by which the digitally captured cross sections of the Visible Human Project have been used to generate 3D renderings of anatomical structures. Essentially, the digital images of the cross sections are manipulated in a 3D-rendering program so that they are arranged sequentially and in alignment, with the edges of any structure keyed so that they can be connected with lines to the edges of the same structure in an adjoining cross section. The contours of the 3D forms generated in this fashion are as accurate as the thickness of the cross sections used to generate them: in the case of the male cadaver used in the Visible Human project, this is one millimeter. The figures opposite were generated from the Visible Human dataset by the Center for Human Simulation at the University of Colorado, where the data was generated. But it is available to all, and researchers around the world have used it to develop virtual 3D models of human anatomy.

Thomas O. McCracken, general editor

New Atlas of Human Anatomy
New York, 2000

THE VISIBLE HUMAN DATASET was intended to be used primarily for 3D modeling in virtual space, but several anatomists have adapted it to 2D illustration. One of the first anatomical atlases based on the data was developed by a group of scientists and anatomical illustrators at Colorado State University who came together in 1986, ironically, to develop techniques to turn 2D anatomical illustrations into 3D computer models. The group, which formed a company called Visible Productions and developed the necessary 3D modeling techniques, used the Visible Human dataset to create 3D models of human anatomy. As one of its founders, Thomas O. McCracken, was an anatomical illustrator as well as an anatomist, the team found it irresistable to refine specific images of their 3D models for presentation in a 2D anatomical atlas. To create the images, the team selected the virtual models it wanted to reproduce; rendered their surface – or skin – using photographs of identical tissue samples as references; and added shading. The resulting pictures are clearly "illustrations" in the sense that they involve a process of selective emphasis, but they are nonetheless abstracted from real-world data.

While it would be presumptous to say that with volumes like the *New Atlas of Human Anatomy,* the five-hundred-year tradition of the printed anatomical atlas has come to a close, it is likely that the next entry in a book such as this would have to be a product that runs on a computer and visualizes human anatomy in 3D. Indeed, programs that allow students to do virtual dissections of the Visible Human Project cadavers presently exist, and there are others that give even deeper account of specific aspects of regional anatomy. The day is not far off when a physician will be able to look at a 3D model of the musculature of the arm and see not only the anatomical structures but be able to flex it and learn precisely how the motion deforms the muscles and compresses or extends the surrounding blood vessels and nerves; to view a model of the human heart and see its muscles contract and expand as blood courses through it.

Opposite: The skull, lateral view

Muscles of the shoulder and upper arm

The head and neck with the muscles removed to show the major blood vessels. Anterior view
Opposite: The heart and the main arteries and views of the head, right upper limb, and the trunk.
Anterior view

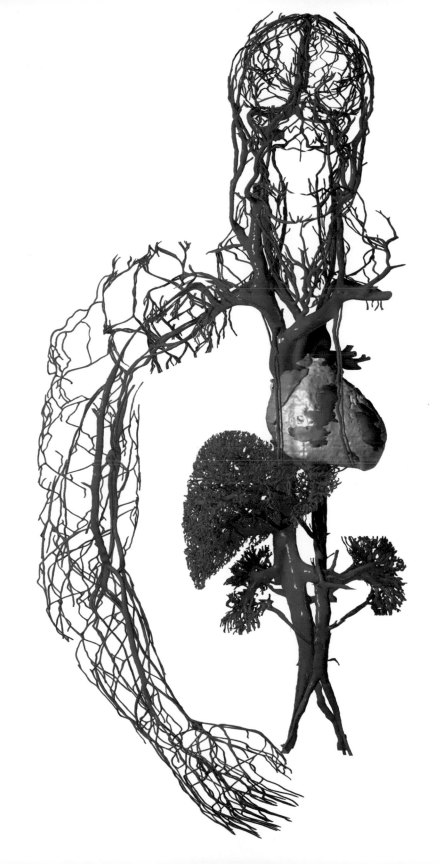

The female reproductive system, showing the pelvic girdle, right coxa (hip bone), left coxa (hip bone), right ovary, left ovary, uterus, and vagina. Anterior view

The male reproductive system, showing the urinary bladder, seminal vesicles, prostate gland, vas (ductus) deferens, testes, pubic symphysis, penis, and glans of penis. Anterior view

The heart with the superior and inferior venae cavae removed. Posterior view. The right and left pulmonary veins, which empty oxygen-rich blood into the left atrium, can be seen clearly

The right eye showing the extrinsic muscles and the optic nerve. Superior view

INDEX

Please note: Numbers printed in *italics* refer to illustrations.

Alberti, Leon Battista, 54
Albinus, Bernard Siegfried, 43, 50–55,
 56, 59, 60, 62, 177, 187, 229, 319; *52*
Antonides van der Goes, Jan, 49
Aristotle, 7
art, science vs., 64–67
Atlas of Anatomy, An (Grant), 320; *321*

Baillie, Matthew, 237, 238
Baldinucci, Filippo, 34
Ballard, Martha, 59
Balzac, Honoré de, 256
Baroque style, 8, 33, 34, 46, 51
Basire, James, 237
Baskerville, John, 60, 196
Battle of Ten Nude Warriors (Pollaiuolo),
 8; *6*
Baudelaire, Charles, 56
Beatrizet, Nicolas, 27–28, 95
Becerra, Gaspar, 27, 28, 95
Bell, Charles, 229, 281
Bell, John, 229, 282
Bellini, Giovanni, 13
Belvedere Torso, 28
Berengario da Carpi, Jacopo, 13–14, 16,
 19, 26, 28, 33; *15*
Bertinatti, Francesco, *65*
Bidloo, Govaert (Govard), 43–49, 61,
 131–32, 153, 177, 229; *44, 46*
Blooteling, Abraham van, 43, 131
Bonamy, Constantin Louis, 271
Borghese Warrior, 36
Bourdon, Amé, 36; *36*
Bourgery, Jean-Baptiste Marc, 271
Braune, Christian Wilhelm, 307
Browne, John, 36
Bucretius, Daniel, 31, 114

camera obscura, 50, 163, 177
Camper, Petrus (Pieter), 55, 60, 195
Caraglio, Jacopo, 20
Caravaggio, 28, 34
Carswell, Robert, 237, 238, 282
Carter, Henry Vandyke, 67, 297
Casseri, Giulio Cesare (Julius Casserius),
 31–32, 36, 39, 113–14; *31, 34*
Cats, Jacob, 46
CAT scans (CT scans), 319, 324, 325,
 326; *326*
Cellini, Benvenuto, 13
Cézanne, Paul, 54
Charles V, Holy Roman Emperor, 69
Charlotte, Queen, 196
Cheselden, William, 49–50, 163; *48*
Chevreul, Eugène, 56
Childs, George, 281
CIBA Collection of Medical Illustrations,
 The (Netter), *322*
Cleland, John, 61
Clement XI, Pope, 26
Clift, William, 237
Cloquet, Jules, 255–56, 271, 282
Coleridge, Samuel Taylor, 49
Colombo, Realdo, 26, 27, 95
color, 51–52, 55, 56
color printmaking, 52, 187; lithography,
 56; mezzotints, 52, 55–56, 187
computed tomography (CT) scans, 319,
 324, 325, 326; *326*
Cook, Henry, 131
Copernicus, Nicolaus, 69
copperplate engravings, 26, 113
Corneille, Pierre, 45
Courbet, Gustave, 60–61
Courtin, Louis, 55–56, 255

CREDITS AND ACKNOWLEDGMENTS

THIS BOOK WOULD NOT have been possible without access to the superb collections of anatomy atlases at the National Library of Medicine in Bethesda, Maryland, and the Thomas Fisher Rare Book Library at the University of Toronto. Both of these institutions have created excellent websites (http://www.nlm.nih.gov/exhibition/historicalanatomies/home.html and http://digital.library.utoronto.ca/anatomia/) that feature anatomical illustrations from their collections, with a wealth of accompanying information, that will reward repeated visits from anyone interested in the material in this book. Many of the descriptive captions in this book were adapted from information provided on the Anatomia website by the Fisher Rare Book Library and used by permission. The publisher would like to thank the following for providing the illustrations:

National Library of Medicine, Bethesda, Maryland: pp. 1–2, 12–65, 68–100, 102–11, 114–119, 121, 123–42, 144–51, 162–227, 262–69, 306–18, 327

Thomas Fisher Rare Book Library, University of Toronto: pp. 101, 120, 122, 143, 152–61, 228–61, 270–95

The Metropolitan Museum of Art, Joseph Pulitzer Bequest: p. 6

The Royal Collection © 2005 Her Majesty Queen Elizabeth II: pp. 9–11

Center for Human Simulation, University of Colorado: p. 329

Anatographica (images © 1999, 2000, 2002 by Visible Productions LLC): pp. 330–39

The publisher would also like to thank the following individuals for their assistance: Dr. Donald A. B. Lindberg, M.D., director of the National Library of Medicine; Anne Dondertman and James Ingram at the Thomas Fisher Rare Book Library; Vic Spitzer and Susan McNevin at the Center for Human Simulation; and John Kelly at Anatographica.